Framing the Past:
Essays on Art Education

Edited by
Donald Soucy and Mary Ann Stankiewicz

Foreword by
Foster Wygant

National Art Education Association
1916 Association Drive
Reston, Virginia 22091-1590

About NAEA ...

Founded in 1947, the National Art Education Association is the largest professional art education association in the world. Membership includes elementary and secondary teachers, art administrators, museum educators, arts council staff and university professors from throughout the United States and 66 foreign countries. NAEA's mission is to advance art education through professional development, service, advancement of knowledge, and leadership.

Cover: *Vita Brevis Arts Longa,* by Humberto Aquino

Acknowledgements: *Framing the Past: Essays in Art Education* was funded in part from a grant from The Canada Council.

ISBN 0-937652-52-0

To Stephen Gregory and Cecilia Charlotte

Contents

I. Art Education Historiography

II. The Nineteenth Century

III. The Turn of the Century

IV. The Twentieth Century

Illustrations

Foreword

Usually it is supposed that where there is a profession, there is a history which is part of the fundamental knowledge of the "real professional" in the field. We might expect that educators would be especially alert to the lessons from past teaching, if only in response to citizens whose ideas of school derive from personal experience some generations earlier. But the history of education is no longer a common requirement in teacher preparation, and for many years the one historical text treating the full span of American art education had been out of print.

Until recently, studies in the history of art education have been rare, apparently attributable to a quirk of personality. In my own case, the conventional wisdom about ignorance of history was paraphrased by a professor, Arthur Young, advising a doctoral seminar in the middle fifties, to this effect: "Before you offer all these bright ideas for change in art education, you'd better find out what has been done before." So I wrote a historical thesis, at just about the time when the shock waves of Sputnik created national demand for bold new planning in American curricula.

A few years after, Edwin Ziegfeld proposed an informal network of the few who were interested in the history of art education: I recall the names of Robert Saunders and John Keel, and of course Frederick Logan would have been the honored mentor. But we were busy in the sixties with the ideas of people like Bruner, Barkan, Beittel, McFee, and Eisner; with federally-funded projects and conferences; with curriculum proposals for the inner city; and with the new enthusiasms—perceptual awareness, environmental studies, related arts, aesthetic education, and behavioral objectives. There was little apparent need for guidance from the past, and as Keel once remarked, no one could be a full-time historian in art education.

In the eighties, the mood has changed. It may be that all those new trends of the sixties have lost their drive, or that their multiplicity finally stimulated a look to the past to resolve confusions. For whatever reason, historical studies in art education have become attractive in the past few years, if not downright fashionable, as witness their frequency among doctoral programs and professional

conferences, and the leading scholars and younger faculty who have turned their researches toward our history.

Much of this effort has been limited, as doctoral studies and spare time interests require, to the gathering of facts concerning an institution, an individual, a locale, or some curricular development. But recently there are signs of a wider range of interests and more solid theoretical bases, so that historical study seems to have become one of the major arenas for scholarship in art education. The present editors, Soucy and Stankiewicz, for example, have provided guidance from the more general field of historiography. And the studies which they have collected here, as an early harvest of the recent growth, demonstrate the potential richness of topics, techniques, and interpretations—each of them valuable, and collectively a service to the profession. The sheer variety of the articles prompts reflection on the nature and status of our history. Obviously, the needs of the profession, of individuals, and of the further development of the history, are not identical.

For the uninformed encounter with the history of art education, the first need is some simple organization of a few facts and warranted generalizations—something to remember easily—even though such simplifications are probably unsound. But which facts? We are pushed immediately to the kind of question deplored in semantics: what is art education? The exploration of that naive question leads to the threshold view on the ground level of wisdom. We need an encompassing view that will make good sense of the simplest historical datum.

In the historical vista, "art education" is not simply what goes on in assumed typical classrooms, nor is it an anthology of leadership opinion. Generally it exhibits neither an efficient, unified organizational structure, nor a rational developmental progress.

We must first see art education as a complex of interactions, a process of patterns and misfits, beginnings, blendings, transformations, and declines—a nebulous form, ever-changing, with no precise outline. Within the complex we must include all art activity in the school, of course, but in the library and museum as well, and in evening classes and community agencies for the elderly and the ill—all, perhaps, except the activity of the professional artist as artist. Viewing such formal and informal education, curriculum analysts provide categories for sharper focus: the why, what, who, how, and when of art education. Our historical complex will include the agencies, foundations, organizations, and people—the theoreticians, strategists, staffers, and teachers—and what they do and say; the research, the books, the content and editorial policies of journals; and the art, artists, historians, critics, and aestheticians who provide the sources and models for art education. Some such sets of items, considered as interacting,

suggest the scope of the "art education" that "is" and "was," and the enormous variety of topics for the historian.

Nevertheless, without attention to the context of external conditions, that scope is too narrow. Obviously, all education is governed by external forces. Art education is perhaps especially changeable: its purpose, method, and subject emphasize individual sensitivity and innovation. Shifts in education and art directly influence the teaching of art: has any school subject seen a more radical transformation of its parent discipline in the past century, or undergone more fluctuations of pedagogical theory? These influences in turn are factors of the more general socio-cultural conditions. It is good that the present collection of studies represents investigation of all of these major categories of influence: the domains of art, education, social structure, and culture. We need the contextualist in order to understand art education as responsive to broader forces, and to gain more penetrating exposure of the ways those forces work.

If this more comprehensive aspect is requisite to the first level of understanding in the history of art education, it would also be sufficient for the most elevated wisdom. But to reach such an exalted position, we would need a vastly greater store of researches in factual detail, and of interpretations that link facts with probabilities in countless networks. We need, for instance, more studies of:

ideas, popular and rejected: their sources, protagonists, opponents, triumphs, defeats, transformations, and their relations to other ideas and issues;

leaders: their careers, formative influences, beliefs and values, perceptual and cognitive frames, contributions, and ways of working;

influential programs which exemplify particular curricula, philosophies, or responses to external conditions;

unexceptional programs, and the work of worthy but unexceptional teachers, which (though difficult to document) would represent the middle of the road in art education at a given time;

the nature of art education at a point in time, as a static rendering of that complex process through a cross sectional slice, exposing the status of all the components of the complex described above;

continuities: the tracing of enduring ideas and practices, penetrating whatever disguises of changing language and method, amidst changing external conditions;

the why, what, who, how, and when: purposes, content, learners and teachers, methods, and curricula;

research in or relating to art education, and the influence of particular bodies of research;

major experimental projects, and their influence.

There are other needs. All of the foregoing has been phrased as though art education in each country were similarly structured, and as though international influences or comparisons were inconsequential. Nothing could be further from the truth, as the origins, authorship, and content of this collection of studies will amply demonstrate.

In the United States, for example, where there is no central governmental control or guidance, the history of art education may appear as a succession of unrelated divergencies from a purely hypothetical mainstream—a series of episodes with no central thread of narrative. Yet it may be that, behind the abrupt shifts that seem to have been tried and advocated in almost every decade, there has been an advance in professional knowledge and judgement. Has there been some hidden set of corrective adjustments, an obscure dialectic, of a kind which may have been steadily and openly conducted in some other nation? Is the process quite different, seen historically, in Canada or Britain? Certainly, as soon as historical study in each country has progressed adequately, we will want more comparative and relational studies, which may require collaboration between scholars in several countries.

Finally, no one will produce the only cogent reading of any historical material. We should look forward to the development of competing perceptions, arrays of fact, and interpretations—alternative histories focused on the same topic. We might then come close that the upper level of wisdom.

Until now, there have been few published books in the field, and little concerted effort to develop the needed scholarship. We would welcome, therefore, the present collection, which represents what justly may be called the first full generation of historical discipline in art education.

Foster Wygant

Preface

We have tried to present art education history not from a single perspective, but from a variety of them. Some authors in this book discuss traditional topics, others attempt to revise that tradition. Some are concerned principally with revealing the past, others the present. There are chapters that provide a broad overview, while others discuss one specific issue as it was manifested in a certain time and place. Although the book's focus is on art in the public schools, there is also discussion of art education in museums and private schools.

The authors' different perspectives led to different approaches to historical writing, which range from biography to social history. There are chapters concentrating on textual analysis, others on cultural transmission, and others on the development of prominent ideas or philosophies. Throughout this diversity, the chapters are tied together by their attempt to provide a glimpse of what we now know regarding the teaching of art in English-speaking countries and in Quebec during the past 150 years.

The editors chose to seek out this diversity while still maintaining a common thread that connected all of the chapters. We have many people and institutions to thank for assisting us in this job. Our collaboration began when one of us was at the University of Maine and the other at the University of New Brunswick, and we thank both these institutions for providing us with a grant from the University of Maine—University of New Brunswick Exchange Program. After one of us moved from Maine to California, collaborating became more expensive due to cross-continent telephone calls and travel. We thank the University of New Brunswick Academic Development Fund for its assistance with these added expenses.

A year after work on the book began, drafts of eleven of the chapters were presented with other papers at an international symposium on art education history in Halifax, Nova Scotia, co-sponsored by the Canadian Society for Education through Art and the University of New Brunswick. This opportunity for face-to-face discussion was also supported by the Social Sciences and Humanities Research Council of Canada and the British Council.

Each author is indebted to a number of librarians and archivists, too numerous to mention here, without whose help research would have been much more difficult, and in some cases not even possible. We thank Geoff Milburn of the Althouse Press at the University of Western Ontario and Tom Hatfield of the National Art Education Association for their advice on preparing the manuscript for publication. We are indebted to David Thistlewood and John Steers of the National Society for Education in Art and Design for arranging distribution in Britain. We thank Gail Gilmore, who typed early drafts of the manuscripts with the support of Andy Hughes and Gerald Clarke, Deans of Education at the University of New Brunswick. Barbara Cooper of Publications Plus designed and produced the final manuscript. We also thank Anny Soucy who, along with Don Soucy, created the index.

The Canada Council subsidized the pre-printing costs for the book with a Special Projects Assistance grant. This grant helped pay for typing, photocopying, mailing, and phone calls, and, more important, it allowed us to include an index, a full colour cover, and photos within the book. We gratefully thank the Council for their generous assistance.

The painting reproduced on the cover, *Vita Brevis Arts Longa* by Humberto Aquino, is used with the gracious permission of the artist and of Dr. and Mrs. Marvin Klein, the owners. The editors discovered the painting in the catalog *Latin American Artists in New York since 1970,* published by the Archer M. Huntington Art Gallery at the University of Texas, Austin, in 1987. We both felt this painting had a particularly appropriate resonance with these essays; the book's title was chosen to complement the painting. For their help in securing necessary permissions and color separations for the cover, the editors thank Jessie Otto Hite, Assistant Director for Public Relations at the Archer M. Huntington Art Gallery, and Roland Castruita of Wetmore and Company, Houston, Texas.

As usual the editors have saved the most deeply felt acknowledgements for last. Kellie Hosch kept one household going during periods of intense work. Anne and David watched the children, read the drafts, saw to creature comforts, and let us bounce ideas off them. We appreciate their support.

Donald Soucy
Mary Ann Stankiewicz

ANY ONE WHO CAN LEARN TO WRITE CAN LEARN TO DRAW

and, as writing is not taught to those only who are destined to become authors, but as forming an essential part of general education, so is drawing equally important to others besides professional artists. To write —to draw a form or figure that shall be recognized as the representative of a letter or word, is one thing; and to be able to design, draw, or write such forms, upon principles of grace and accuracy—to understand the Art of writing—is another. Thus it is also with Drawing, another mode of expressing ourselves, not less useful or necessary than that by letters

The oft-repeated opening line of Chapman's drawing book. (J. G. Chapman [1840] 1870, *The American Drawing Book*. NY: A.S. Barnes. F. Wygant Collection).

I. Art Education Historiography

U. S. DEPARTMENT OF THE INTERIOR,

BUREAU OF EDUCATION,

WILLIAM T. HARRIS, COMMISSIONER.

ART AND INDUSTRY.

EDUCATION

IN THE

INDUSTRIAL AND FINE ARTS

IN

THE UNITED STATES.

BY

ISAAC EDWARDS CLARKE, A. M.

PART II.—INDUSTRIAL AND MANUAL TRAINING
IN PUBLIC SCHOOLS.

WASHINGTON:

GOVERNMENT PRINTING OFFICE.

1892.

Interpretations found in Isaac Edwards Clarke's report to Congress have been repeated in art education histories for more than a century.

A History of Art
Education Histories

1

Donald Soucy

Few librarians worry about finding enough shelf space for their books on art education history. In the United States, Frederick Logan's 1955 *Growth of Art in American Schools* served as the only major survey for over three decades, and it had just one press run of 6,000 copies. Only 1,000 copies were printed of James Parton Haney's 1908 history, one of the very few published prior to Logan. In Great Britain, just a few hundred copies remain of Stuart Macdonald's 1970 book on *The History and Philosophy of Art Education,* which, by error, was withdrawn and pulped shortly after publication. Despite this loss, two other British books— Gordon Sutton's *Artisan or Artist?* (1967) and Richard Carline's *Draw They Must* (1968)—place England well ahead of Canada, which has no book surveying its art education history. Books taking an international perspective, such as Nikolaus Pevsner's *Academies of Art, Past and Present* ([1940] 1973), are also uncommon.[1]

Although this lack of books does not indicate a robust research discipline, there are other symptoms that suggest that the field is growing. There is more historical research being published, more discussion about the methodologies involved (e.g. Erickson 1977, 1985; Korzenik 1983, 1985a; Soucy and Webb 1984; Hamblen 1985a, 1985b; Mason 1985; Rush 1985; Savage 1985; Soucy 1985a; Kauppinen 1987) and, in Britain at least, more effort to organize documentary evidence (Ashwin 1975) and archival materials (Swift 1985; George 1987; R. Thistlewood 1988). In order to better understand and direct this growth, it is useful to look at it in the context of earlier developments in art education historiography, though very little has been published about these developments. John S. Keel briefly reviewed the literature in 1963. More recently, historiographic sources were listed in a chapter by Clarence Bunch in 1978, in a book by Ross Norris in 1979, and in an article on Quebec art education history written by Angela Grigor in 1982. But although these bibliographies are useful, a substantial critical overview of art education histories has never been published. An attempt at such an overview is offered here, with emphasis placed on North American histories, along with some mention of British sources.[2]

The Late Nineteenth Century:

The Clarke Legacy

Ignored until recently by trained historians, art education has usually had its history recorded by art educators themselves.[3] One of the earliest accounts, from 1873, was issued by the publishers of William Bartholomew's school drawing books. Bartholomew was a drawing teacher in Boston, and his books were in use throughout the United States and parts of Canada during the 1860s.[4] In the 1870s, Bartholomew's publishers lost a substantial portion of the lucrative text-book market because of increased competition. In an effort to regain customers, they distributed their 1873 "history" as a form of self-advertisement, trying to convince school officials that "the history of Bartholomew's drawing system is, in fact, the history of public-school instruction in drawing in this country" (*Drawing* 1873, 8).

Much of Bartholomew's competition came from a new drawing series authored and illustrated by a recent British emigrant, Walter Smith. Smith was championed by, among others, Isaac Edwards Clarke. An official of the U.S. Bureau of Education, Clarke wrote a number of reports on school drawing and technical training (1874, 1885, 1892, 1897, 1898, 1904). In the century since their release, Clarke's reports have molded—and in many ways have shackled—the direction of historical research into nineteenth century North American art education.

To Clarke, the history of art education in the United States was not the history of Bartholomew's drawing, rather it was the history of Walter Smith in Massachusetts, Clarke's home state. According to Clarke, widespread art education only came about in 1870 with the passing of the Massachusetts Free Instruction in Drawing Act. The resulting art program was systematized by one man, Walter Smith, and was effected by the business elite in order to form a working class more suited to industrial needs. Clarke had relatively little to say about the non-industrial educative role of fine art.[5]

Studies prior to Clarke's, such as one published by George Ward Nichols in 1877, had historically interpreted art education's links to industrial needs. But no one, before or since, has surpassed Clarke in documenting this interpretation and in stimulating its dissemination. In 1890 Clarke's reports formed the basis of an art education history in the *Encyclopaedia Britannica* (Burke)—and that was just the beginning. In the twentieth century, even writers who claim to present a broad overview of art education history often stick to Clarke's narrow industrial focus. You can find versions of Clarke's interpretation in various theses (e.g., Belshe 1946; Green 1948); in most short historical surveys found in books (e.g., Farnum 1941; de Francesco 1958; Gaitskell 1958; Eisner 1965, 1972; Kaufman 1966;

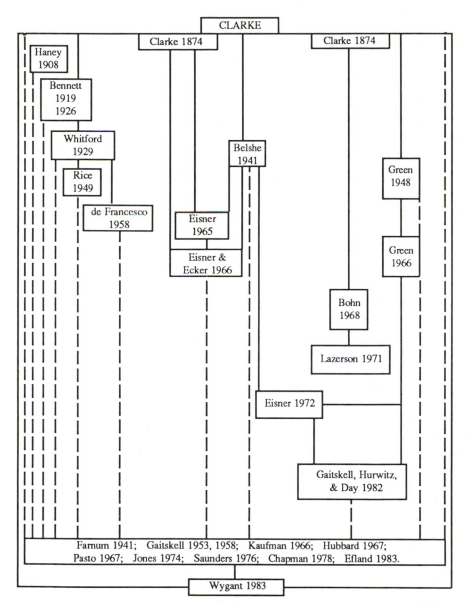

This chart illustrates how Clarke's interpretations have filtered through a century of U. S. art education histories. The solid lines represent acknowledged sources (e.g., Eisner 1972 cited Bleshe 1941). Broken lines represent possible transmission of historical interpretations (e.g., Gaitskell did no primary research outside of Canada for his 1953 article and would have depended on earlier interpretations to formulate his own). Wygant's extensive use of primary sources in his 1983 book was aided by his knowledge of all of these secondary sources.

Hubbard 1967; Eisner and Ecker 1966; Chapman 1978; Gaitskell, Hurwitz and Day 1982; Boris 1986; Freedman 1987a; Soucy and Pearse 1988); and in historical articles in journals (e.g., Gaitskell 1953; Pasto 1967; Bohn 1968; Jones 1974; Saunders 1976; Efland 1983a). Even the British history by Macdonald (1970) has parallels to Clarke. For example, both Clarke and Macdonald portray Robert Benjamin Haydon as a pivotal, heroic figure in early nineteenth century British art education; both emphasize the role of Walter Smith in the United States; and both downplay the influence of John Ruskin.

Some researchers, such as Bohn—whose 1968 article in the *History of Education Quarterly* is one of the very few on art education history published elsewhere than in an art education journal—depended directly on Clarke for their information. Others relied on secondary sources that were based on Clarke. One example is Lazerson (1971), who cites Bohn for his information. Other examples are the many writers who depend on Eisner and Ecker's 1966 historical overview. Eisner and Ecker drew information from a 1946 doctoral dissertation done at Yale by Francis Bland Belshe. Belshe, in turn, had taken much of his information from Clarke, also a Yale graduate.

Relying on Clarke is, of course, easier than doing primary research. But another reason for the persistence of interpretations similar to Clarke's is the legacy of Walter Smith. A graduate of England's South Kensington National Art Training School, Smith shared Clarke's bias toward drawing for industrial purposes.[6] In pursuit of that bias, Smith not only authored drawing books, he also established lasting structures in the art education bureaucracy—structures that were subsequently imitated outside of Massachusetts. In the early twentieth century, many art educators writing about their profession's history were employed in high-ranking positions that were made legitimate at least partly by Smith. Because women had so little access to these positions, they wrote virtually none of the early art education histories. This, in part, explains why these histories paid such scant attention to the non-industrial forms of art education that were prevalent in the private schools and ladies' colleges. As for the men who did get to write histories of art education, they apparently did so to promote their school subject and, consequently, their careers. They therefore emphasized and praised Smith's administrative models—the models in which they now worked—and ignored forms of art education that were not related to those models. They also shied away from criticizing too strongly Smith's theories, because to do so could undermine their promotion of the structures that Smith built.

Henry Turner Bailey provides an example. Bailey published an article on art education history in 1900 and another in 1929. He was a graduate of the Massachusetts Normal Art School, an institution whose founding Smith had spearheaded in 1873.[7] Bailey was also State Agent for Promotion of Industrial Drawing for the Commonwealth of Massachusetts, a position that, in an earlier form,

In his art education histories, Henry Turner Bailey promoted his Alma Mater, the Massachusetts Normal Art School. He also praised Walter Smith, his predecessor as Massachusetts's overseer of school art. (Bailey 1910, *The Flush of the Dawn* The Davis Press. Soucy Collection).

was held by Smith. By the turn-of-the-century, Bailey's ideas on teaching art had moved away from those of Smith's.[8] Still, Bailey's Alma Mater and his official position no doubt influenced his historical treatment of his predecessor. Although in his history of 1900 Bailey occasionally disputed Smith's ideas, for the most part he lauded Smith, glossed over their differences, and took pains to draw out their similarities. In his 1929 history, Bailey summed up the advances of art education in the United States by claiming that "Behind all this development stands first in influence, as the alma mater *par excellence,* the Massachusetts Normal Art School organized by Walter Smith" ([1929] 1936, 488).

The Early Twentieth Century

An early conduit for Clarke's interpretations was Haney's 1908 history. As Robert Saunders (1961) noted, Haney depended on Clarke for most of his information up to 1885, and then supplemented it with descriptions of public school art exhibitions at state fairs and world expositions. Whereas Haney mistakenly professed to give a broad history of art education, Charles Alpheus Bennett admitted to a narrower focus. In a short historical article written in 1919, and later in his books of 1926 and 1937, Bennett, like Clarke, discussed primarily the manual and industrial uses of art education. In his books, Bennett used Clarke as a source. In 1929, William G. Whitford wrote a short history of art education in which he used Bennett's 1926 book as a source. Subsequently, Whitford (1923, 1929) joined Haney in becoming a source for future historical looks at art education (e.g., Rice 1949; de Francesco 1958), thereby serving to perpetuate some of Clarke's interpretations.

Although Whitford and later twentieth century historians borrowed facts, interpretations, and historical anecdotes from Clarke, they often did not share Clarke's positive attitude toward the industrial purposes of art education. As ideas from the Child Study Movement and Progressivism took hold, histories began to criticize the rigidity of the industrial drawing systems. But these histories still identified industrial drawing as the most relevant predecessor of early twentieth century art education. They paid little attention to other antecedents, such as Ruskin's Romanticism, that were more closely related to their own Progressive ideals.[9]

As Purdue (1977) has noted, neither have these histories paid much attention to William Morris and the Arts and Crafts Movement. Although Purdue overstates his case when he argues that this Movement infused a socialist aesthetic into American art education, it is true that it provided many of the roots for art education's pre-World War II emphasis on learning through production of actual works. This emphasis stood in contrast to the abstract exercises of the industrial drawing texts. Walter Crane (1910a, 1910b), a close associate of Morris's, made

these connections between art education and the Arts and Crafts Movement in short historical pieces he wrote for the *Encyclopaedia Britannica,* but his work was the exception. For the most part, histories kept the emphasis on industrial drawing.

The Mid-Twentieth Century

Later histories maintained a dependence on Clarke, and therefore continued to centre on Massachusetts and Walter Smith. One of the most ambitious art education histories written during the first half of this century was Harry Beck Green's 1948 dissertation, *The Introduction of Art as a General Education Subject in American Schools.* Green's interpretations, like Belshe's before him (1946), clearly parallel those of Clarke's, and Clarke is the most frequently cited single source in the dissertation.

Green did try to distance himself from Clarke, assuring us that "Clarke's volumes were quoted only when he spoke for himself or when he reprinted some document not otherwise available" (p. 2). But in researching the nineteenth century, Green seems to have used Clarke as his starting point, setting out from there to find information related to Clarke's interpretations. As a result, about half of Green's thesis concentrates on Massachusetts, with about half of that discussing Walter Smith. In supplementing the information from Clarke, Green turned mostly to government reports from Boston and the State of Massachusetts. His dissertation, along with his 1966 *Art Education* article that he based on it, served as a recognized source for subsequent art education histories (e.g., Eisner 1972; Gaitskell, Hurwitz, and Day 1982), thus helping to usher Clarke's ideas into the latter half of the twentieth century.

Green's and Belshe's dissertations also emphasized nineteenth century educationists who published or advocated drawing books, such as William Bentley Fowle, Rembrandt Peale, William Minifie, Henry Barnard, John D. Philbrick, and Charles C. Perkins. These same educators figure prominently in the historical surveys by Haney (1908), Whitford (1929), de Francesco (1958), Eisner (1965, 1972), and Eisner and Ecker (1966). Not surprisingly, this same litany of nineteenth century figures are the ones who receive historical attention from Clarke. Clarke had clear reasons for highlighting them: they advocated the type of art education that foreshadowed the industrial concerns of Smith. Clarke described this group of educators as merely a selective sample of such advocates, not an exhaustive list of them. Yet, some subsequent histories have implied that this partial list of promoters of one particular type of drawing instruction constitutes an overview of nineteenth century art education.[10] These same histories often summarize the entire eighteenth century with a few quotes from Benjamin Franklin about the utilitarian value of drawing instruction. As you might expect,

Franklin's quotes were included in Clarke (1885) and Green (1948) and referred to by Belshe (1946) and Whitford (1929).

Overviews of nineteenth century art education also usually discuss Elizabeth Peabody and Horace Mann, even though Clarke and Green had relatively little to say about them. Peabody and Mann gained much of this historical prominence after Logan's 1955 book and after they were featured in a doctoral dissertation and articles by Robert Saunders (1957-58, 1958, 1958-59, 1961, 1971, 1977).[11]

Interestingly, Logan was unaware of Green's dissertation when he wrote *Growth of Art in American Schools* (1955). Furthermore, though Logan was aware of Haney's 1908 history, he did not cite it as a source for historical information. Neither did Logan cite Whitford or Belshe, and Clarke is referred to only in the bibliography, not in the footnotes. Logan was a principal source for many subsequent histories (e.g., Eisner 1965; Eisner and Ecker 1966; Hubbard 1966; Saunders 1976), but, though his book was not part of the chain linking these later histories to Clarke, neither did it serve to break that chain; short surveys that cite Logan often give relatively more emphasis than he did to the industrial purposes of drawing in late nineteenth century Massachusetts (e.g., Kaufman 1966; Chapman 1978).

Logan's book did, however, establish the focus for many subsequent writings on early twentieth century art education. For example, following Logan's lead, histories often portray Arthur Wesley Dow as the sole central figure in the composition-design movement that began early in the century. Only recently has this interpretation been questioned, principally by Stankiewicz's research into the design theories of Denman Ross.[12]

Logan exemplified two other trends in mid-century art education histories. One was to utilize a "book review approach" to history, consisting primarily of critical reviews of art education texts (Soucy 1985a, 14). Logan again used this approach in a 1975 update of his earlier history. The second trend was to search the past for evidence supporting contemporary art education theory—to laud those things that served as stepping stones to today's enlightened pedagogy, and to discredit anything that did not. Another example of this second trend was a 1953 thematic issue of *School Arts* that discussed "Old and New Ways of Teaching Art." Nora Zweybruck's article in that issue was a hagiographic historical view of Franz Cizek, the "father" of the "new art education." It was no coincidence that her article was preceded by one that discussed Ralph Pearson's recently revised book *The New Art Education,* a book praised by the *School Arts* editors. In contrast, when a historical article by Lanice Dana in this issue failed to acclaim the new child-centered approach, the editors felt it necessary to both begin and end the piece by washing their editorial hands and stating they disagreed with the author.

That 1953 issue's first article was "Art Education Has a History," written by Charles Dudley Gaitskell, Director of Art for the Province of Ontario. In 1947 Gaitskell had completed a doctoral dissertation that contained two chapters on the history of art instruction in Ontario's schools. These chapters were the first significant Canadian study on art education history. Gaitskell later condensed the two chapters and included them in a book (1948).

The one attempt to survey the history of art education for all of Canada was a 1954 master's thesis written by Robert Saunders at The Pennsylvania State University. Saunders was hampered by geography and time, which prevented him from travelling to Canada for his research. He thus found himself heavily dependent on Gaitskell's history. Three years later, in 1957, George E. Tait also picked up on Gaitskell's work, writing a doctoral dissertation with a more detailed look at the history of public school art in Ontario. In all three of these histories—Gaitskell's, Saunders', and Tait's—good art education was that which emphasized the child rather than the art produced. Saunders realized this emphasis could be problematic. In critiquing his own study, he noted his tendency to judge past experiences on the basis of the influential ideas of Viktor Lowenfeld, a member of his thesis committee (Saunders 1954, 87).[13]

The 1960s and 1970s

After Tait's dissertation the momentum stopped in Canada. A few other things were written: Calvin did a 1967 master's thesis on Montreal art educator Anne Savage; that same year Hinterreiter published an overly-laudatory article on Arthur Lismer.[14] But in general, Tait's work was followed by a two decade hiatus in Canadian art education historical research.

The situation in the United States was better—but only a little. In the closing sessions of the pivotal 1965 Penn State Seminar in Art Education for Research and Curriculum Development, Harlan Hoffa noted regretfully that no historical research had been presented at the conference (Mattil 1966, 424).[15] That was a good indication of the lack of importance the profession attached to its history. Another indication was that only a few historical dissertations were written in the 1960s and 1970s (e.g. Saunders 1961; Dobbs 1972; Mock-Morgan 1976; Purdue 1977; Stankiewicz 1979).

Although the 1965 Seminar featured no historical papers, that year's National Society for the Study of Education yearbook did: one by Elliot Eisner and another by John Keel. The following year, 1966, Keel joined Saunders in editing a special issue of *Art Education* devoted exclusively to the profession's history. Prior to this, *Art Education* had included very few historical articles during its eighteen years of publication (e.g. Rice 1949; Rios 1956; Barkan 1962). Saunders

and Keel (1966b) hoped that this would change and that "response to this issue will be such that future issues may again be used for historical catching up in our profession." That response did not happen. The next year did see historical articles by Battist (1967) and Pasto (1967), but after that *Art Education* remained silent on the subject until an article by Jones in 1974 and a second special issue on history in 1976. This 1976 issue again contained an article by Keel and another by Saunders, and was edited by Logan.[16] Hamblen (1987) has reported that, even with these special issues, only thirty-one history-related articles were published in either *Art Education* or *Studies in Art Education* between 1958 and 1976. In comparison, sixty-eight history articles appeared in the two journals between 1977 and 1986.

Its relative dormancy during the 1960s and 1970s left art education historical research unconnected to developments occurring in mainstream education history during that same period. For example, both mainstream history and general art education research tried to gain credibility through quantitative studies. Yet no such studies emerged in art education history. Similarly, with only a handful of historical writers, art education was unprepared to heed the calls of Bernard Bailyn and Lawrence Cremin, who argued that "education" should be viewed not simply as schooling, "but as the entire process by which a culture transmits itself across generations" (Bailyn 1960, 14). Also generally unheeded by art educators were the appeals to see the past on its own terms, to not criticize historical practices solely on the basis of today's standards, and to not fall victim to the "sin of evangelism, by seeking to inspire teachers with professional zeal rather than attempting to understand what really happened" (Cremin 1965, 43).

Bailyn and Cremin urged historians to contextualize education within broader social structures. There were only isolated attempts to do so in art education. During the 1950s, Wygant undertook graduate work at Teachers College, Columbia University, where Cremin had been on staff since 1949. For his doctoral dissertation, Wygant wrote "A History of Art Education at Teachers College, Viewed as Response to Social Change" (1959). Another contextualized history was Peter Purdue's 1977 doctoral dissertation on the effect that socialist thought had on art teaching in America. But these few exceptions (see also Weiley 1957) were not enough to prevent art education history from lagging behind the mainstream by a decade or two. As education historian J. Donald Wilson observed, a 1985 article (Soucy 1985b) calling for new directions in art education history "is reminiscent of what some of us were saying about Canadian education history about 15 years ago" (letter to Letia Richardson, 7 October 1985).

The 1980s and Beyond

Beginning around the early 1980s, the lack of interest in art education's past was replaced by a sense of curiosity. Scholars such as Foster Wygant and Robert

Saunders were finally finding their long-standing interest in art education history being shared by a small but growing group of researchers. As a result, the topic increased its presence in professional journals and conferences. In 1985 The Pennsylvania State University hosted a major international conference on art education history (Wilson and Hoffa 1985). In 1987 a similar, though smaller, international symposium was held in Halifax, Canada, co-sponsored by the Canadian Society for Education Through Art and the University of New Brunswick. This was followed in 1988 by another symposium in Bournemouth, England, held in conjunction with the hundredth anniversary conference of the National Society for Education in Art and Design. In 1989 the Second Penn State Conference on the History of Art Education was organized and, during that same year, the Museum of Contemporary Art of the University of Sao Paulo in Brazil held its Third International Symposium on the History of Art Education.

In addition to books connected to these conferences,[17] a few other books are emerging from all of this increased research. Arthur Efland (1989) has completed a major survey, which finally gives us something to supersede Logan's 1955 text. Wygant provides a new overview of *Art in American Schools in the Nineteenth Century* (1983). He has also drafted a book on *Art in American Schools: 1900-1970* (1986). Other books such as those by Clive Ashwin (1981), Diana Korzenik (1985b), Frayling (1987), and Soucy and Pearse (in press) explore specific topics related to the profession's history, as do a number of monographs (e.g. MacGregor 1979; Zimmerman and Stankiewicz 1982; Stankiewicz and Zimmerman 1985; Messer 1985); exhibition catalogues (e.g. Thistlewood 1981; Ashwin 1982; Kirby 1987; Richardson 1987; Soucy 1987a); doctoral dissertations (e.g. Baker 1982; Smith 1983; Swift 1983; Grigor 1985; Bolin 1986; Rogers 1987; Hollingsworth 1988); and special issues of professional journals (e.g. Rush and Stankiewicz 1985; Soucy 1986a; Thistlewood 1988b).

This historical research is increasing not only in quantity but also in conceptual and methodological sophistication (Hamblen 1987). Writers are now taking a more judiciously critical view of their subjects. For example, the once sacrosanct ideas of Cizek and Lowenfeld are coming under the historical scrutiny of Peter Smith (1982a, 1982b, 1984, 1985a, 1985b, 1987, 1988a, 1989)[18] and Kerry Freedman (1986, 1987a, 1987b, 1988). Stankiewicz (1984b) has attempted to debunk some of the myths of self-expression that were popularized by Ruth Shaw, the inventor of finger paint. Korzenik (1981), Freedman (1987b, 1989a, 1989b), and Leeds (1989) challenge our assumptions about child art, arguing that these assumptions are socially determined and vary over time. In Britain, Peter Abbs (1987) and Robin Morris (1987) historically examine some of the problematic aspects of the legacies of Modernism and Progressivism.

Researchers are also tending to view art education's history within its wider social context. In her paper for the 1985 Penn State Conference, Leslie Savage exemplifies the benefits of revising art education history by synthesizing it with

social history. She does this by injecting a more sophisticated social perspective into Quentin Bell's (1963) interpretation of the development of British schools of design in the early nineteenth century. Her method could be profitably utilized in revising other earlier historical interpretations of art education. Diana Korzenik takes a social history approach in her 1985 book, *Drawn to Art,* as does David Thistlewood (1986b) in sections of his article that overviews a century of British art education, and as Arthur Efland (1983b) does in his article on "Art Education During the Great Depression." Kerry Freedman (1986, 1987a, 1988) examines the teaching of art as a form of social control. Freedman is joined by Thomas Popkewitz to explore ideology and how social relations fostered by art education have corresponded to those of economic life (1985, 1988). Others (e.g. Efland 1983a; Soucy 1987b) benefit from revisionist examinations into how sectors of the dominant social class intended education to effect change in subordinate classes. Still others (e.g. Erickson 1979, 1988; Stankiewicz 1979, 1982a, 1982b, 1983, 1985b, 1988b; Zimmerman and Stankiewicz 1982; Stankiewicz and Zimmerman 1984, 1985; Collins and Sandell 1984; Efland 1985; Richardson 1987; Soucy 1987b, 1989; Smith 1988b; Thistlewood 1989; Zimmerman 1989) take cues from feminist historians, at least to the degree of discussing issues related to women.

Despite these advances, art education still trails behind mainstream educational history. This is apparent from the published proceedings of the 1985 Penn State history conference (Wilson and Hoffa), which well exemplify the state of research at that time and are of very mixed quality. Some of the papers reflect their authors' dedication to historical questions, along with their awareness that writing history involves complex methodological and philosophical issues. Other papers, however, at best display an encouraging curiosity about the past on the part of their writers. Some of these papers border on antiquarianism, collections of shallowly interpreted facts. Others provide interpretations that go well beyond the scope allowed for by the available evidence. Most apparent are papers that narrowly confine their discussion to ideas in art education without adequate acknowledgement of social contexts within which those ideas were expressed.

Thus, many of our recent histories still imply that ideas shape the past more so than do social conditions. To illustrate the point, compare two articles that discuss Andrew Carnegie's philanthropic financing of art education projects. Judson's (1989) historical description of the Carnegie Institute in Pittsburgh informs us about what was taught and whose art education ideas were manifested in that teaching. Freedman (1989c), on the other hand, provides us with that same information in regard to the Carnegie-funded Owatonna art education project of the 1930s, but these facts are just the necessary background for more sophisticated questions. Freedman's real concern is with the internal contradictions manifested by foundation philanthropy in its efforts to set social goals based on narrow private interests. It is this type of question that leads to a more in-depth view, not only of our past, but also of our present (consider, for example, that

since the mid-1970s, names such as Rockefeller and Getty and the Rand Corporation figure so prominently in art education).

The determination to examine such questions, to go beyond a mere chronological listing of uncontextualized art education ideas, is becoming stronger among those with more than a passing infatuation with art education history.[19] Yet, it is not simply a matter of intent; we may intend to use the tools of contemporary historians, but our pursuit of art education degrees may not have adequately prepared us to do so. The field, therefore, will still have a long struggle to determine the relative merit of different historical research methods, purposes, focuses, and philosophies. Furthermore, notwithstanding the historians' demand that facts and ideas from the past must be contextualized, we still have to find out what those facts and ideas actually were. Mainstream historians can afford to disparage mere intellectual history; their field already has volumes of such histories from which they can spring their more contextualized studies. Art education does not have such a luxury.[20]

Because so little of the initial spadework has been done, art education historians have had to do a lot of scratching around the surface before discovering where best to dig. It is only now, when art education's tap-roots are becoming apparent, that we can determine the connections between their offshoots with some sense of confidence. Still, we have yet to unearth even some of the more shallow roots. For example, except for Korzenik's book (1985b) and her subsequent related articles and papers (e.g. 1987), we have made little effort to describe the past as it was experienced by workers. Our histories usually quote business leaders and prominent educationists, while working class people are portrayed not as historical actors, but rather as those who are acted upon. Conflicts, collaborations, and compromises between social groups over art education have been virtually ignored. Were workers passive recipients of art training for moral, economic, or vocational ends? Or did they strive to either acquire or reject specific forms of art education? Which social group's cultural values have been institutionalized by art education? How, for example, were the traditions of various immigrant cultures preserved or lost in the American melting pot?

More attention might also be paid to geographic concerns. Historical looks at one or two centers are still propped up as histories of a whole country. We still freely apply to Canada interpretations that arise from the United States. We rarely distinguish urban data from rural.[21] We still view communities as a place, when it may be more beneficial instead to view them as a process (Hogan 1985). Closer links can also be formed with art history. For instance, concerns such as the relationship between a painter's sex and her or his status as amateur or serious artist cross both disciplines. Stankiewicz (1987) raises another issue: neither art histories nor art education histories have revealed much about the education of the many non-prominent, traditional artists of the nineteenth century.

These issues reflect a litany of current concerns in mainstream education historiography: class, gender, race, culture,[22] ideology. Art education has yet to adequately address these concerns. But just as dramatic changes took place in education history during the mid 1960s and early 1970s, changes are currently taking place in art education historiography, albeit on a less significant scale. Researchers bringing about these changes can profit greatly by learning from competent historians who are not primarily art educators. In the same vein, these competent historians can benefit from discovering art education's unique role in the "process by which a culture transmits itself across generations."

Notes

1. Whereas American art education histories tend to emphasize the teaching of children, many historical articles on British art education (e.g. Baynes, Langdon, and Myers 1977; Ashwin 1985; Thistlewood 1985, 1986a, 1987, 1988a; Haslam 1988; Meyer 1988; Swift 1988; Yeomans 1988) spotlight art training for adults. Similarly, all of the North American histories in this present volume discuss the teaching of children, while one of the two British contributions—Thistlewood's—along with Chalmers's study of a British Colony, look primarily at teaching adults.

2. I thank Foster Wygant for informing me about and providing me with copies of many of the difficult to find early art education histories. Other research for this chapter was assisted by a grant from the University of New Brunswick Academic Development Fund. Although the research uncovered many histories of art education, there is no attempt in this paper to cite all of them.

3. The practice continues today. For example, among the fourteen authors in this collection all except two (Thistlewood and Wood) teach art education at the university or supervisory level.

4. Bartholomew's Drawing cards are illustrated in Diana Korzenik's chapter in this volume. In our chapter, Anne Wood and I discuss the use of Bartholomew's texts in Nova Scotia. See also Soucy 1986b.

5. In his 1986 University of Oregon dissertation, and again in his chapter in this volume, Paul Bolin also argues that, since the time of Clarke, historians have generally ignored the non-industrial forms of drawing education that existed in Massachusetts in the 1870s. In her chapter, Diana Korzenik contends that, in actual practice, even Smith's industrial drawing books were used by children as a springboard to fantasy, spontaneity, and inventive art making.

6. The influence that the South Kensington school had on Great Britain and Massachusetts is well recorded, but less is known about its influence on other places. In his chapter, Chalmers traces the South Kensington presence in New Zealand. In earlier work, Chalmers (1985a, 1985b) also looks at South Kensington's influence in Canada. Its influence in Nova Scotia is discussed by Pearse and Soucy (1987; Soucy and Pearse in press). According to Barbosa (1978), Walter Smith's influence extended into Brazil.

7. According to Boris (1986, 85), Isaac Edwards Clarke also graduated from the Massachusetts Normal Art School, receiving an M.A. in Fine Arts, but in our research into Clarke's education, neither Diana Korzenik, Arthur Efland, Foster Wygant, nor I have found any evidence to support Boris in this. Korzenik, a contributor to this volume, is Professor of Art Education at Smith's school, now known as the Massachusetts College of Art.

8. See the chapter by Stankiewicz.

9. For discussions on Ruskin and art education, see the chapters by Amburgy, Efland, Stankiewicz, and Wood and Soucy. See also Stankiewicz 1984a, Amburgy 1985, Boris 1986, Haslam 1988, and Amburgy and Soucy 1989. The effect of Progressivism and child-centred approaches to art education in the twentieth century are discussed in the chapters by Efland (U.S.), Lemerise and Sherman (Quebec), Rogers (British Columbia), and Swift (England). See also Cremin 1961, Grigor 1985 and 1986, Wood 1985 and 1986, Abbs 1987, Freedman 1987a, Wygant 1988 and 1989, MacIver 1989, and Tarr 1989.

10. An exception to this is Peter C. Marzio's 1976 book, *The Art Crusade,* which attempts to study a different group of drawing book authors. As a historian of technology, Marzio is also an exception to the rule that only art educators write art education history. See also Marzio 1969 and Stankiewicz 1986.

11. Saunders's chapter in this volume builds on this earlier work. For other discussions on Peabody and Mann, see Forman 1968 and Wygant 1983.

12. See chapter by Stankiewicz. See also Stankiewicz 1985b and 1988a, and Wygant 1985. For information on Dow, see Mock-Morgan 1976 and 1985.

13. In her chapter, Korzenik proposes a sophisticated approach somewhat related to the one used by Saunders. She suggests that we view past practices in the light of contemporary developmental psychology.

14. Savage and Lismer are discussed in the chapter by Lemerise and Sherman. McLeish ([1955] 1973) and Wood (1986) also discuss Lismer's work in art education, while McDougall (1987) discusses Savage's. In the 1980s, Lismer still receives unbalanced laudatory historical treatment. See, for example, articles or book chapters by Darroch (1981), Harold Pearse (1986), Pearse and Soucy (1987), Soucy and Pearse (in press), and by Angela Grigor (1986), who also discusses Lismer in her 1985 doctoral dissertation.

15. For a discussion of the 1965 Penn State Seminar, see Efland 1984, 1988, and 1989 and the chapter by Efland in this volume.

16. This special history issue contained an article by Sandra Packard (1976) on Jane Addams. Packard gives a highly flattering, uncritical depiction of Jane Addams. For a more balanced view, see Boris (1986) and Amburgy's chapter in this volume. See also Cremin (1961).

17. As noted in the Preface, early drafts of many chapters of this book were presented at the Halifax Seminar. Papers from the Bournemouth conference are slated for a book

that David Thistlewood is editing as part of the Art and Design Education Series being published by Longman in association with the National Society for Education in Art and Design. Thistlewood's book is planned to serve as a supplement to Stuart Macdonald's 1970 book, *The History and Philosophy of Art Education*. The National Art Education Association published the proceedings of the first Penn State history conference. Whereas the Halifax Seminar grew out of our work on this book, it was the other way around for the Bournemouth and the two Penn State conferences: the books grew out of the conferences.

18. See also Hollingsworth 1988.

19. This chapter is itself an example of a "book review" approach to history, in which facts and ideas from texts are listed with only slight regard to social context. Now that these facts and ideas are uncovered, we may be able to ask broader and more fruitful questions about art education historiography.

20. As Wygant (1988, 1989) shows, even the art education ideas of prominent theorists such as John Dewey and Margaret Naumburg need further exploration (see also MacIver 1989 and chapters here by Amburgy and Efland). Similarly, although we know that ideas developed by Herbert Read and Marion Richardson influenced art education, Thistlewood and Swift, in their chapters and elsewhere (e.g. Thistlewood 1984, 1986b; Swift 1983, 1986), make it clear that we still need a better understanding of what Read's and Richardson's ideas actually were. The ideas of Catterson-Smith outlined in Swift's chapter (and in Swift 1977, 1978, and 1983) will also be informative to most North Americans. Although Steveni's short history of British art education (1968) discusses Catterson-Smith, the three major books on England's art education history—Sutton 1967, Carline 1968, and Macdonald 1970—have little to say about him. (For additional information on Richardson, see Holdsworth 1988.)

21. In his chapter on art education in British Columbia, Rogers makes this distinction between urban and rural. For more historical discussion on British Columbia's art education, see Chalmers 1985 and Rogers 1983, 1984, 1985, and 1987.

22. In their chapter, Lemerise and Sherman provide a cross cultural study of Quebec art education. Lemerise, a French Quebecois, and Sherman, an Anglophone Quebecker, have each looked at their own cultures and have synthesized their findings into this study.

References

Canadian (Authors or Subjects)

Amburgy, Patricia, and Donald Soucy. 1989. "Art Education, Romantic Idealism, and Work: Comparing Ruskin's Ideas to Those Found in 19th Century Nova Scotia." *Studies in Art Education* 30 (no. 3): 157-63.

Calvin, H.A. 1967. "Anne Savage, Art Teacher." Master's thesis, Sir George Williams University, Montreal.

Chalmers, F. Graeme. 1985a. "South Kensington and the Colonies: David Blair of New Zealand and Canada." *Studies in Art Education* 26 (no. 2): 69-74.

_____. 1985b. "South Kensington and the Colonies II: The Influence of Walter Smith in Canada." In Wilson and Hoffa, 108-12.

Darroch, Louis. 1981. *Bright Land: A Warm Look at Arthur Lismer*. Toronto: Merritt Publishing Co.

Gaitskell, Charles D. 1947. "Art Education in the Province of Ontario." Dr. of Pedagogy diss., University of Toronto.

_____. 1948. *Art Education in the Province of Ontario*. Toronto: Ryerson Press.

_____. 1953. "Art Education Has a History." *School Arts* 53 (no. 2): 6-7.

_____. 1958. *Children and Their Art, Methods for the Elementary School*. N.p.: Harcourt, Brace and Co.

Gaitskell, Charles D., Al Hurwitz, and Michael Day. 1982. *Children and Their Art: Methods for the Elementary School* 4th ed. New York: Harcourt Brace Jovanovich.

Grigor, Angela. 1982. "Some of the Trends Evident in Art Education." *Canadian Review of Art Education Research* 9: 21-31.

_____. 1985. "The One and the Many: Concepts of the Individual and the Collective in Art Education During the Progressive Era in Education 1920-1960." Ph.D. diss., Concordia University, Montreal.

_____. 1986. "The Influence of Progressive Ideas on Arthur Lismer's Philosophy of Education." *The Annual Journal* [Canadian Society for Education Through Art] 17: 38-40.

Hinterreiter, H. Gilda. 1967. "Arthur Lismer: Artist and Art Educator. A Reflection on His Life, Work and Philosophy." *School Arts* 66 (no. 5): 21-28.

McDougall, Anne. 1977. Anne Savage: *The Story of a Canadian Painter*. Montreal: Harvest House.

MacIver, Donald. 1989. "On the Dewey-Naumburg Debate." *The Canadian Review of Art Education* 16 (no. 1): 53-57.

MacGregor, Ronald N. 1979. *A History of the Canadian Society for Education Through Art*. Lexington, Mass.: Ginn Custom Publishing.

McLeish, John A.B. [1955] 1973. *September Gale A Study of Arthur Lismer of the Group of Seven*. 2d ed. Toronto: J.M. Dent & Sons.

Messer, Margaret, ed. 1985. For the Children. *25 Years with the Saskatchewan Society for Education Through Art*. Saskatoon, Sask.: The Saskatchewan Society for Education Through Art.

Pearse, Harold. 1986. "Arthur Lismer and the Roots of Canadian Art Education." [Nova Scotia] *ATA Journal* 8 (no. 1): 18-26.

Pearse, Harold, and Donald Soucy. 1987. "Nineteenth Century Origins of Saturday Morning Art Classes for Children in Halifax, Nova Scotia." *Studies in Art Education* 28 (no. 3): 141-48.

Purdue, Peter. 1977. "Ideology and Art Education: The Influence of Socialist Thought on Art Education in America Between the Years 1890-1960." Ph.D. diss., University of Oregon.

Richardson, Letia. 1987. *First Class. Four Graduates from the Vancouver School of Decorative and Applied Arts, 1929.* Vancouver, B.C.: The Floating Curatorial Gallery Women in Focus.

Rogers, Anthony W. 1983. "The Beautiful in Form and Colour: Art Education in British Columbia Between the Wars." Master's thesis, University of British Columbia.

_____. 1984. "William P. Weston, Artist and Educator." *Art Education* 36 [sic] (no. 5): 27-29.

_____. 1985. "British Art Education in the Schools, 1895-1910 and Its Influence on the Schools of British Columbia." In Wilson and Hoffa, 87-93.

_____. 1987. "W.P. Weston, Educator and Artist: The Development of British Ideas in the Art Curriculum of B.C. Public Schools." Ph.D. diss., University of British Columbia.

Saunders, Robert J. 1954. "The Parallel Development of Art Education in Canada and the United States, with Emphasis on the History of Art Education in Canada." Master's thesis, The Pennsylvania State University.

Savage, Leslie. 1985. "The History of Art Education and Social History: Text and Context in a British Case of Art School History." In Wilson and Hoffa, 94-98.

Soucy, Donald. 1985a. "Approaches to Historical Writing in Art Education: Their Limits and Potentialities." In Wilson and Hoffa, 11-18.

_____. 1985b. "Present Views of the Past: Bases for the Future of Art Education Historiography." *Canadian Review of Art Education Research* 12: 3-10.

_____, ed. 1986a. "A History of Maritime Art Education" (special history issue). [Nova Scotia] *ATA Journal* 8 (no. 1).

_____. 1986b. "Religion and the Development of Art Education in 19th Century Nova Scotia." *Arts and Learning Research* 4: 36-43.

_____. 1987a. WAVES: *Approaches to Art Education 1887-1987.* Halifax, N.S.: Anna Leonowens Gallery.

_____. 1987b. "Social Factors in Nineteenth Century Art Education: A Comparison Between Nova Scotia's Public and Private Schools." *The Bulletin of the Caucus on Social Theory and Art Education* 7: 49-54.

_____. 1989. "More than a Polite Pursuit: Art College Education for Women in Nova Scotia, 1887-1930s." *Art Education* 42 (no. 2): 23-24, 37-40.

Soucy, Donald, and Harold Pearse. In press. *The First Hundred Years: A History of the Nova Scotia College of Art and Design.* Fredericton, N.B.: University of New Brunswick.

Soucy, Donald, and Nick Webb. 1984. "History—Who Cares?" *Art Education* 36 [sic] (no. 5): 37-38.

Tait, George E. 1957. "The History of Art Education in the Elementary Schools of Ontario." Ed.D. diss., University of Toronto.

Tarr, Patricia. 1989. "Pestalozzian and Froebelian Influences on Contemporary Elementary School Art." *Studies in Art Education* 30 (no. 2): 115-21.

Wood, B. Anne. 1985. *Idealism Transformed: The Making of a Progressive Educator.* Montreal: McGill-Queen's University Press.

_____. 1986. "The Hidden Curriculum of Ontario School Art, 1904-1940." *Ontario History* 78 (no. 4): 351-69.

Great Britain

Abbs, Peter. 1987. "Towards a Coherent Arts Aesthetic." In *Living Powers: The Arts in Education,* edited by Peter Abbs, 9-65. London: The Falmer Press.

Ashwin, Clive. 1975. *Art Education Documents and Policies 1768-1975.* London: Society for Research into Higher Education.

_____. 1981. *Drawing and Education in German Speaking Europe: 1800-1900.* Ann Arbor: UMI Research Press.

_____. 1982. *Middlesex Polytechnic. A Century of Art Education 1882-1982.* Middlesex: Middlesex Polytechnic.

_____. 1985. "The British Colleges of Art and Design: The End of an Experiment." In Wilson and Hoffa, 76-79.

Baynes, Ken, Richard Langdon, and Bernard Myers. 1977. "Design in General Education: A Review of Developments in Britain." *Art Education* 30 (no. 8): 17-21.

Bell, Quentin. 1963. *The Schools of Design.* London: Routledge and Kegan Paul.

Carline, Richard. 1968. *Draw They Must. A History of the Teaching and Examining of Art.* N.p.: Edward Arnold Ltd.

Crane, Walter. 1910a. "Arts and Crafts." *Encyclopaedia Britannica* 11th ed. Vol. 2, 700-701. Cambridge: At the University Press.

_____. 1910b. "Art Teaching." *Encyclopaedia Britannica* 11th ed. Vol. 2, 703-5. Cambridge: At the University Press.

Frayling, Christopher. 1987. *The Royal College of Art: One Hundred & Fifty Years of Art & Design.* London: Barrie and Jenkins.

George, Ron. 1987. "Introduction to the Papers." In *The Bramley Occasional Papers* Vol. 1, edited by David Thistlewood. Bretton Hall: The National Art Education Archive.

Haslam, Ray. 1988. "Looking, Drawing and Learning with John Ruskin and the Working Men's College." *Journal of Art & Design Education* 7 (no. 1): 65-79.

Holdsworth, Bruce. 1988. "Marion Richardson." *Journal of Art & Design Education* 7 (no. 1): 65-79.

Kirby, John. 1987. "'Useful and Celebrated', The Sheffield School of Art 1843-1940." Sheffield: Sheffield City Polytechnic and Sheffield Arts Department in association with J.W. Northend Ltd.

Macdonald, Stuart. 1970. *The History and Philosophy of Art Education.* New York: American Elsevier Press.

Mason, Rachel. 1985. "Interpretive Research in Art Education: Some Problems with Anthropological and Historical Method." In Wilson and Hoffa, 375-79.

Meyer, William R. 1988. "The Junior Art Department (1918-1944)." *Journal of Art & Design Education* 7 (no. 2): 123-35.

Morris, Robin. 1987. "Towards a Shared Symbolic Order." In *Living Powers: The Arts in Education,* edited by Peter Abbs, 183-203. London: The Falmer Press.

Pevsner, Nikolaus. [1940] 1973. *Academies of Art Past and Present.* New York: Da Capo.

Steveni, Michael. 1968. *Art & Education.* New York: Atherton Press.

Sutton, Gordon. 1967. *Artisan or Artist? A History of the Teaching of Art and Crafts in English Schools.* Oxford: Pergamon Press.

Swift, John. 1977. "Visual Memory Training: A Brief History and Postscript." *Art Education* 30 (no. 8): 24-27.

_____. 1978. "Robert Catterson-Smith's Concept of Memory Drawing 1911-1920." Master's thesis, Birmingham Polytechnic.

_____. 1983. "The Role of Drawing and Memory Drawing in English Art Education 1800-1980." Ph.D. diss., Birmingham Polytechnic.

_____. 1985. "The Marion Richardson Archive." *Canadian Review of Art Education Research* 12: 68-69.

_____. 1986. "Marion Richardson and the 'Mind Picture'." *Canadian Review of Art Education Research* 13: 49-62.

_____. 1988. "Birmingham and Its Art School: Changing Views 1800-1921." *Journal of Art & Design Education* 7 (no. 1): 5-29.

Thistlewood, David. 1981. *A Continuing Process. The New Creativity in British Art Education 1955-65.* London: Institute of Contemporary Arts.

_____. 1984. *Herbert Read. Formlessness and Form. An Introduction to His Aesthetics*. London: Routledge & Kegan Paul.

_____. 1985. "National Systems and Standards in Art and Design Higher Education in Britain." In Wilson and Hoffa, 80-86.

_____. 1986a. "A.E. Halliwell: Art and Design Educationist." *National Art Education Archive* (Bretton Hall) (no. 2): 4-5.

_____. 1986b. "Social Significance in British Art Education 1850-1950." *Journal of Aesthetic Education* 20 (no. 1): 71-83.

_____. 1987. "A.E. Halliwell: Art and Design Educationist." In *The Bramley Occasional Papers* Vol. 1, edited by David Thistlewood, 1-6. Bretton Hall: The National Art Education Archive.

_____. 1988a. "The Early History of the NSEAD: The Society of Art Masters (1888-1909) and the National Society of Art Masters (1909-1944)." *Journal of Art & Design Education* 7 (no. 1): 37-64.

_____, ed. 1988b. *Journal of Art & Design Education* (special history issue) 7 (no. 1).

_____. 1989. "The Formation of the NSEAD: A Dialectical Advance for British Art and Design Education." *Journal of Art & Design Education* 8 (no.2):135-52.

Thistlewood, Roslyn. 1988. "The Archives of the NSEAD." *Journal of Art & Design Education* 7 (no. 1): 31-35.

Yeomans, Richard. 1988. "Basic Design and the Pedagogy of Richard Hamilton." *Journal of Art & Design Education* 7 (no. 2): 155-73.

United States

Amburgy, Patricia. 1985. "Loved Illusions and Real Beliefs: The Concept of Aesthetic Experience." In Wilson and Hoffa, 35-39.

Bailey, Henry Turner. 1900. *A Sketch of the History of Public Art Instruction in Massachusetts*. Boston: Wright & Porter.

_____. [1929] 1936. "Art Teaching in the U.S." *Encyclopaedia Britannica* 14th ed. Vol. 2, 488. London: The Encyclopaedia Britannica Company.

Bailyn, Bernard. 1960. *Education in the Forming of American Society*. New York: Vintage Books.

Baker, David. 1982. "Rousseau's Children: An Historical Analysis of the Romantic Paradigm in Art Education." Ph.D. diss. The Pennsylvania State University.

Barbosa, Ana Mae. 1978. "Brazilian Art Education at the Crossroads." *Art Education* 31 (no. 2): 12-13.

Barkan, Manuel. 1962. "Transition in Art Education: Changing Conceptions of Curriculum Content and Teaching." *Art Education* 15 (no. 7): 12-18, 27-28.

Battist, Sondra. 1967. "Child Art & Visual Perception." *Art Education* 20 (no. 1): 21-27.

Belshe, Francis B. 1946. "A History of Art Education in the Public Schools of the United States." Ph.D. diss., Yale University.

Bennett, Charles A. 1919. "Industrial Art Education—America's Opportunity." *School and Society* 10 (no. 248): 373-77.

_____. 1926. *History of Manual and Industrial Education up to 1870.* Peoria, Ill.: The Manual Arts Press.

_____. 1937. *History of Manual and Industrial Education 1870 to 1917.* Peoria, Ill.: The Manual Arts Press.

Bohn, Donald. 1968. "'Artustry' or the Immaculate Misconception of the '70's." *History of Education Quarterly* 8 (no. 1): 107-10.

Bolin, Paul. 1986. "Drawing Interpretation: An Examination of the 1870 Massachusetts 'Act Relating to Free Instruction in Drawing'." Ph.D. diss., University of Oregon.

Boris, Eileen. 1986. *Art and Labor. Ruskin, Morris, and the Craftsman Ideal in America.* Philadelphia: Temple University Press.

Bunch, Clarence. 1978. *Art Education: A Guide to Information Sources.* Detroit: Gale Research Co.

Burk, Addison B. 1890. "Schools of Design." *American Supplement to Encyclopaedia Britannica* 9th ed. Vol. 2, 631-34. Philadelphia: Hubbard Brothers.

Chapman, Laura. 1978. *Approaches to Art in Education.* New York: Harcourt Brace Jovanovich.

Clarke, Isaac Edwards. 1874. *Drawing in Public Schools: The Present Relation of Art to Education in the United States.* Bureau of Education. Circulars of Information 1874, no. 2. Washington, D.C.: Government Printing Office.

_____. 1885. *Art and Industry.* Part 1, *Drawing in Public Schools.* U.S. Senate report. 46th Cong., 2d sess., Vol. 7. Washington: Government Printing Office.

_____. 1892. *Art and Industry.* Part 2, *Industrial and Manual Training in Public Schools.* U.S. Senate report. 46th Cong., 2d sess., Vol. 7. Washington: Government Printing Office.

_____. 1897. *Art and Industry.* Part 3, *Industrial and Technical Training in Voluntary Associations and Endowed Institutions.* U.S. Senate report. 46th Cong., 2d sess., Vol. 7. Washington, D.C.: Government Printing Office.

_____. 1898. *Art and Industry.* Part 4, *Industrial and Technical Training in Schools of Technology and in U.S. Land Grant Colleges.* U.S. Senate report, 46th Cong., 2d sess., Vol. 7. Washington, D.C.: Government Printing Office.

_____. 1904. *Art and Industrial Education.* In *Monographs on Education in the United States,* no. 14, edited by Nicholas M. Butler. Albany: J.B. Lyon Company.

Collins, Georgia, and Renee Sandell. 1984. "Women's Achievements in Art." In their *Women, Art, and Education,* 79-110. Reston, Va.: National Art Education Association.

Cremin, Lawrence. 1961. *The Transformation of the School.* New York: Alfred A. Knopf.

_____. 1965. *The Wonderful World of Ellwood Patterson Cubberly: An Essay on the Historiography of American Education.* New York: Bureau of Publications, Teachers College, Columbia University.

Dana, Lanice Paton. 1953. "Where Is the New Approach Better?" *School Arts* 53 (no. 2): 15-17.

de Francesco, Italo L. 1958. *Art Education Its Means and Ends.* New York: Harper & Brothers.

Dobbs, Stephen. 1972. "Paradox and Promise: Art Education in the Public Schools." Ph.D. diss., Stanford University.

Drawing in the Public Schools. A Brief History of Its Origin and Progress. 1873. New York: Woolworth, Ainsworth, and Company.

Efland, Arthur. 1983a. "School Art and Its Social Origins." *Studies in Art Education* 24 (no. 3): 149-57.

_____. 1983b. "Art Education During the Great Depression." *Art Education* 36 (no. 6): 38-42.

_____. 1984. "Curriculum Concepts of the Penn State Seminar: An Evaluation in Retrospect." *Studies in Art Education* 25 (no. 4): 205-11.

_____. 1985. "Art Education for Women in 19th Century Boston." *Studies in Art Education* 26 (no. 3): 133-40.

_____. 1988. "Studies in Art Education: Fourth Invited Lecture. How Art Became a Discipline: Looking at Our Recent History." *Studies in Art Education* 29 (no. 3): 262-74.

_____. 1989. *A History of Art Education: Intellectual and Social Currents in Teaching the Visual Arts.* New York: Teachers College Press.

Eisner, Elliot W. 1965. "American Education and the Future of Art Education." In *Art Education, The Sixty-Fourth Yearbook of the National Society for the Study of Education,* edited by W. Reid Hastie, 299-325. Chicago: The National Society for the Study of Education.

_____. 1972. "The Roots of Art in Schools: An Historical View from a Contemporary Perspective." In his *Educating Artistic Vision,* 29-63. New York: Macmillan.

Eisner, Elliot W., and David Ecker. 1966. "What is Art Education? Some Historical Developments in Art Education." In *Readings in Art Education,* edited by Elliot W. Eisner and David Ecker, 1-13. Waltham, Mass.: Blaisdell Publishing Company.

Erickson, Mary. 1977. "Uses of History in Art Education." *Studies in Art Education* 18 (no. 3): 22-29.

_____. 1979. "An Historical Explanation of the Schism Between Research and Practice in Art Education." *Studies in Art Education* 20 (no. 2): 5-13.

_____. 1985. "Styles of Historical Investigation." *Studies in Art Education* 26 (no. 2): 121-24.

_____. 1988. "Mary Erickson Responds." *Studies in Art Education* 29 (no. 4): 241.

Farnum, Royal Bailey. 1941. "The Early History of Art Education." In *Fortieth Yearbook of the National Society for the Study of Education,* edited by Guy Whipple. Chicago: University of Chicago Press.

Forman, Bernard I. 1968. "Early Antecedents of American Art Education: A Critical Evaluation of Pioneer Influences." *Studies in Art Education* 9 (no. 2): 38-51.

Freedman, Kerry. 1986. "A Public Mandate for Personal Expression: Art Education and American Democracy in the 1940s and 1950s." *Arts and Learning Research* 4: 1-10.

_____. 1987a. "Art Education as Social Production: Culture, Society and Politics in the Formation of Curriculum." In *The Formation of School Subjects,* edited by Thomas S. Popkewitz, 63-84. New York: The Falmer Press.

_____. 1987b. "Art Education and Changing Political Agendas: An Analysis of Curriculum Concerns of the 1940s and 1950s." *Studies in Art Education* 29 (no. 1): 17-29.

_____. 1988. "Abstract Expressionism and Art Education: Formalism and Self-Expression as Curriculum Ideology." *The Bulletin of the Caucus on Social Theory and Art Education* 8: 17-25.

_____. 1989a. "Issues of Equity in Art Education: Ideologies of Individualism and Cultural Capital." In *Equity in Education,* edited by W. Secada. London: The Falmer Press.

_____. 1989b. "Narcissism and Normalcy: Historical Foundations of Art Education for Young Children." *Canadian Review of Art Education* 16 (no. 1): 21-33.

_____. 1989c. "The Philanthropic Vision: The Owatonna Art Education Project as an Example of 'Private' Interests in Public Schooling." *Studies in Art Education* 31 (no. 1): 15-26.

Freedman, Kerry, and Thomas S. Popkewitz. 1985. "Art Education and the Development of the Academy: The Ideological Origins of Curriculum Theory." In Wilson and Hoffa, 19-27.

_____. 1988. "Art Education and Social Interests in the Development of Schooling: Ideological Origins of Curriculum Theory." *Journal of Curriculum Studies* 20 (no. 5): 387-405.

Green, Harry Beck. 1948. "The Introduction of Art as a General Education Subject in American Schools." Ed.D. diss., Stanford University.

_____. 1966. "Walter Smith: The Forgotten Man." *Art Education* 19 (no. 1): 3-9.

Hamblen, Karen. 1985a. "An Art History Chronology: A Process of Selection and Interpretation." *Studies in Art Education* 26 (no. 2): 111-20.

_____. 1985b. "Historical Research in Art Education: A Process of Selection and Interpretation." In Wilson and Hoffa, 1-10.

_____. 1987. "Using Written Histories to Understand Levels of Professional Maturity." *Arts and Learning Research* 5 (no. 1): 120-31.

Haney, James Parton. 1908. "The Development of Art Education in the Public Schools." In *Art Education in the Public Schools of the United States,* edited by J.P. Haney, 21-77. New York: American Art Annual.

Hogan, David. 1985. "Whither the History of Urban Education?" Review of *Schools in Cities: Consensus and Conflict in American Educational History,* edited by Donald D. Goodenow and Diane Ravitch. History of Education Quarterly 25 (no. 4): 527-41.

Hollingsworth, Charles H. Jr. 1988. "Viktor Lowenfeld and the Racial Landscape of Hampton Institute During His Tenure from 1934-1946." Ph.D. diss., The Pennsylvania State University.

Hubbard, Guy. 1966. "Art in General Education: An Historical Review with Contemporary Implications." *Art Education* 19 (no. 1): 11-13.

_____. 1967. *Art in the High School.* Belmont, Calif.: Wadsworth Publishing.

Jones, Ronald L. 1974. "Aesthetic Education: Its Historical Precedents." *Art Education* 27 (no. 9): 12-16.

Judson, Bay Hallowell. 1989. "Master Teachers at the Carnegie." *Art Education* 42 (no. 2): 41-47.

Kauppinen, Heta. 1987. "Contemporary Historiography and Art Education." *Canadian Review of Art Education* 14: 63-69.

Kaufman, Irving. 1966. *Art and Education in Contemporary Culture.* New York: Macmillan.

Keel, John S. 1963. "Research Review: The History of Art Education." *Studies in Art Education* 4 (no. 2): 45-51.

_____. 1965. "Art Education, 1940-64." In *Art Education, The Sixty-Fourth Yearbook of the National Society for the Study of Education,* edited by W. Reid Hastie, 35-50. Chicago: The National Society for the Study of Education.

_____. 1976. "Child Study, Fred Burke, and Art Education: Notes on a Turn-of-the-Century Challenge." *Art Education* 29 (no. 1): 25-29.

Keel, John S., and Robert J. Saunders, eds. 1966a. *Art Education* (special history issue) 19 (no. 1).

_____. 1966b. "Guest Editorial." *Art Education* 19 (no. 1): 2.

Korzenik, Diana. 1981. "Is Children's Work Art? Some Historical Views." *Art Education* 34 (no. 5): 20-24.

_____. 1983. "Art Education Ephemera." *Art Education* 36 (no. 5): 18-21.

_____. 1985a. "Doing Historical Research." *Studies in Art Education* 26 (no. 2): 125-28.

_____. 1985b. *Drawn to Art: A Nineteenth-Century American Dream.* Hanover, N.H.: University Press of New England.

_____. 1987. "Manchester—A Nineteenth Century Art Center." Manchester (June/July): 16-19, 59.

Lazerson, Marvin. 1971. *Origins of the Urban School: Public Education in Massachusetts, 1870-1915.* Cambridge, Mass.: Harvard.

Leeds, Jo Alice. 1989. "The History of Attitudes Toward Children's Art." *Studies in Art Education* 30 (no. 2): 93-103.

Logan, Frederick M. 1955. *Growth of Art in American Schools.* New York: Harper & Brothers.

_____. 1975. "Up Date '75, Growth in American Art Education." *Studies in Art Education* 17 (no. 1): 7-16.

_____, ed. 1976. "Heritage" (special history issue). *Art Education* 29 (no. 1).

Marzio, Peter C. 1969. "The Art Crusade." Ph.D. diss., University of Chicago.

_____. 1976. *The Art Crusade: An Analysis of American Drawing Manuals, 1820-1860.* Washington, D.C.: Smithsonian.

Mattil, Edward, ed. 1966. *A Seminar in Art Education for Research and Curriculum Development.* University Park, Pa.: The Pennsylvania State University.

Mock-Morgan, Mavera E. 1976. "A Historical Study of the Theories and Methodologies of Arthur Wesley Dow and Their Contribution to Teacher Training in Art Education." Ph.D. diss., University of Maryland.

_____. 1985. "The Influence of Arthur Wesley Dow on Art Education." In Wilson and Hoffa, 234-37.

Nichols, George Ward. 1877. *Art Education Applied to Industry.* New York: Harper and Brothers.

Norris, Ross A. 1979. *History of Art Education: A Bibliography: Secondary and Primary Sources.* Columbus, Ohio: Published by author.

Packard, Sandra. 1976. "Jane Addams: Contributions and Solutions for Art Education." *Art Education* 29 (no. 1): 9-12.

Pasto, Tarmo. 1967. "A Critical Review of the History of Drawing Methods in the Public Schools of the United States." Parts 1, 2. *Art Education* 20 (nos. 8, 9): 2-7, 18-22.

Rice, H.R. 1949. "Homogeneity in Art Education." *Art Education* 2 (no. 2): 2-4.

Rios, John F. 1956. "Teachers' Training in Secondary School Art 1900-1955." *Art Education* 9 (no. 7): 9, 17.

Rush, Jean C. 1985. "Experience Beyond Memory, Future Past Recall." *Studies in Art Education* 26 (no. 2): 67-68.

Rush, Jean C., and Mary Ann Stankiewicz, eds. 1985. *Studies in Art Education* (special history issue) 26 (no. 2).

Saunders, Robert J. 1957-58. "Two Stones Skim the Pond." *Everyday Art* 36: 98-11, 22.

_____. 1958. "A Reflection Made Ripples on the Pond." *Everyday Art* 36 (spring): 10-11, 21-22.

_____. 1958-59. "Stepping Stones Across the Pond." *Everyday Art* 37: 10-13.

_____. 1961. "The Contribution of Horace Mann, Mary Peabody Mann, and Elizabeth Peabody to Art Education in the United States." Ed.D. diss., The Pennsylvania State University.

_____. 1971. "Art Education: History." *The Encyclopaedia of Education* Vol. 1, 282-89. New York: The Macmillan Co. & the Free Press.

_____. 1976. "Art, Industrial Art, and the 200 Years War." *Art Education* 29 (no. 1): 5-8.

_____. 1977. "Historical Background: Good-bye, Hegel; Hello, Star Child." In his *Relating Art and Humanities to the Classroom,* 6-14. Dubuque, Iowa: Wm. C. Brown.

Smith, Peter. 1982a. "Germanic Foundations: A Look at What We Are Standing On." *Studies in Art Education* 23 (no. 3): 23-30.

_____. 1982b. "Lowenfeld in a Germanic Perspective." *Art Education* 35 (no. 2): 25-27.

_____. 1983. "An Analysis of the Writings and Teachings of Viktor Lowenfeld: Art Educator in America." Ph.D. diss., Arizona State University.

_____. 1984. "Natalie Robinson Cole: The American Cizek?" *Art Education* 37 (no. 1): 36-39.

_____. 1985a. "Franz Cizek: The Patriarch." *Art Education* 38 (no. 2): 28-31.

_____. 1985b. "The Lowenfeld Motivation Revisited." *Canadian Review of Art Education Research* 12: 11-17.

_____. 1987. "Lowenfeld Teaching Art: A European Theory and American Experience at Hampton Institute." *Studies in Art Education* 29 (no. 1): 30-36.

_____. 1988a. "The Hampton Years: Lowenfeld's Forgotten Legacy." *Art Education* 41 (no. 6): 38-42.

_____. 1988b. "The Role of Gender in the History of Art Education: Questioning Some Explanations." *Studies in Art Education* 29 (no. 4): 232-40.

_____. 1989. "Lowenfeld in a Viennese Perspective: Formative Influences for the American Art Educator." *Studies in Art Education* 30 (no. 2): 104-14.

Stankiewicz, Mary Ann. 1979. "Art Teacher Preparation at Syracuse University, the First Century." Ph.D. diss., The Ohio State University.

_____. 1982a. "The Creative Sister: An Historical Look at Women, the Arts, and Higher Education." *Studies in Art Education* 24 (no. 1): 48-56.

_____. 1982b. "Woman, Artist, Art Educator: Professional Image Among Women Art Educators." In *Women Art Educators,* edited by Enid Zimmerman and Mary Ann Stankiewicz. Bloomington, Ind.: Indiana University.

_____. 1983. "Rila Jackman, Pioneer at Syracuse." *Art Education* 36 (no. 1): 13-15.

_____. 1984a. "'The Eye Is a Nobler Organ': Ruskin And American Art Education." *Journal of Aesthetic Education* 18 (no.2): 51-64.

_____. 1984b. "Self-Expression or Teacher Influence: The Shaw System of Finger Painting." *Art Education* 37 (no. 2): 20-24.

_____. 1985a. "Mary Dana Hicks Prang: A Pioneer in Art Education." In *Women Art Educators II,* edited by Mary Ann Stankiewicz and Enid Zimmerman, 22-38. Bloomington, Ind.: Indiana University.

_____. 1985b. "A Generation of Art Educators." In Wilson and Hoffa, 205-12.

_____. 1986. "Drawing Book Wars." *Visual Arts Research* 12 (no. 2): 59-72.

_____. 1987. Review of *An American Art Student in Paris: The Letters of Kenyon Cox, 1877-1882,* edited by H. Wayne Morgan. *History of Education Quarterly* 27 (no. 3): 426-28.

_____. 1988a. "Form, Truth, and Emotion: Transatlantic Influences on Formalist Aesthetics." *Journal of Art and Design Education* 7 (no. 1): 81-95.

_____. 1988b. "Mary Ann Stankiewicz Responds." *Studies in Art Education* 29 (no. 4): 242.

Stankiewicz, Mary Ann, and Enid Zimmerman. 1984. "Women's Achievements in Art Education." In *Women, Art, and Education,* by Georgia Collins and Renee Sandell, 113-40. Reston, Va.: National Art Education Association.

_____, eds. 1985. *Women Art Educators II*. Bloomington, Ind.: Indiana University.

Weiley, Earl A. 1957. "Socio-economic Influences in the Development of American Art Education in the Nineteenth Century." Ed.D. diss., University of Michigan.

Whitford, William G. 1923, October. "A Brief History of Art Education in the United States." *Elementary School Journal*, 29: 109-15.

_____. 1929. "Brief History of Art Education in the United States." In his *An Introduction to Art Education*, 7-18. New York: D. Appleton and Co.

Wilson, Brent, and Harlan Hoffa, eds. 1985. *The History of Art Education: Proceedings from the Penn State Conference*. Reston, Va.: National Art Education Association.

Wygant, Foster. 1959. "A History of Art Education at Teachers College, Viewed as Response to Social Change." Ed.D. diss., Teachers College, Columbia University.

_____. 1983. *Art in American Schools in the Nineteenth Century*. Cincinnati: Interwood Press.

_____. 1985. "Art Structure: Fundamentals of Design Before the Bauhaus." In Wilson and Hoffa, 158-62.

_____. 1986. *Art in American Schools: 1900-1970*. Cincinnati: copyright held by author.

_____. 1988. "Dewey and Naumburg: An Unresolved Debate." *Canadian Review of Art Education* 15 (no. 20): 29-39.

_____. 1989. "A Response to Professor MacIver." *Canadian Review of Art Education* 16 (no. 1): 59-60.

Zimmerman, Enid. 1989. "The Mirror of Marie Bashkirtseff: Reflections About the Education of Women Art Students in the Nineteenth Century." *Studies in Art Education* 30 (no. 2): 164-75.

Zimmerman, Enid, and Mary Ann Stankiewicz, eds. 1982. *Women Art Educators*. Bloomington, Ind.: Indiana University.

Zweybruck, Nora. 1953. "Cizek as Father of Art Education." *School Arts* 53 (no. 2): 11-14.

THE

EYE AND HAND;

BEING A SERIES

OF

PRACTICAL LESSONS IN DRAWING,

FOR THE TRAINING OF THOSE

IMPORTANT ORGANS:

ADAPTED TO

THE USE OF COMMON SCHOOLS:

BY

WILLIAM B. FOWLE,

LATE PRINCIPAL OF THE MONITORIAL SCHOOL IN BOSTON; AUTHOR OF THE COMMON SCHOOL SPELLER, BIBLE READER, FAMILIAR DIALOGUES, TEACHERS' INSTITUTE, &c. &c. &c.

BOSTON:

PUBLISHED BY LEML. N. IDE,

No. 138½ Washington Street.

1849.

In 1824, William Bentley Fowle produced the first drawing book for U. S. common schools. His second drawing book, shown here, is from 1849. (Soucy Collection).

II. The Nineteenth Century

Elizabeth Palmer Peabody and William Torrey Harris. (Concord Free Public Library, Massachusetts).

Elizabeth P. Peabody's Quest for Art in Moral Education

2 *Robert J. Saunders*

In the 1860s Elizabeth Palmer Peabody came into her own. With her discovery of the Froebelian Kindergarten, all her unanswered questions concerning the right methods to use when teaching children about their own goodness, the Christian nature, and divine order of the universe, which she had accumulated over thirty years of teaching, found their answers. The pieces of the divine puzzle fell into place when, in her fifty-fourth year, she read Frederick Froebel's *The Education of Man*. It was a quest that began over thirty years before, in her first schools. Perhaps it even began before, when she taught her younger brothers and sisters at home.

Elizabeth Palmer Peabody was born in 1804, the first child in a family of six children; she had two sisters and three brothers. Her mother, for whom she was named, was exceptionally well educated. Mrs. Peabody had a classical education, studied Greek, Latin, history, astronomy, and the works of Shakespeare. She had a sense of chivalry which came from Spenser's "The Faerie Queene," and could draw well enough to teach her children. Elizabeth's father, Nathaniel, had been a preceptor in a boy's academy, and became a dentist and student of homeopathic medicine. In Salem, where they moved when Elizabeth was four years old, he became a member of the Board of Education. Mrs. Peabody taught a school from 1809 to 1818 for her own and neighboring children. Elizabeth began teaching classes, and at age thirteen would sit in her father's study listening to school board meetings. She already had developed a serious sense of purpose in life.

The Peabodys were Unitarians. They held a position among the intellectual and cultural elite of the community when religious affiliation provided social status for the members of the middle class. As Unitarians, they freed their children from the traumas of Calvinist damnation and predestination while passing on to them the burdens of public service and humanitarianism. Elizabeth was able to draw on this background when, in 1819, at the age of fifteen, she visited Boston for the first time with the purpose of opening a school. This she did not do until 1826, but she met Rev. William Ellery Channing, Boston's leading Unitarian minister, for whom she became a chronicler. He, in turn, became her mentor (Ronda, 1984).

Elizabeth's first encounters with art instruction, other than what she had had at home, probably occurred in 1823. She took a teaching position at the home of the Vaughans in Hallowell, Maine. There she taught the children of the Vaughans and other children of the community. Her father, in a letter dated 26 April 1823, wrote her to "be prepared to instruct Drawing & painting & embroidery & ornamental Needlework, &c, &c,. For most girls in the country think that the *ne plus ultra* of an education" (Saunders 1961, 76). In the library of the Vaughans, Elizabeth discovered *Essays in Practical Education* by Maria and Richard Edgeworth (1801), first published in 1798. The Edgeworths described these skills for young ladies as "Female Accomplishments." Boys, on the other hand, were taught linear perspective and drawing skills useful for understanding machinery and building houses. The Edgeworths also warned against the use of fashionable toys with mechanical parts for nursery children. They recommended instead solid geometrical shapes and forms, that is, toys with which children could discover geometric order and form. They also recommended clay and modelling wax for nursery aged children (Edgeworth 1801, 1:4-5).

Elizabeth may have been enthusiastic about what she read in these essays and even used some of their recommendations in her own schools. Very possibly her use of clay bins for modelling and sculpture may have come from the Edgeworths. But she also found the Edgeworths "wanting in a deep all-pervading—lively sense of Moral Governor & Father of the Spirit" (Saunders 1961, 87). Both Elizabeth and her mother took exception to this want of religion in the Edgeworths, for they believed that religion was "the only foundation for a good education" (Saunders 1961, 87-88). Elizabeth's first purpose in education was to develop character, her second to impart knowledge.

Elizabeth probably found in the methods of a young drawing instructor, Francis Graeter, that sense of a Moral Governor which she found lacking in the Edgeworths. Mr. Graeter was a German immigrant, artist, and illustrator whom she employed in her first Boston schools. Later, she recommended him to Bronson Alcott for Temple School.

Graeter's methods for teaching drawing were directed towards awakening children's awareness of the divine order of the natural world around them, then to organize this awareness by correctly recording their visual perceptions on paper. Graeter showed them engraved prints depicting patterns and designs found in trees, leaves, flowers, petals, sea shells, and other natural objects. While children observed the engravings, Graeter questioned them on the ordered design and patterns they found in the objects, and related them to the spiritual values and the necessity for order within human behavior.

He would also tell them about a book in German named "Tree Architecture" that:

demonstrated that every species of tree was the product of two forces, whose action might be represented by an angle, more or less acute: and this angle would be found in all branchings down to the smallest twig, and also in the edging of the leaves. For instance,—to take the two extreme contrasts,—in the oak the forces are evenly balanced so that the angle is a right angle. In the willow the angle is very acute. (Peabody 1880, 346-47)

Elizabeth, in describing Graeter's methods and philosophy to William Ellery Channing one evening, explained these two forces as working on both nature and man, one from within and the other from without.

Where forces act at right angles the production is a very strong one. The oak does not yield to forces external to itself, nor obey the attraction of light like the willow . . . while a willow seems weak and is easily influenced from without. . . . When the aesthetic sensibility and the moral sentiment were pretty nearly in equilibrium, the man became an oak, to resist all outside influences. When aesthetic sensibility was not so balanced, we had the willows of humanity. But here is proof that the artistic in man is also the divine. (Peabody 1880, 347-49)

Elizabeth did not explain this proof, but ended her chapter on that enigmatic note.

The imagination for both Elizabeth and Rev. Channing was a power, an energy, which everyone has to some degree, but which needed direction toward the manifestation of righteousness rather than the manifestation of evil. As an energy, the imagination is amoral. They expected any work by a truly creative genius in art, music, dance, or literature to contain a righteous spiritual sense, preferably centred around a Supreme Spiritual Being, and which should elevate human concepts toward the divine. Elizabeth felt that the people's realization of manifest righteousness and moral responsibility to God must be nurtured by a wise and sensitive teacher, one whose "intellectual and moral philosophy should be true" or she "might do infinite mischief to the children committed to [her] care for development and education" (Peabody 1880, 119-20).

On another evening in 1843, while visiting Washington Allston, the American Transcendentalist painter, they also spoke of the imagination. After a discussion about her imaginative description of a scene from Spenser's "The Faerie Queene," Allston reminded her of the importance of keeping the imagination on a level above the senses. He said:

In a certain strict sense, . . . imagination does not create, it only sees the spiritual creations of God. It is not your senses, but your imagination, that saw what you described to me; but the visual object is unquestionably always there. It can be transferred to the canvas, so as to satisfy you, however, only if the painter sees what transcended your senses. (Peabody 1886, 4-5)

At the time of these conversations, Elizabeth was still formulating her own opinions on the use of art in the spiritual growth and moral education of children.

Spiritual growth for Elizabeth did not mean religious instruction so much as the awareness of an all pervading sense of a Supreme Spiritual Being.

Elizabeth returned to Boston in 1826 to open her first schools there. With her sister Mary, she conducted schools in four locations over the next seven years. During this period Elizabeth wanted to establish herself professionally and socially. She was thirty years old, and her interests did not turn toward marriage. In a society that insisted on the sanctity of the home, the "emphasis on women's spiritual mission encouraged participation in the voluntary associations which flourished with evangelical religion. For unmarried women especially, the result was an active public life" (Rose 1981, 176). Fortunately for Elizabeth, the Unitarians at that time were being criticized by the orthodox Christians for their intellectualism and rationalistic criticism of the Bible. In response to this a new spirit of Unitarian evangelism inspired members of the church to respond more actively to the problems of poverty and unemployment resulting from the rapid increase of immigrants and people from the farmlands and hinterlands coming to Boston. Unitarian evangelism was "an aggressive campaign to seek heartfelt conversions as an antidote to the problems that came with socioeconomic change" (Rose 1981, 3). Rev. William Ellery Channing asked for a religion "with power" while "Unitarian preachers in the 1830s aimed to convert the whole person, not just the mind, but the heart as well" (Rose 1981, 2).

For twenty years Elizabeth would sustain her evangelical spirit until she could speak of a moral and aesthetic education that would convert the whole person. For the nonce, she taught her schools and established a reputation in classical and Hebrew history with the publication of a three part *Key to History* (1832-33), describing the steps and methods for teaching Hebrew and Greek history.

In September 1834, Elizabeth joined Bronson Alcott in founding Temple School. She chronicled a good part of Alcott's methods in *A Record of a School* (1835), among them his methods for teaching drawing. Alcott used drawing as a method for teaching the very young to see, first by giving them engravings to observe. He thought that "practice of the eye in looking at forms," and practice of the hand "in imitating them should be simultaneous" (Peabody 1835, 19). Children had access to slates, pencils, and blackboards which gave them "free scope." The teachers found that young children's "first shapings" were usually gigantic. Elizabeth observed that "Miniature, when it appears first in order of development, seems to be always the effect of checked spirits or some artificial influence" (Peabody 1835, 19). Francis Graeter taught drawing at Temple School between noon and one o'clock on Tuesdays. Drawing was also used in geography lessons for making maps and was incorporated with lessons in writing, thinking, and speaking to develop the children's abilities to express ideas. Elizabeth wrote, "A great deal of time was given over to explaining the philosophy of

Expression. They were taught to see that sculpture, painting, and words were only different modes of expression" (Peabody 1835, 23).

Elizabeth saw the imagination as that faculty of the mind which affects every aspect of human living; but she believed that verbalizations for picturing mental images did not develop the imagination so much as guide it. She feared that Alcott's methods of philosophical questioning and verbalizing would lead to what Dr. Channing referred to as "abstract introversion" (Peabody 1880, 356). Elizabeth knew intuitively that before children could fully express their ideas certain aspects of their growth had to be developed, but she did not yet know what those aspects were.

Because of her uncertainty about some of Alcott's methods and concern for her own yet to be established reputation, as well as conflicts arising in her living conditions with the Alcotts, Elizabeth eventually withdrew her support from Temple School. She also tried to dissuade Alcott from publishing his own book, *Conversations with Children on the Gospels* (1836), which proved fatal to Temple School (Ronda 1984). The solution to her questions did not become clear to Elizabeth until she discovered the writings of Frederick Froebel. Before then, her always inquiring mind, and a shift in Unitarian evangelism, took her into different directions.

Through the 1830s, the Transcendentalist movement was gaining interest, and in 1837 the Transcendentalist Club was founded. In 1840, Elizabeth, forced to give up her schools because of her association with Alcott, needed a new source of income and opened a bookstore on West Street in Boston. With the bookstore, Elizabeth Palmer Peabody established herself professionally independent of the Boston establishment, and created a Transcendental social circle in Boston. Her bookstore became a center for a largely Transcendentalist clientele (Rose 1981). They met to talk, hear lectures, take part in reading groups, and buy books, periodicals, and art supplies. She carried a select line of both English and foreign language publications.

Elizabeth conducted her own publishing business. Among her titles was *The Theory of Teaching by a Teacher* (1841), and *A Method of Teaching Linear Drawing*, by the author of "Easy Lessons in Perspective," now believed to be by Louisa Minot (Saunders 1962). The latter is a small book which demonstrated step-by-step methods for teaching geometrical drawing, but contained a preface pointing out the moral aspects of learning drawing as represented through the geometrical order of nature. From January 1841 to April 1843, Elizabeth published the Transcendentalist magazine, *The Dial*.

In 1848, Elizabeth published a collection of essays by Transcendentalist writers called *Aesthetic Papers*. She planned it as a series of publications sold by subscription. It was a literary success but a financial failure. It included Emerson's essay "War," and Thoreau's essay on "Resistance to Civil Govern-

ment," which later became "Civil Disobedience," and Elizabeth's own essay, "The Dorian Measure: A Modern Application." With this essay, Elizabeth combined her enthusiasms for Classical history and the arts, with the evangelist's Utopian dreams.

"The Dorian Measure: A Modern Application" was inspired by Elizabeth's reading of *The History and Antiquities of the Human Race* by Karl Otfried Muller (1797-1840). She opened the essay with the origins of the Dorians, and the place of Apollo-Jupiter in the religious, cultural, and educational life of ancient Greece. She then drew a parallel between them and the Christ-God relationship of the Hebraic-Christian cultures. For Elizabeth, the Dorians had a true understanding of the human relationship to a Supreme Spiritual Being and the manifestation of this relationship to the state. The state consisted of all the educational, cultural, and religious aspects of the intellectual being. The Dorians brought these elements into harmonious organization through the early training of their children in dance and music. In this respect, music pertained to all aspects of rhythm and harmony as revealed in man and nature. It included singing, playing musical instruments, and physical rhythms developed through dance, games, and gymnastics. Elizabeth stressed the importance of the correct use of dance and music in both Doric and Christian religious festivals for the child's moral training. She believed that when children learned aesthetic and intellectual pursuits based upon natural harmonies, they would as adults govern themselves by the true nature of honesty and moral judgement.

Along with the Dorians, Elizabeth cited the Spartans as being almost the only peoples "who esteemed the higher attributes of the female mind as capable of cultivation" (Peabody 1886, 111). She attributed the long conservation of Dorian virtue to the fact that temporal and intellectual training of the children was "presided over by the cultivated female intelligence" (Peabody 1886, 112). Going beyond their training in language and logic, she found the Pythagorean philosophy of geometrical principles to be the highest instrument of Dorian education, and the source of her own beliefs about the geometrical order of nature and the universe (Peabody 1886, 113).

Elizabeth applied these beliefs to instruction in drawing. The methods she described for teaching geometrical drawing were similar to those most prevalent throughout the nineteenth century. She was familiar with the major drawing guides of the period. In 1833 she had sent a copy of William Bentley Fowle's *Principles of Linear and Perspective Drawing* (1824) to her sisters, Mary and Sophia, who were then in Cuba. If Mary indeed had translated Peter Schmid's *Guide to Drawing* which her husband, Horace Mann, published in the *Common School Journal* (15 June 1844, to 15 December 1845), then Elizabeth may have assisted in translating some of the German and would have known the lessons. And, as mentioned above, Elizabeth had published *Methods for Teaching Linear*

Drawing in 1841. The significant difference between the methods used in the common schools as reflected in these guides and those described by Peabody in "The Dorian Measure" was philosophical. It lay in the spiritual and moral attributes she gave to geometrical order. She associated the learning of upright behavior with vertical lines and perpendicular angles, and assigned attributes of divine order to the shape of leaves and natural objects which the drawing guide merely used for architectural and industrial motifs.

Peabody saw a sequence of drawing instruction beginning at an early age. She believed that teaching music, drawing, and dance should precede the teaching of reading, which should be postponed to the age of six or seven years. "If singing should take the lead of reading," she said, "so should drawing of writing" (Peabody 1886, 127).

In "The Dorian Measure: A Modern Application," Peabody formulated her views on the type of individual who could best serve the nation, and the educational system for bringing it about, but these views remained theoretical. Parts were missing. She had the Dorian model and metaphor, but how to put this actually into the school room eluded her. Elizabeth knew something was missing, but not what it was. And she did not know it would take another ten years to find it.

1850 saw the end of the Transcendental movement. Without her clientele, Elizabeth closed the book store in 1851. For the rest of the decade she seemed directionless. Elizabeth travelled to all parts of New England selling Bem's Historical Charts, a device for recording and teaching history. She crusaded for Hungarian independence and the anti-slavery movement. Her mother died in January 1853. She worked in Theodore Weld's school in Eaglewood, New Jersey from September 1854 to 1858. Her father, who was living with her, died in 1855. In 1859 her sister, Mary, who had married Horace Mann in 1843, was widowed and moved with her three sons to "Wayside," the Cambridge home of her sister, Sophia, and Nathaniel Hawthorne, who were then living in Europe. Elizabeth joined Mary there. Thus it was that Elizabeth Palmer Peabody was living in Cambridge when she was invited to attend a small gathering at the home of a friend in Roxbury.

During the party, Elizabeth, much impressed with the naturalness, behavior, and intelligence of a young girl, asked her who her teacher was, and learned it was her mother who was also there. Thus she met Margarethe (Mrs. Carl) Schurz, and her daughter Agathe, whom her mother had educated in her own school, a "kindergarten," in Watertown, Wisconsin. From subsequent conversations, and Elizabeth's reading of Frederick Froebel's *The Education of Man*—a personal copy which Margarethe Schurz sent her from Watertown—Elizabeth came to the end of her quest.

In her previous educational enterprises, Elizabeth found something lacking. Along with others, Horace Mann among them, she had advocated teaching seeing

and observing through drawing, and teaching drawing before reading and writing. She agreed with Rev. Channing that too early a use of Alcott's questioning might lead to abstract introversion. She had not forgotten Allston's admonitions about the imagination. But what she discovered in reading Froebel has now become so much a part of our present educational philosophies that it seems strange to think that there was a time without it. For Elizabeth, the Froebelian system of kinder-garten instruction was, as she frequently said, "the second coming of Christ" (Ronda 1984, 430). It became the cause of her greatest evangelical crusade. She discovered that instead of beginning with thinking, which was where Allston, Mann, herself, and so many others had begun, Froebel "begins with doing some-thing to be thought about" (Peabody 1880, 356).

In reading Froebel, she also found a kindred spirit. How could she not fol-low Froebel's lead, when his opening remarks were like reading her own heart:

> An eternal law pervades and governs all things. The basis of this all-controlling law is an all-pervading, living, self-conscious and therefore eternal Unity. This Unity is God. God is the source of all things. (Froebel 1912, 3)[1]

Froebel laid it all out for Elizabeth, the philosophy, which was so much like her own, the process, the methods, the sequence of Mother-songs and word games, the gifts (from colored worsted wool balls to geometrical solids and shapes of increasingly complex formation), the body movements that lead from sensory perceptions to intellectual ideas—methods and activities which have been so well described elsewhere that they need not be described here (Logan 1955, Saunders 1961, Sienkiewicz 1985, Wygant 1983). It is the process and direction of Elizabeth's thought which interests us here, not the details of Froebel's system.

In 1860 Elizabeth opened her first kindergarten, the first English-speaking kindergarten in the United States, at 15 Pinckney Street on Beacon Hill, Boston. She opened a second kindergarten in 1861 at 24 Winter Street. The Civil War with its causes and anti-slavery crusades intervened. In 1866 she joined Mary in Cambridge and together they opened a third kindergarten. But Elizabeth began seriously to question her own application of the true Froebelian principles.

On 8 June 1867, with letters of introduction from Mrs. Schurz, she sailed for Europe to observe Froebel's methods first hand from Luise Levin Froebel, his second wife and widow, in Hamburg, and the Baroness Marenholz-Bulow in Berlin. She also visited other parts of Germany, France, Italy, and England. Threatened with a paralytic stroke on her return through London, she was brought back during the summer of 1868 under the care of her nephew, George Combe Mann, who was in England at the time.

Upon her return, Elizabeth turned her kindergarten in Cambridge over to those who had conducted it during her absence, no doubt with her new observa-tions in force. In 1869, Elizabeth published her transcription of a lecture by

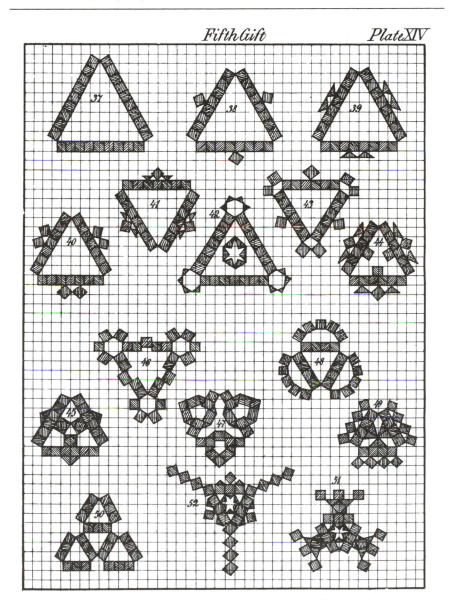

Fifth Gift *Plate XIV*

Froebel devised sequential gifts for kindergarten children. In North America these gifts were adapted and marketed by Milton Bradley and other companies. In 1869, Milton Bradley published *Paradise of Childhood*, the first illustrated kindergarten guide in the English language. The book survived many decades and numerous revised editions. The above plate comes from the 1887 edition, which boasted of E. P. Peabody's endorsement in its "Preface." (Soucy Collection).

Cardinal Wiseman, "Identification of the Artisan and the Artist," along with her own essay, "A Plea for Froebel's Kindergarten as the First Grade of Primary Education" (Peabody 1886). With Mary, in 1869, she published *Moral Culture of Infancy and Kindergarten Guide with Music for the Plays.*

In 1870, in Boston, Elizabeth and Mary opened the first public Kindergarten in the United States supported by charitable funds. Then Elizabeth returned to London to found the Froebel Union, and in 1872 with Mary founded the Kindergarten Association of Boston, and in 1877 and 1878 the American Froebel Union. During those years, between 1873 and 1877, they edited a periodical, *The Kindergarten Messenger.*

As Transcendentalism passed into the history of the previous generation, members of the original movement wrote their own accounts. Elizabeth joined them by publishing a third edition of *A Record of a School* in 1874, followed in 1877 with her *Reminiscences of Rev. Wm. Ellery Channing, D.D.,* and in 1886 a publication of her essays in *A Last Evening with Allston and Other Papers.* Among the other papers were, "The Dorian Measure . . .," "A Plea for Froebel's Kindergarten as a Primary Art School,"[2] and "Hawthorne's 'Marble Faun'," an essay on the amoral nature of the imagination. In chronicling the inspiration of others, Elizabeth chronicled herself. She left us an intimate record of a woman's endless search for intellectual and spiritual truth, indomitable and dauntless in mid-nineteenth century Victorian America. She was single minded in her quest, generous in sharing it all, with an oceanic constitution and capacity for self-explanation.

Her last crusade, in opposition to the Americanization of Froebel's system, which she called "pseudo-kindergartens," led to teaching future kindergartners. In 1886 she published a series of *Lectures in the Training Schools for Kindergarteners.* But it was a losing battle and much that she believed in passed with her generation under the new Pragmatism.

Mary died in Jamaica Plain, 11 February 1887. On 3 January 1894, in The Gordon, a residential hotel in Boston, death interrupted Elizabeth's plans to write reminiscences of her mother, of her sister Sophia's earlier years, of her experiences as a teacher, a book on the moral meanings of history, and her account of the life of Christ, and she joined Mary and the family. The soul has its time that is not ours. Only her brother, Nathaniel, outlived her. But her works outlived them all—for a while.

Notes

1. Quotation from a translated edition, Froebel 1912. E.P.P. would have read the original German text.

2. In the 1886 republication E.P.P. changed part of the 1869 title from, ". . . as the First Grade of Primary Education," to ". . . as a Primary Art School." For an excellent account of this essay, see Sienkiewicz 1985.

References

Edgeworth, Maria, and Richard L. Edgeworth. 1801. *Practical Education*. 2 Vols. New York: George F. Hopkins and Brown & Stansbury.

Froebel, Frederick. 1912. *Froebel's Chief Educational Writings, The Education of Human Nature*. Translated by S.S. Fletcher and J. Welton. London: Edward Arnold & Co.

Logan, Frederick. 1955. *Growth of Art in American Schools*. New York: Harper and Brothers.

Peabody, Elizabeth P. 1835. *A Record of a School*. Boston: James Munroe and Co.

_____. 1880. *Reminiscences of Rev. Wm. Ellery Channing, D.D.* Boston: Roberts Bros.

_____. 1886. *Last Evening with Allston and Other Papers*. Boston: D. Lathrop and Company.

Ronda, Bruce A., Ed. 1984. *Letters of Elizabeth Palmer Peabody: American Renaissance Woman*. Middletown, Conn.: Wesleyan University Press.

Rose, Anne C. 1981. *Transcendentalism as a Social Movement, 1830-1850*. New Haven: Yale University Press.

Saunders, Robert J. 1961. *The Contributions of Horace Mann, Mary Peabody Mann, and Elizabeth Peabody to Art Education in the United States*. Ed.D. diss., Ann Arbor, Mich.: University Microfilms, No.: Mic. 61-2397.

_____. 1964. "The Search for Mrs. Minot: An Essay on the Caprices of Historical Research." *Studies in Art Education* 6 (no. 1): 1-7.

Sienkiewicz, Carol. 1985. "The Froebelian Kindergarten as an Art Academy." In *The History of Art Education, Proceedings from the Penn State Conference,* edited by Brent Wilson and Harlan Hoffa. Reston, VA: National Art Education Association: 125-27.

Wygant, Foster. 1983. *Art in American Schools in the Nineteenth Century*. Cincinnati, Ohio: Interwood Press.

REV. ALEXANDER FORRESTER, D. D.,

First Principal of Provincial Normal School, Truro, N. S., 1855-1869.

Forrester was one of the first in Nova Scotia, and likely among the first in Canada, to promote common school art activities involving paint and three-dimensional construction. (Photograph Collection Public Archives of Nova Scotia).

From Old to New Scotland: Nineteenth Century Links Between Morality and Art Education

3 *B. Anne Wood and Donald Soucy*

The nineteenth century transmission of utilitarian-based industrial drawing programs from Britain to North America has been well documented. Repeating Isaac Edwards Clarke's reports of 1874 and 1885, historical accounts have claimed that the first significant North American common school art education program occurred in Massachusetts in 1870. That year, the state legislated mandatory drawing instruction for the public schools. To oversee the program, the English art instructor, Walter Smith, was hired. A graduate of Henry Cole's National Art Training School at South Kensington, Smith organized a comprehensive industrial drawing program for the common and normal schools. The program was packaged in a series of texts and, in the 1870s and 1880s, was adopted by many school systems in the United States and Canada. Cole and many of his colleagues believed industrial drawing served economic needs by providing designers with practical skills (Macdonald 1970). A nation of such designers would outstrip international competition in the marketplace, resulting in their country achieving the greatest good for the most people.

There has been an increasing challenge to this pervasive historical focus on utilitarian-based art education. Paul Bolin (1986) argues that industrial drawing was only one of a variety of types of drawing available in Massachusetts public schools during the 1870s. Louise Stevenson (1986) notes how the mid-nineteenth century work of Yale's art historian, James Mason Hoppin, was influenced by philosophical notions of organicism. Stevenson adds that Hoppin's observations on art were peppered with the vocabulary of associationist theory, to which the evangelical Yale scholar had been introduced by John Ruskin. Mary Ann Stankiewicz (1984) describes Ruskin's influence on Hoppin and other American art education theorists, such as Harvard art historian Charles Elliot Norton. Stankiewicz argues that the romantic idealism represented by these scholars provided a theoretical base for the turn-of-the-century picture study and school decoration movements. It did so, she said, by emphasizing, among other things, "the value of art for the education of morals" (54).

How common were these non-utilitarian ideas of art education? Did they take hold only in the academic confines of Yale and Harvard? Or were they prevalent in the general populace? To explore these questions, we have examined how one idea—art for the education of morals in the common schools—was manifested in mid-nineteenth century Nova Scotia. We discovered that this idea was imported from Scotland during the mid-nineteenth century. Furthermore, when we looked at the broader historical context, we found that art and other forms of moral education were promoted partly for specific political objectives.

The Scottish Roots

The main propagator of art and moral education in Nova Scotia during that period was the Reverend Dr. Alexander Forrester, the province's second Superintendent of Education and first Normal School principal. Forrester, like Hoppin and the other New Haven scholars at Yale, was an evangelical Presbyterian. Born in Scotland, Forrester attended Edinburgh University between 1821 and 1825. He was licensed to preach in 1831, gaining his first parish four years later. In 1843, he joined four hundred other evangelicals who followed Thomas Chalmers out of Edinburgh's St. Andrew's Church to declare the establishment of the Free Church of Scotland (Harvey 1972).

To the Free Churchmen, pastoral duties entailed activism in social as well as in ecclesiastical spheres. An active ministry was especially important in industrial towns such as Paisley, where textile workers were facing serious social and economic problems. Fostering educational opportunities was seen as one way of alleviating some of these problems. As well as universal access to schooling, these evangelical Presbyterians advocated a particular type of educational program derived from the Glaswegian humanitarian David Stow. Stow was a Free Churchman and Glasgow merchant who strongly influenced Forrester. Both were distressed by the squalor and wretchedness that surrounded their industrial communities. In 1816 Stow established a Sunday school for poor children. Achieving some success, he was induced to expand into general infant education. In 1826 Stow founded the Glasgow Infant School Society, which evolved into the Glasgow Normal Seminary. Forrester and others considered Stow's school to be one of the founding teacher training institutions in Great Britain.

Stow depicted the teacher not simply as a supplier of information but rather as a stimulator of self reliance, the intellect, the imagination, and the moral sense. The Stow teacher began by "descending to a level with his scholars; by his borrowing images and illustrations from objects and things with which they are familiar; and by this means, leading them on from the known to the unknown,

from the visible to the invisible" ("What is," 1858, 3). To achieve this, Stow developed exercises called "word painting" in which students and teacher engaged in a dialogue of description, questioning, ellipses, and analogy. The teacher's purpose in these exercises was first to ascertain the children's prior knowledge and then to help them understand the principle—often a moral one—behind the lesson being taught.

Although Stow drew on the work of other educationists such as Pestalozzi, he differed from them in his fundamental aim: the moral regeneration of society based on the scriptural injunction, "Train up the child in the way he should go; and when he is old, he will not depart from it." Drawing on faculty psychology, Stow believed that morality was a faculty held in common by all individuals, and it could therefore become the universal goal of all common schooling. With the Bible providing a common foundation, Stow asserted that principles of morality could be effectively taught to children of all denominations, social classes, and cultures. Habits or correct conduct could thus be cultivated and exercised within the whole of society. Stow therefore represented a shift in the direction of Scottish education from an intellectual to a more simplified moralistic emphasis.

Forrester, like Stow, adhered to the belief in the primary role that religion and morals should play in education. To Forrester, school was "the nursery of the Church" (1867, 38). A requisite for modern teachers, therefore, was that they be devout Protestants, able to inculcate their values into impressionable young minds.

With moral education as an end, Forrester propagated music and the visual arts as a means (1860, 247; 1867). Forrester believed that when we look for the source of aesthetic beauty "we have only to trace the various steps in the process, until we can get no further, and then assign all to the omnipotent Creator" (1867, 172). He felt that people with taste obtained satisfaction from a "loftier source" than the "mere corporal" gratifications of sensual delight (1867, 26). Because of this moralizing function, art education was for everybody, not just for future artists.

Notions on the development of taste were intertwined with those on the imagination; while taste allowed the discernment of the beautiful, imagination could translate the beautiful into meaningful art objects. Furthermore, it was only through the imagination that one could conceive of the ideal. In Forrester's philosophy, ideal beauty was "the glory of the unseen Spirit" (1867, 168). It was these eternal ideals that set the standards for all human endeavors. In order to promote this quest for the ideal, education must evoke the imaginative powers of even the most literal of students.

The Politics of Moral Education

Within five years of his arrival in Nova Scotia in 1848, Forrester was appointed the province's second Superintendent of Education. In 1855 he took on a second post as the first principal of the newly established provincial Normal School. One of his primary concerns was to use these positions to improve morality in the colonial populace. To Forrester, a common moral code was best reinforced by a uniform system of teacher training, common sets of authorized texts, a centrally controlled organization and set of procedures, and compulsory schooling financed by direct assessment.

The province's first Superintendent of Education, John William Dawson, was an old school Kirk Calvinist who approached moral education more cautiously than did the evangelical Forrester. A graduate of Pictou Academy, Dawson had been affected by the sectarian strife that had centred around the academy during the 1820s to 1840s. He developed a strong suspicion of any form of sectarian control in education and, like Egerton Ryerson in Upper Canada, recommended non-denominational moral education. Forrester took a different position. Because the Bible was the lynch-pin in his system of education, he attempted to have legislation passed in the House of Assembly that would make daily lessons in the scriptures mandatory in all common schools of the province. The bill was defeated by more moderate Protestants, who realized the inflammatory effect this would have on Roman Catholics; their authorized version of the Bible would have been disallowed by this legislation.

Denominational rivalry in the province was not restricted to educational issues. In the May 1859 elections the Conservatives lost their majority, and observers attributed this to the victory of the anti-Catholic forces. A prevailing belief among nineteenth century Protestants was that there was a direct "relationship between a nation's spiritual purity and its secular success" (Johnston 1977, 48) and that Catholicism bred factionalism, lack of self-control, irrationalism—all of which would impede Nova Scotia's commercial, industrial, and social progress. Only transformed individuals with common ideological aspirations could achieve a transformed society, they believed. Forrester's universalistic remedies for schooling in Nova Scotia, including his views on art and aesthetic education, should therefore be seen as part of a deliberate Protestant campaign to galvanize a majority of Nova Scotia's population behind this vision of a transformed society (Forrester 1862, 5; 1863, 8; 1864, 5).

The state was now to stand in *loco parentis*. It was vastly cheaper, Forrester argued, to build commodious school houses and to provide a suitable education for every child than to build more jails and hospitals ("The Preventative" 1860, 178). Furthermore, he believed the positive state had the right to force schooling on children, even if it meant removing them from parents who rejected this form

of education ("Compulsory Education" 1860, 178). It was no coincidence that Nova scotia's Tory party had, by that time, also begun to advocate direct assessment and free schooling. This major social welfare policy was advanced increasingly in conjunction with the Tories' overall policy to expand and consolidate the powers of the state. Expansion represented a break from traditional Tory policy of limited state intervention, and was advocated to lead the province into the dawning age of industrial capitalism.

It was because of this more sophisticated concept of the positive state, and the need of a common ideological understanding among the nation's people, that Forrester chose Stow's system of teacher training over the monitorial, Pestalozzian, or intellectual systems in effect in England and Scotland. To Forrester's mind, Stow's system best addressed the difficulties of life, and it provided the best assurance to the state that school graduates would be "capable of taking their position and performing the duties for a nation [as] their Creator intended them" (1864, 8). Although moral education would have been advocated by many moderate Scottish educators, it is doubtful that they would have emphasized social activism to the degree promoted by Stow. Nor would they have stressed practical pedagogical knowledge over high scholarship. Through Stow's system, a moral sensibility and a common ideological perspective could be cultivated and enlarged in a whole generation of Nova Scotians.

Morality and Art Education Curriculum

Stow's theories on the imagination were among those that Forrester adapted for Nova Scotia. Many of Forrester's ideas in this regard were well in advance of anything else proposed in the province prior to the late nineteenth century. For example, foreshadowing turn-of-the-century sand tables and other New Education activities, Forrester suggested that the teacher get a box of blocks and have the students build models of pyramids, bridges, or houses.

Forrester proposed other object-based lessons for developing the imagination. He felt moral and spiritual truths should be illustrated through careful and diligent study of the finest specimens of sculpture and painting. These recommendations laid the groundwork for the picture study lessons that were later prevalent in provincial schools. Seeds for the school decoration movement were also planted because of Forrester's ideas on beauty in the classroom. Concern for school decoration is generally considered to have been common in the late nineteenth and early twentieth centuries, yet in Nova Scotia there were calls for schoolhouse ornamentation as early as 1866 ("Meeting" 1867).

According to Forrester, cultivating the aesthetic and developing the taste of students required not only the contemplation of art but also the creation of art.

Forrester would concur with Ruskin's admission that "I would rather teach draw-
ing that my pupils may learn to love Nature, than teach the looking at Nature that
they may learn to draw" (Ruskin [1857] 1971, 13). Thus, Forrester's thinking
differed from many of his contemporaries who, if they advocated school drawing
at all, did so only through the use of copy books. Forrester, on the other hand,
believed it was also necessary for the student to draw from real life, the "All-
perfect original" (1867, 174). Not that Forrester was against drawing books. On
the contrary, he wanted such books to be systematically used.

Initially, three series of drawing texts were recommended in Nova Scotia,
two from England and one from the United States. The British texts were put out
by Henry Cole's circle at the South Kensington National Art Training School.
Such books reflected a strict utilitarian outlook and were based primarily on
geometry, with a heavy emphasis on copying flat ornamentation (Macdonald
1970). The third series was by Boston painter William Bartholomew, whom
Foster Wygant describes as "probably the most prolific author of drawing texts"
(1983, 47). Bartholomew's texts differed from his competitors' in a significant
way: his books emphasized representational drawing of non-stylized objects, and
included exercises in shading and perspective. It was these naturalistic exercises,
with their assumed links to God's wonders, that likely led Forrester to prefer
Bartholomew's series over the other two (1867, 425). By 1866 Bartholomew's
books were the only ones left on the prescribed list.

The perceived nexus of art and nature affected the province's art-related
instruction for the rest of the nineteenth century. For instance, in Nova Scotia's
first graded provincial curriculum, issued in 1884, both colour and form study
were found not in the drawing program but rather in nature study. After all,
colour and form were essentially handmaidens to the more important study and
appreciation of God's natural world.

Forrester's other art education ideas included his linkage of drawing with
penmanship. However, his views on this matter contained an interesting twist.
Instead of the usual rationale—held by educators such as Dawson, Ryerson, and
Horace Mann—which said that drawing was beneficial because it aided writing,
Forrester argued that proper penmanship was beneficial because it "cultivates and
approves the taste" (1867, 263). Another aspect of aesthetic education put for-
ward by Forrester is that students should be engaged in "criticising works of the
imagination of various descriptions" (27). Thus, Forrester's tactics for develop-
ing the imagination reveal a concern for the student as appreciator, producer, and
critic of art.

Such a concern calls to mind slogans arising from the discipline-based art
education movement of the 1980s, therefore making Forrester's ideas seem strik-
ingly modern. Yet his notions are also typically mid-nineteenth century, with
many of them echoing ideas of Ruskin. Stankiewicz has noted that during that

era "Ruskin's writings both reflected and helped to create a climate of opinion in which art education came to be considered a kind of moral education" (1984, 51). In Nova Scotia, educators occasionally cited Ruskin as an authority, quoting him, for example, in the drawing section of the province's 1864 Free School Act. That Act, which Forrester helped to draft, gave the first official status to school drawing in Nova Scotia.

Forrester also resembled Yale's evangelical New Haven scholars in that he, like them, was a transitional figure. He stood between the Enlightenment "mental discipline" generation—of which Dawson was a member—and the specialized professionals of the modern era. Influenced by German Romanticism and Scottish common sense realism, these evangelicals looked upon self-control as a precondition for a moral world and the creation of a harmonious Christian state. Ironically, their social activism hastened the demise of their doctrinal hegemony and led to the onset of secularization.

Morality and Art Education Practise

To what degree did the morality-based art curriculum influence actual classroom practise in Nova Scotia? Forrester placed such importance on the arts that in 1859 and 1860 he decided to supplement the Normal School's three-person staff with two part-time teachers, one for music and one for drawing. However, the government disagreed with Forrester's priorities, and consequently it failed to allocate all the necessary funds for the expansion. Instead of changing his plans, Forrester raised money for the salaries in various ways, including dipping into his own pocket (Harvey 1975). Thus from at least 1860 onwards, Normal School students were given one hour a week of drawing instruction.

Added to this instruction were Forrester's own Normal School classes. In addition to various branches of science, Forrester gave classes in teaching methods. In that course, and in his lectures on nature study, he introduced his ideas on art and aesthetics. His ideas on moral education permeated all of his courses. By the time Forrester stepped down from the Normal School principalship in 1868, 297 of the teachers employed in the province, or 24.1 percent, were Normal School graduates. Forrester's *Teacher's Text-Book* (1867) also reached educators who did not attend the Normal School, or who were students there after Forrester left. In addition, Forrester's theories on art and morals appeared in other education literature, such as the provincial *Journal of Education*.

Although it can be established that these various channels assured an audience for Forrester's beliefs, getting teachers to act on them was another matter. The Normal School at that time had to deal primarily with work that should have been covered at the secondary level. Students were accepted into Normal School

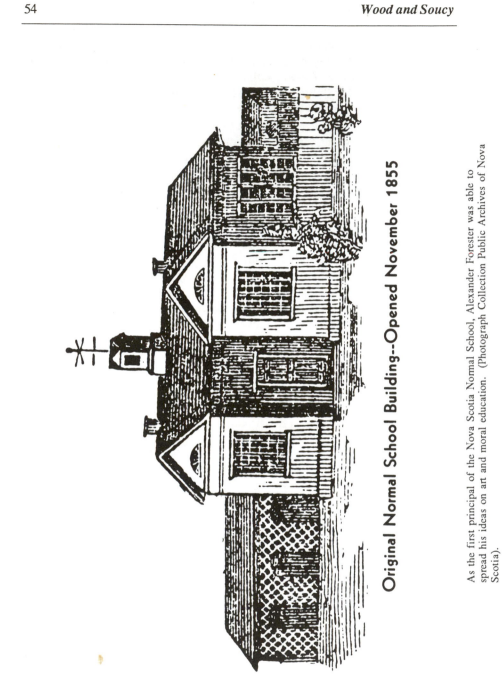

Original Normal School Building--Opened November 1855

As the first principal of the Nova Scotia Normal School, Alexander Forester was able to spread his ideas on art and moral education. (Photograph Collection Public Archives of Nova Scotia).

with grade nine, and many needed basic work in the Three Rs. As Forrester lamented in 1866, "The longer I continue in connection with this institution, I feel all the more constrained to reduce the theoretical and increase the practical" (Harvey 1975, 62-63). Only 18 percent of the teachers who were supervised that year gave good or frequent oral lessons, the basis of Stow's system. Twenty-seven percent were judged to have given inferior or infrequent oral lessons, and most teachers, 55 percent, made no attempt at all at oral lessons. Drawing fared even less well. In 1866, only 6.7 percent of the province's academy and common school students were listed as taking that subject. There was a slight increase in drawing instruction over the next couple of years, so that about 10 percent of the students were taking drawing by the time Forrester retired in 1868. It stayed at that level until the 1880s (extrapolated from *Annual Reports* 1867 to 1887).

Over the long term, however, Forrester's theories continued to be reflected in the province's art education curriculum. The study of form and colour in nature, along with the widespread popularity of picture study in the province, all had their bases in the ideas of Forrester and those of his followers. Furthermore, Forrester was one of the first in Nova Scotia, and likely among the first in Canada, to promote common school art activities involving paint and three-dimensional construction. Thus, the morality-based school art program called forth a much broader range of media and concepts than the industrial drawing emphasized by the strictly utilitarian viewpoint.

A dozen years after Forrester's death, the naturalistic drawing program he had introduced into the schools was replaced by Walter Smith's industrial drawing course. During the 1880s, educational reformers were preoccupied with the problems of unskilled urban youth, the decline of the apprenticeship system, and the growth of industrialism. By 1886, 46 percent of Nova Scotia's students were being taught the Smith program (*Annual Report* 1887).

The new industrial drawing program promised an abundant crop of skilled industrial workers, while the previous, more aesthetically based program claimed it would produce school graduates who had both taste and the desire to lead morally upright lives. Although neither program achieved its intended harvest, both broadcast their seeds abundantly, and later flowered in many of the art and aesthetic education theories of the twentieth century.

References

Annual Report of the Common, Superior, Academic, and Normal and Model Schools in Nova Scotia. For years 1866 to 1886. 1867 to 1887. Halifax: Queen's Printer.

Bolin, Paul. 1986. "Drawing Interpretation: An Examination of the 1870 Massachusetts 'Act Relating to Free Instruction in Drawing'." Ph.D. diss., University of Oregon.

Clarke, Isaac E. 1874. *Drawing in Public Schools: The Present Relation of Art to Education in the United States.* Bureau of Education. Circulars of Information 1874, no. 2. Washington: Government Printing Office.

Clarke, Isaac E. 1885. *Art and Industry.* Part 1, *Drawing in Public Schools.* U.S. Senate report. 46th Cong., 2d sess., Vol. 7. Washington: Government Printing Office.

"Compulsory Education." 1860. *Journal of Education and Agriculture,* 2 (no. 12).

Forrester, Alexander. 1860. "Educational Report for 1859." In "Appendices," *Journal of the House of Assembly,* 243-71.

_____. 1862. "Educational Report." *Journal of the House of Assembly,* Appendix no. 25.

_____. 1863. "Educational Report." *Journal of the House of Assembly,* Appendix no. 22.

_____. 1864. "Educational Report for 1863." *Journal of the House of Assembly,* Appendix no. 20.

_____. 1867. *The Teacher's Text-Book.* Halifax: A. & W. MacKinlay.

Harvey, Robert P. 1972. "The Foundation of the Normal and Model Schools at Truro with Special Reference to Alexander Forrester, Their First Principal, 1858-1869." Master's thesis, Dalhousie University, Halifax.

_____. 1975. "The Teacher's Reward: Alexander Forrester at Truro." *The Nova Scotia Historical Quarterly* 5 (no. 1): 47-68.

Johnston, A.J.B. 1977. "The 'Protestant Spirit' of Colonial Nova Scotia: An Inquiry into Mid-Nineteenth Century Anti-Catholicism." Master's thesis, Dalhousie University, Halifax.

Macdonald, Stuart. 1970. *The History and Philosophy of Art Education.* New York: American Elsevier.

"Meeting of the Educational Association." 1867. *Journal of Education* [Nova Scotia] (no. 2): 18-19.

"The Preventative Both Better and Cheaper than the Restorative." 1860. *Journal of Education and Agriculture* 2 (no. 12).

Ruskin, John. [1857] 1971. *The Elements of Drawing.* New York: Dover.

Stankiewicz, Mary Ann. 1984. "'The Eye Is a Nobler Organ': Ruskin and American Art Education." *The Journal of Aesthetic Education* 18 (no. 2): 51-64.

Stevenson, Louise L. 1986. *Scholarly Means to Evangelical Ends: The New Haven Scholars and the Transformation of Higher Learning in America 1830-1890.* Baltimore: Johns Hopkins University Press.

"What Is Education?" 1858. *Journal of Education and Agriculture* 1 (no. 1, July).

Wygant, Foster. 1983. *Art in American Schools in the Nineteenth Century.* Cincinnati: Interwood Press.

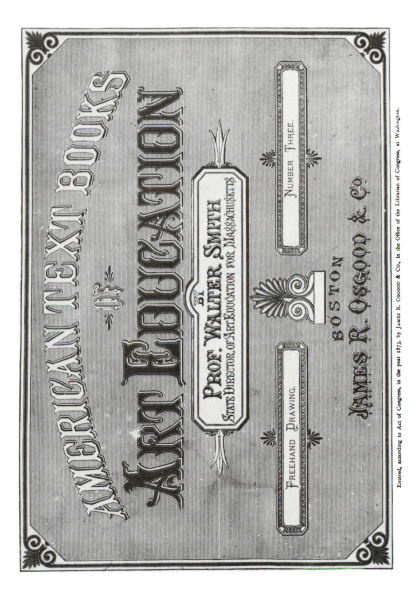

AMERICAN TEXT BOOKS

Art Education

BY
PROF. WALTER SMITH
STATE DIRECTOR OF ART EDUCATION FOR MASSACHUSETTS

FREEHAND DRAWING.

NUMBER THREE.

BOSTON
JAMES R. OSGOOD & Co.

Entered, according to Act of Congress, in the year 1873, by JAMES R. OSGOOD & Co., in the Office of the Librarian of Congress, at Washington.

During the 1870's and 1880's, Walter Smith's drawing books were used in schools throughout the United States and Canada. This book is from 1873. (Soucy Collection).

Copy of the handwritten draft of Chapter 248 of the 1870 Massachusetts legislative *Acts and Resolves*, titled: "An Act Relating to Free Instruction on Drawing." Debates led to a number of revisions in the early drafts of the Act. This draft dates from 5 May 1870. (Archives of the Commonwealth of Massachusetts).

The Massachusetts Drawing Act of 1870: Industrial Mandate or Democratic Maneuver?

4 *Paul E. Bolin*

In 1870 Massachusetts lawmakers enacted legislation that mandated drawing as one of nine required subjects taught in all public schools of that state. The law was titled "An Act Relating to Free Instruction in Drawing." With passage of this Act, Massachusetts became the first state to legislate compulsory public school drawing education. The statute also required cities in Massachusetts with populations that exceeded 10,000 to provide free "industrial or mechanical drawing" for citizens over fifteen years of age.

Since the 1870s, the Massachusetts Drawing Act has been referred to by numerous writers. Authors have often focused on the industrial aspects of the law and concluded, like Bennett (1926), that "the chief argument for the teaching of drawing in the public schools was its industrial utility value and not its cultural value" (430). Writers such as Dobbs (1972, 20), Saunders (1976, 5; 1977, 10), Efland (1983, 156; 1985, 118), and Bolin (1985, 105) have termed the legislation an "Industrial Drawing Act."

This chapter offers an alternative view to the idea that legislators intended the law to be an "Industrial Drawing Act." Instead, based on legislative history and document analysis, presented here is an interpretive belief that the Massachusetts Drawing Act was the outcome of a democratic legislative process, and was specifically crafted in response to numerous influences, pressures, and ideas concerning drawing education present in New England at the time this bill was approved. Information in this chapter supports a position that the statute was enacted not to promote a singular industrial direction for drawing education. Rather, it appears the legislation was adopted in response to a multiplicity of drawing education purposes and practices promoted by general citizens, politicians, and educators in late nineteenth century Massachusetts.

Initiation of the Legislative Process

During the 1869 Massachusetts legislative session the following petition was delivered to state lawmakers.

To the honorable General Court of the State of Massachusetts.

Your petitioners respectfully represent that every branch of manufactures in which the citizens of Massachusetts are engaged, requires, in the details of the processes connected with it, some knowledge of drawing and other arts of design on the part of the skilled workmen engaged.

At the present time no wide provision is made for instruction in drawing in the public schools.

Our manufacturers therefore compete under disadvantages with the manufacturers of Europe; for in all the manufacturing countries of Europe free provision is made for instructing workmen of all classes in drawing. At this time, almost all the best draughtsmen in our shops are men thus trained abroad.

In England, within the last ten years, very large additions have been made to the provisions, which were before very generous, for free public instruction of workmen in drawing. Your petitioners are assured that boys and girls, by the time they are sixteen years of age, acquire great proficiency in mechanical drawing and in other arts of design.

We are also assured that men and women who have been long engaged in the processes of manufacture, learn readily and with pleasure, enough of the arts of design to assist them materially in their work.

For such reasons we ask that the Board of Education may be directed to report, in detail, to the next general court, some definite plan for introducing schools for drawing, or instruction in drawing, free to all men, women and children, in all towns of the Commonwealth of more than five thousand inhabitants.

And your petitioners will ever pray.

JACOB BIGELOW.	JOHN AMORY LOWELL.
J. THOS. STEVENSON.	E.B. BIGELOW.
WILLIAM A. BURKE.	FRANCIS C. LOWELL.
JAMES LAWRENCE.	JOHN H. CLIFFORD.
EDW. E. HALE	WM. GRAY.
THEODORE LYMAN.	F.H. PEABODY.
JORDAN, MARSH & CO.	A.A. LAWRENCE & CO.

BOSTON, June, 1869 (*Thirty-fourth Annual Report* 1871, 163-64).

Twelve individuals and two businesses endorsed this petition. These prominent signatories were involved in industry and politics in a manner that helped form a common purpose. Many were highly regarded for their efforts to develop New England textile and carpet manufacture, as well as for improvements to machine design and railroads. Joseph White, Secretary of the Massachusetts Board of Education at the time the petition was signed, described the petitioners as,

> well known and highly respected citizens, distinguished for their interest in popular education, and for their connection with those great branches of mechanical and manufacturing industry which absorb large amounts of the capital, and give employment to great numbers of the residents of the Commonwealth. (*Thirty-fourth Annual Report* 1871, 163)

Parallel with their industrial involvement, a number of the petitioners engaged in electoral politics. John Clifford held numerous public offices in Massachusetts, including governor, which he attained in 1853. Abbott Lawrence, co-founder of the A.A. Lawrence & Co., a business represented on the drawing petition, was elected to the United States Congress in 1834. His son, James, signed the drawing petition. These and other petitioners expressed strong economic protectionist sentiments, and actively promoted legislative tariffs on imported European textile commodities. Petitioning the 1869 Massachusetts legislature seemed a natural and appropriate maneuver for this body of citizens. Many of them participated both in manufacture and government policy-making, and were well acquainted with benefits that could be gained through alliances of business and government. The petitioners believed that drawing education, like textile import tariffs, could be legislated. Thus, when faced with another business predicament—this time involving the availability of qualified draftsmen rather than textiles—these petitioners sought a solution through proposing and appealing for government assistance. Signers of the petition pursued public drawing education as a strategy for decreasing the state's dependence on European-trained draftsmen. They perceived this legislation as a means to possibly ameliorate economic conditions in helping train Massachusetts citizens for the individual personal advantages of such education, as well as for the state's benefit. Seeking to improve conditions in Massachusetts through increasing the number of trained machinery and textile pattern designers, the petitioners actively pursued publicly financed drawing education legislation.

Legislative Development of the Drawing Act

Massachusetts legislators expedited the drawing education proposal presented them by the petitioners. Within days lawmakers approved the following legislative Resolve:

RESOLVE RELATING TO PROVISION FOR FREE INSTRUCTION IN
MECHANICAL DRAWING IN THE CITIES AND LARGE TOWNS OF THE
COMMONWEALTH.

Resolved, That the board of education be directed to consider the expediency of
making provision by law for giving free instruction to men, women and children in
mechanical drawing, either in the existing schools, or in those to be established for
that purpose in all towns in the Commonwealth having more than five thousand
inhabitants, and report a definite plan therefor to the next general court.

Approved June 12, 1869

(Secretary of the Commonwealth 1869, 817).

In response to this Resolve, the ten-member Massachusetts Board of Educa-
tion formed from its body a four-person drawing education subcommittee. This
subcommittee consisted of Board members Gardiner Hubbard, David Mason
(Chair), and John Philbrick, as well as Board of Education Secretary, Joseph
White. Their purpose was to secure information pertinent to the Resolve, and "to
make all needful inquiries and investigation, and to report their conclusions
thereon for the consideration of the whole Board" (*Thirty-fourth Annual Report*
1871, 164).

During the months that followed, the drawing subcommittee actively sought
opinions and information concerning "mechanical drawing" education. They
conferred with individuals from the community who manifested interest in this
form of drawing instruction. Drawing petitioners Francis Lowell, Jr. and Rever-
end Edward Hale met with the subcommittee to personally communicate beliefs
and concerns of the fourteen petitioners.

The petitioners were only one segment of the population interested in ad-
vancing drawing education. These prominent men were, however, a unified puis-
sant body. In their meeting with the drawing subcommittee, "the views of the
petitioners were fully explained and elaborately set forth in a carefully prepared
bill to be presented to the legislature" (*Thirty-fourth Annual Report* 1871, 164).
This action was not favorably received by the subcommittee. The legislature had
specifically requested the Board of Education to investigate and report on the
matter of instituting schools for mechanical drawing instruction. The fact that an
"elaborate" legislative "bill" had been drawn up by the petitioners, without prior
input from the drawing subcommittee and other citizens, may have been viewed
by this four-member board as improper and presumptuous. In response to the
petitioners' actions, the subcommittee "deemed it advisable to seek for further
information and suggestions from gentlemen of well-known experience and skill
in this department of instruction" (*Thirty-fourth Annual Report* 1871, 164).

Commonwealth of Massachusetts.

IN THE YEAR ONE THOUSAND EIGHT HUNDRED AND SEVENTY.

AN ACT

relating to free Instruction in Drawing.

Be it enacted by the Senate and House of Representatives, in General Court assembled, and by the authority of the same, as follows: —

SECTION 1. The first section of chapter thirty eight of the General Statutes is hereby amended so as to include Drawing among the branches of learning, which are by said section required to be taught in the public schools.

Section 2. Any city or town may, and ~~Sect. 2.~~ ~~Every~~ city and town having more than ~~five~~ ten thousand inhabitants shall annually make provision for giving free instruction in Industrial or Mechanical Drawing to persons over fifteen years of age, either in day or evening schools, ~~in such manner as shall be approved by the Board of Education~~ under the direction of the School Committee

Section 3. This act shall take effect upon its passage.

H. R. May 5 1870
Passed to be engrossed
Sent up for concurrence
Wm S Robinson Clk
Senate, May 10. 1870
Passed to be engrossed in concurrence
S. N. Gifford Clerk

When Henry Turner Bailey was a student at Massachusetts Normal Art School, industrial and mechanical drawing skills were part of the art teacher preparation curriculum. These pages are from Bailey's student notebook, 1883. (Special Collections, University of Oregon Library).

To help secure information regarding instruction in mechanical drawing, late in 1869 the subcommittee prepared and delivered a circular to prominent drawing educators throughout New England. The circular requested opinions on six general topics related to mechanical drawing, that ranged from the "advantages which might be expected to result from the contemplated instruction in mechanical or industrial drawing," to what these individuals saw as "the organization and supervision of the proposed Drawing Schools" (*Thirty-fourth Annual Report* 1871, 165).

The subcommittee received numerous replies to the circular. Though some responses were secured from authorities who resided outside Massachusetts, the subcommittee believed the replies provided the most "approved methods" for drawing instruction in that state's schools (*Thirty-fourth Annual Report* 1871, 145). Because of their perceived value, nine of the most thorough responses to the circular were selected for publication. In a legislative Resolve, dated May 11, 1870, it was ordered that two thousand copies be printed in pamphlet form, and "that two copies thereof be given to each member and officer of the legislature, and the remainder be deposited in the office of said Board [of Education] for distribution among the several cities and towns of the Commonwealth" (Board of Education 1870, 5). Replies of these nine individuals demonstrate an extensive range of purposes for and benefits received from instruction in mechanical drawing. Some writers focused on economic advantages anticipated from instruction in mechanical drawing; others addressed drawing relative to more broad-ranging educationally propitious issues, such as its potential to instill moral character, develop intellectual capabilities, and aid in teaching other school subjects.

Discussions by various authorities lamented the impoverished condition of mechanical drawing in Massachusetts and throughout the United States. Respondent John Woodman of Dartmouth College believed mechanical drawing instruction would benefit local economies, and declared that a "proper training in Drawing of ten or fifteen years, in many a town in Massachusetts, might double the industrial efficiency, and put two for one on account of this influence" (Board of Education 1870, 31-32). Louis Bail of Yale College described America's plight of having only a few available skilled mechanical draftsmen: "The whole nation is deploring the lack of good ornamental designers. We are becoming tired of sending so many millions to Europe for articles that we might produce cheaper at home if we had skilful designers" (17). The economic potential for drawing education was stated with equal emphasis by numerous other respondents.

Besides the possible financial benefits acquired from drawing education, many other advantages were presented by the nine authorities. William Bartholomew, a teacher of drawing in the public schools of Boston, believed drawing "cultivated the habits of *neatness* and *accuracy*," as well as taste (Board of Education 1870, 24). He also discussed drawing relative to imaginative and inventive faculties, and concluded that drawing should be undertaken as a "means

of *improvement* as well as [for] *amusement*" (27). J.W. Dickinson, who taught drawing at the Westfield Normal School, advocated drawing lessons as a "valuable auxiliary" to study in arithmetic, geometry, botany, natural history, and penmanship (41). Drawing was seen by Boston public school drawing instructor Charles Barry as being of "inestimable use," and he believed it "tended to improve the intellect of the masses, [and] purify the tone of their moral character" (43). A past Commissioner of Education, Henry Barnard, asserted that drawing was directly useful in various academic subjects such as natural history, natural science, and geography, and that its acquisition "can introduce its possessor more directly into the region of the beautiful, the true and the good, both intellectually and morally" (47).

Responses to the drawing subcommittee's circular contained a variety of benefits secured from an education in drawing. Rather than advocate a single view, these prominent drawing educators espoused diverse purposes for drawing education. The nine respondents were, however, unified in their belief that concerted effort should be made to promote drawing education in Massachusetts. This exhortation was stated by the drawing subcommittee in its report to the entire Massachusetts Board of Education. The report was unanimously approved by the Board, which passed an affirmative drawing education recommendation to Massachusetts lawmakers. In its statement to the legislature, the Board of Education recommended passage of:

> An enactment requiring elementary and free hand drawing to be taught in all the Public Schools of every grade in the Commonwealth; and which shall further require all cities and towns having more than [blank] inhabitants, to make provision for giving annually free instruction in industrial or mechanical drawing to men, women and children, in such manner as the Board of Education shall prescribe (*Thirty-fourth Annual Report* 1871, 166).

This recommendation rankled the petitioners, who saw it as ambiguous in wording and lenient in effect. This perception was addressed by Joseph White, a member of the drawing subcommittee:

> The Board are aware that the action recommended falls far short of that contemplated by the petitioners and embraced in the draught of a Bill presented by their Committee for the consideration of the Board. Nevertheless it is a beginning, and the steps are in the right direction. They are easily taken, . . . and will lead, . . . to the adoption of the more comprehensive and complete arrangements designed by the petitioners (*Thirty-fourth Annual Report* 1871, 166).

It is difficult to determine whether this statement by Joseph White reflected ideas he believed would occur, or if it was made to appease the petitioners. However, it appears that incongruent aims existed between what the signatories desired of the legislation, and what the Board of Education proposed to Massachusetts lawmakers.

The petitioners were desirous of instituting mechanical drawing education. The Board of Education seemed to have taken a different approach in its recommendation to the legislature. Unlike any previous public proposal on the topic, the Board divided the issue of drawing education into two separate matters. The first section of the proposal addressed the type of drawing education recommended to be required in all graded public schools: elementary and free hand drawing. The second part of the recommendation focused on industrial or mechanical drawing instruction for men, women, and children. Use of these specific drawing terms by the Board of Education may be tied to information received in replies to the subcommittee's circular. Throughout the nine responses to the circular, mention was made of elementary, free hand, industrial, and mechanical drawing. Elementary and free hand drawing were described as basic types of instruction that required little more than blackboards, chalk, pencils, paper, and a few models or flat copies. Industrial and mechanical drawing were more advanced approaches, and necessitated use of rulers, drawing pens, drawing boards, T-squares, and mathematical instruments.

The Massachusetts legislature was presented with a dilemma. Lawmakers had been furnished a number of diverse purposes, approaches, and terms, related to drawing education. Many of these varied directions went well beyond the mechanical drawing education advocated by the fourteen petitioners. Thus, Massachusetts lawmakers sought to answer the primary question: What form of drawing education legislation should be drafted to satisfy these heterogeneous constituent factions?

As a solution, legislators proposed and adopted a Drawing Act based on compromise. They undertook a legislative maneuver that supported local autonomy for each Massachusetts school committee. To not limit or constrict the possible interpretations of the statute by school officials, legislators enacted a law that placed all Massachusetts cities and towns in a position to select the type of drawing education most appropriate for scholars in their public schools. This freedom of choice is evident in an examination of the approved legislation:

AN ACT RELATING TO FREE INSTRUCTION IN DRAWING.

Be it enacted, &c., as follows:

SECTION 1. The first section of chapter thirty-eight of the General Statutes is hereby amended so as to include Drawing among the branches of learning which are by said section required to be taught in the public schools.

SECTION 2. Any city or town may, and every city and town having more than ten thousand inhabitants, shall annually make provision for giving free instruction in industrial or mechanical drawing to persons over fifteen years of age, either in day or evening schools, under the direction of the school committee.

SECTION 3. This act shall take effect upon its passage.

Approved May 16, 1870.

(Secretary of the Commonwealth 1870, 183-84)

Interpretive Conclusions Concerning the Drawing Act

It appears the Drawing Act of 1870 was adopted to accommodate a variety of purposes for drawing education in the graded public schools of Massachusetts. In Section 1, the general term "Drawing" was used, rather than specified types of drawing instruction such as "elementary" and "free hand," that were proposed by the Board of Education. This legislative action appeared to conflict with the industrially focused desire for drawing education promoted by the petitioners. These individuals seemed disgruntled by the perceived ambiguity written into the Drawing Act; they viewed the law as being more broad in purpose and narrow in effect than the version they had submitted to the drawing subcommittee. But because the drawing subcommittee had received and in turn had promoted a variety of purposes for drawing education, it is not surprising that lawmakers chose to leave unspecified the type of drawing education administered in Massachusetts graded public schools.

Writers have tended to focus on the industrial aspects of the 1870 Massachusetts Drawing Act. The law often has been viewed as solely promoting industrial drawing, and frequently has been described as an "Industrial Drawing Act." That title does not seem to accurately describe the legislation. The law was written and adopted as a "Drawing Act" that added drawing to the list of eight then required public school subjects. The statute's only mention of "industrial or mechanical" drawing occurred in Section 2, and specifically applied only to the education of citizens over fifteen years of age. At the time this legislation was enacted, most Massachusetts citizens completed or terminated their formal public education by age fifteen (Clarke 1885). With this historical background, it seems obvious that Section 2 of the Drawing Act was aimed not at the majority of school-age children, but rather at "a class of persons quite distinct from scholars in our Public Schools" (*Thirty-fourth Annual Report* 1871, 171). The specific mention of industrial or mechanical drawing stated in Section 2, coupled with the lack of any designated direction for drawing education in Section 1, makes it appear that lawmakers did not intend to define precisely the type of drawing education provided students in Massachusetts graded public schools. For this reason it seems misleading to label the legislation an "Industrial Drawing Act." To describe the law in this manner does not fully acknowledge the ostensibly broad aim for drawing education recognized by Massachusetts legislators in adopting "An Act Relating to Free Instruction in Drawing."

References

Board of Education. 1870. *Industrial or Mechanical Drawing: Papers on Drawing.* Boston: Wright & Potter, State Printers.

Bennett, Charles A. 1926. *History of Manual and Industrial Education up to 1870.* Peoria, IL: Chas. A. Bennett Co., Inc.

Bolin, Paul E. 1985. "The Influence of Industrial Policy on Enactment of the 1870 Massachusetts Free Instruction in Drawing Act." In *The History of Art Education: Proceedings from the Penn State Conference,* edited by Brent Wilson and Harlan Hoffa, 102-07. Reston, VA: National Art Education Association.

Clarke, Isaac E. 1885. *Art and Industry.* Part 1, *Drawing in Public Schools.* U.S. Senate report. 46th Cong., 2d sess., Vol. 7. Washington, DC: Government Printing Office.

Dobbs, Stephen. 1972. "Paradox and Promise: Art Education in the Public Schools." Ph.D. diss., Stanford University.

Efland, Arthur D. 1983. "School Art and its Social Origins." *Studies in Art Education* 24 (no. 3): 149-57.

_____. 1985. "The Introduction of Music and Drawing in the Boston Schools: Two Studies of Educational Reform." In *The History of Art Education: Proceedings from the Penn State Conference,* edited by Brent Wilson and Harlan Hoffa, 113-24. Reston, VA: National Art Education Association.

Saunders, Robert J. 1976. "Art, Industrial Art, and the 200 Years War." *Art Education* 29 (no. 1): 5-8.

_____. 1977. *Relating Art and Humanities to the Classroom.* Dubuque, Iowa: Wm. C. Brown Co., Publishers.

Secretary of the Commonwealth. 1869. *Acts and Resolves Passed by the General Court of Massachusetts, in the Year 1869.* Boston: Wright & Potter, State Printers.

_____. 1870. *Acts and Resolves Passed by the General Court of Massachusetts, in the Year 1870.* Boston: Wright & Potter, State Printers.

Thirty-fourth Annual Report of the Board of Education. 1871. Boston: Wright & Potter, State Printers.

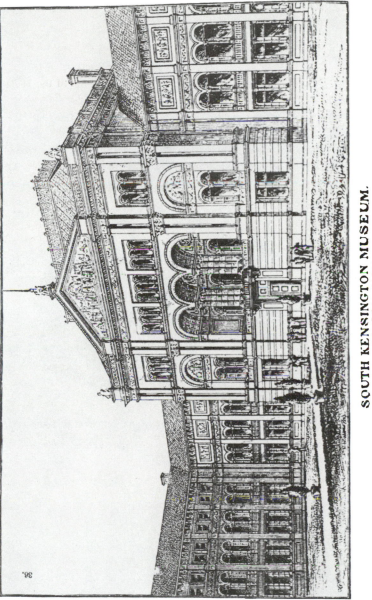

SOUTH KENSINGTON MUSEUM.
CENTRAL HALL.

The South Kensington Museum, now the Victoria and Albert, moved to this building in 1856. Under the direction of Henry Cole, South Kensington's art school and museum became a centre that produced art masters for schools throughout Britain and its colonies. This illustration is from Walter Smith's 1872 book, *Art Education, Scholastic and Industrial*, Boston: James R. Osgood. (Soucy Collection).

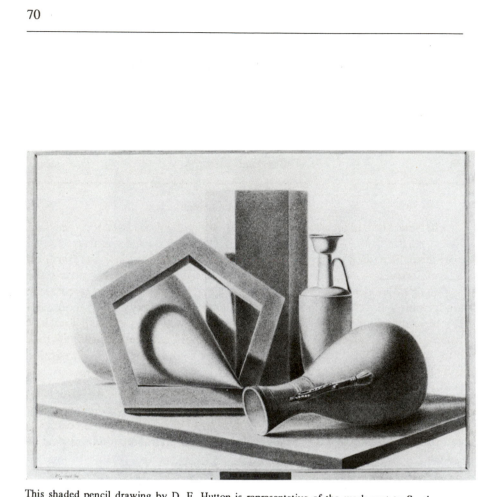

This shaded pencil drawing by D. E. Hutton is representative of the work sent to South Kensington from the New Zealand art schools. (Original work in Hocken Library, University of Otago, New Zealand).

South Kensington in the Farthest Colony

5 F. Graeme Chalmers

In New Zealand art history there is a tendency, by those not concerned with Maori art, to regard 1890 as the beginning of "serious" New Zealand art. In that year three "Romantic-Impressionists," all with some connection to the Barbizon School, arrived in New Zealand. However, these artists do not represent the beginning of European art in New Zealand. Some attention has been given to the topographical draftsmen of the 1840s, 50s, and 60s, but very little to those who sat the examinations of the Department of Science and Art, the South Kensingtonians of the 1870s and 80s. When historians do discuss South Kensington they often malign it. The "system" has been seen as "Simple, concise, methodical—and absurd" (Littlejohns 1928, 32).

Rather than make such judgements, it is my purpose to present a contextual history showing how dominant South Kensington was in New Zealand and how the system was kept alive by patterns of colonization and concepts of education and society that required a built and psychological environment reminiscent of "Home."

South Kensington Takes Hold

Beginning after the Great Exhibition in London in 1851, a new government Department of Practical Art, subsequently incorporated into the Department of Science and Art at South Kensington, initiated in Britain a system of state-aided and controlled art schools and examinations, supposedly concentrating on efficiency and consistent goals. As Minihan (1977) states:

> No beguiling dreams of high art distracted them [the South Kensington Art Masters] from their daily tasks. They were practical men, working to include art in the national elementary school curriculum and to educate the taste of artisans and consumers alike in the interests of British industry and trade. (96)

The Department of Science and Art not only supervised the teaching of art throughout Britain, it also examined generalist teachers in art and trained art masters. The essence of what has been called "The South Kensington System"

lay in the manner in which teachers and children were taught to exactly delineate plane and then solid geometrical forms. Only at an advanced stage was there any reference to nature.[1] This is the system that was exported to New Zealand.

There was much that was strikingly British about colonial New Zealand, including its art and its educational system. A.E. Campbell, who later became Director of Education in New Zealand, explained that:

> The colonist does not instantaneously develop a new philosophy of education simply by crossing the equator. He may, indeed, become thereby more than ever wedded to the old, for nostalgia is one of the dominant influences in his life. . . . Especially if he is concerned to give his children an education that shall link them to the life he has known. Cultural continuity is to the colonist of even greater importance than practical adaptation. (1941, 2)[2]

As the first Labor Prime Minister of New Zealand declared: "Where Britain goes, we go. Where Britain stands, we stand" (Minogue 1965, 204). Minogue, among others, sees this Britishness reflected in the New Zealand psyche and in aspects of the built environment. Minogue also points out that New Zealand faithfully copied all the nineteenth century aspects of British schools. The New Zealand Education Act of 1877 was influenced by the English Act of 1870. Provincial Legislatures were abolished in New Zealand in 1875, and in 1877 the General Assembly passed the Education Act, which instituted a national system of free, secular, and compulsory education.

The Minister of Education in 1879 said his aim was to give New Zealand children schooling "not inferior to that which could be obtained in the primary schools of England and Scotland" (Minogue 1965,203). For art education this meant drawing as outlined in the syllabus of 1878:

> The order of instruction in drawing shall be as follows:
>
> Standard 1: Freehand outline drawing from blackboard exercises (on slate).
>
> Standard 2: The same, but more advanced and use of drawing book.
>
> Standard 3: Freehand outline drawing in drawing book (from copies).
>
> Standard 4: Outline drawing from models and other solid objects.
>
> Standard 5: Practical geometrical drawing.
>
> Standard 6: Practical perspective drawing.
>
> (New Zealand Gazette 1878, 1311)

In addition to dependence and emulation, a further thesis for the "hold" of South Kensington ideas in New Zealand might be found in British missionary attitudes toward the Maori. Carline (1968) posits that the missionary schools, which were among the first to be established in the British colonies, were particularly loath to encourage indigenous arts because they were often the product of contrary religious beliefs. Where art was introduced, it was of a relatively "safe"

variety. Carline cites, as examples, the two Loretto foundations in Calcutta and Darjeeling, which were founded in the 1840s and where model drawing, plant drawing, and designing for embroidery were taught. In New Zealand special regulations for Maori schools were included in the Education Act of 1914. The regulations for drawing stated that the following were to be regarded as among suitable (and safe) objects for study: football, ninepin, carrot, plum, apple, pansy, daffodil, croquet-mallet, cricket-bat, tennis racquet, school bell, and flower pot. Thus, even in the twentieth century, the carry-over from the South Kensington system was still a powerful device for cultural assimilation.

Seventy years later New Zealand is quite different. The new draft art education syllabus states that the curriculum development team consulted widely with the Maori and South Pacific Arts Council, Nga Puna Waihanga, and other interested groups. Art is defined as an inseparable and significant part of the daily life of all New Zealanders. But the closest a South Kensington drawing master came to acknowledging Maori art was in two of a series of twenty lectures on "Design and Historic Ornament" given in Christchurch (Canterbury College 1886, 21). David Blair made token reference to the work of the "Savage" tribes of New Zealand, Fiji, the Sandwich and Friendly Islands, as "illustrating unconscious intelligence in design" and as examples of geometrical patterns and interlacing.

South Kensington also influenced art education in the other colonies.[3] A number of drawing masters moved from colony to colony, and, at least until 1886, immigrants frequently stopped at Cape Town or one of the Australian colonies en route to New Zealand. After completion of the railway across Canada, it was possible to travel to New Zealand by the "all-red" route.[4] Until the federation of the Australian states in 1901 there was a tendency to think of New Zealand as an equal, and of the whole area as "Australasia." It is not surprising, then, that before the four major New Zealand art schools affiliated with South Kensington in the late 1880s and 1890s students who did not go to London some-times went to one of the Australian colonies where they could take the London examinations.

In New South Wales a drawing class was established as part of the Sydney Mechanics' School of Arts in 1859. The Board of Technical Education later took control of the classes. In 1875 an independent art school was established by the Academy of Art in the colony and "A collection of casts was obtained from . . . South Kensington, every effort being made to start on sound lines" (Moore 1934, 224). In Victoria, the Artisans' Schools of Design were established in Melbourne in 1867. A National School of Art was founded in connection with the Melbourne Gallery in 1870. The first drawing master was Thomas Clark (1814-1883), who in 1876 returned to the United Kingdom to teach at the municipal art school in Birmingham and later became director of the School of Art in Nottingham. The South Australian School of Design began in 1861. In 1893 it became

the School of Design, Painting, and Technical Art, and in 1906 the Adelaide School of Art. Harry P. Gill (1855-1916), who directed the school from 1881 until 1914, was a South Kensingtonian. The first art school in Brisbane began in 1881. The first master was Joseph Augustus Clarke (1840-1890). He had studied at South Kensington, and before arriving in Queensland taught topographical drawing to the Indian Army. Art instruction at the Hobart (Tasmania) Technical College began in 1889 and at the Perth (Western Australia) Technical College in 1900.

As did their South Kensington forbears and New Zealand counterparts, these colonial art schools provided courses for artisans, drawing lessons for children, and training for teachers and drawing masters.[5] An Australian professor of fine arts writes:

> South Kensington had indeed trained inspectors and teachers whose influence in this country it would be hard to over-estimate. Children were still being taught in some schools to draw "correctly," according to the laws of perspective, from models as uninteresting as they were simple. . . . The adult was formed under this system to admire unimaginative realism and stereotyped floral decoration, and somehow to associate these with art. (Burke 1958, 2-3)

Returning to New Zealand it would be difficult to find any city or township without an art society or art club, a sketch club, or an art group of some kind. By 1842 Wellington and Auckland had Mechanics' Institutes and Nelson had a literary and scientific institution. Dunedin's institute began in 1851. Among the subjects taught at these institutions were architectural and mechanical drawing, and in 1873 the Auckland Institute held an exhibition of "Fine and Useful Arts." Museums were established in the four main centres between 1865 and 1877. In general, museums in New Zealand are distinct from art galleries, and when the South Kensington system of art education was introduced into New Zealand it was the art societies that were concerned with the "higher aspirations of art" and that arranged exhibitions of "fine" art.

It is incorrect to think of New Zealand as a classless society. In fact, it would be difficult to conceive of a classless society implementing the South Kensington system. Writing in 1877, de Latour points out that social equality prized by the early immigrants had been silently overlaid:

> In the Australasian Colonies, undefinable lines of separation are rapidly springing up between the Colonial patrician and the Colonial plebian, the so-called gentle and the so-called vulgar, these lines dividing in the main money and labor. (155)

As illustrated by the following letter to the editor of the *Lyttleton Times*, it is not an exaggeration to see the South Kensington system as the product of a class-conscious society with the fine arts being reserved for the "gentle," while the utilitarian and practical arts were for members of the working classes, who were

encouraged to better themselves—but not too much![6] Mr. Henry Williams of Glenthorn, Fendalton Bridge, Christchurch, wrote:

> The exhibition of the works of students for the past year of the art school offers an opportunity for pointing out the advantages of this institution to several classes of the community for whom it is especially designed. It is gratifying to find that ladies and others, . . . have illustrated in their successful works the sound and efficient guidance of their studies. The cultivation of taste, and the ability to enjoy the beautiful in nature and art; impart an additional charm to life.
>
> But from a utilitarian aspect the Art School presents almost paramount claims. Who but remembers the Exhibition of 1851, and has carefully noticed the development of English manufactures, has not been impressed with the marvellous influence on the national life, of art and its great foster-mother at South Kensington with the affiliated Schools of Art? China, glass, pottery, watches, dress, furniture, paper hangings, musical instruments, find their centers now in England, instead of the continent, as formerly . . .
>
> In all of these departments of practical art the Art School in our midst is capable of thoroughly preparing students. The Head Master, fully diploma'd from South Kensington, needs no other credentials. He is necessarily not only an artist, but equally as responsible for teaching the theory and practice of drawing as applied to architecture, building construction, and engineering.
>
> No young man who wishes to make his way in the delightful field of practical achievements . . . can afford to miss the advantages here provided for him. (Williams 1882, 5)

Because they were joined by "ladies" and "gentlemen," as well as a few professional artists, the art societies might be perceived as representing the antithesis of the supposed South Kensington concern for the working man. In the major centers art societies were founded in Auckland in 1869, Dunedin in 1876, Christchurch in 1880, and Wellington in 1882. Although landscape painting, portraiture, and similar forms of fine art were encouraged more by the art societies than the art schools, colonial drawing masters served on the boards of these societies.[7] The societies were not necessarily in opposition to South Kensington style exercises: in addition to awards for life and landscape studies, between 1888 and 1911 the Canterbury Society of Arts gave medals for "decorative designs," "architectural designs," and work from still life. In his report for 1884 David Blair mentioned that in the list of working members of the Canterbury Society of Arts, 24 out of 47 members were connected with the School of Art. Some of the art societies made a conscious effort not to be elitist. For example, the South Canterbury Art Society, centered in Timaru, exhibited a catholicity of taste:

> The classes of art works admissible to the Society's Annual Exhibition are: Paintings of all kinds; Drawings generally, including engravings, etchings, architectural and engineering drawings, and decorative designs; Illuminating; Designs for Christmas

and other cards; Designs for the embellishment of any article of utility; Sculpture; Modelling; Wood carving; Photographs. (Collins 1983, 6)

Although not as oriented to "Trade and Manufactures" as the art schools and South Kensington, the art societies, especially before the establishment of public art galleries, saw themselves as having an educational mandate. But it was in New Zealand art schools, teacher training, and elementary schools that the influence of South Kensington was most keenly felt. Reviewing the progress of New Zealand in the nineteenth century, Irvine and Alpers (1902) write:

> The "schools of art" established in the colony are almost exclusively devoted to training students in technical and decorative art: the commercial value of wall-papers and carpet-patterns attracts their energies rather than the higher aspirations of pure art. The colonial temperament is as yet too aggressively commercial to be artistic. (383)

The Art Masters

In 1869 the Otago Provincial Council decided to introduce drawing as part of general education. It is likely that the economic prosperity brought by the discovery of gold in Central Otago was a major factor in this decision. The Province's Home Agent was asked to select a Provincial Art Master for this largely Scots settlement. David Con Hutton (1843-1910) was selected and he became New Zealand's first South Kensington trained art master, having gained his certificate in 1863. Hutton had been Assistant Master at Scotland's Perth School of Art. He brought with him to New Zealand eleven cases of models and casts, and more were ordered in 1873.

Thus, in Otago Province the School of Art in Dunedin began in two large rooms that had been designed as a post office. Classes included a free one for pupil teachers on Saturdays, a fee paying class held three mornings a week for "young ladies," and an afternoon class that was free for pupils of the high school, and which youths not attending a government school could attend by paying a fee. In true South Kensington fashion, it was not long before evening classes for artisans were added, and model drawing, practical geometry, solid geometry, and machine drawing were taught to students in the School of Mines. In his 1893 report to the Otago Education Board, Hutton listed the occupations of the 111 students who attended the evening classes that year as: an architect, a baker, blacksmiths, a builder, brassfinishers, carpenters, cabinetmakers, clerks, clothiers, coachbuilders, coachpainters, a coal merchant, a coffeegrinder, decorators, a draper, dressmakers, engineers, engravers, a frame maker, a grocer, iron mongers, lithographers, moulders, a patternmaker, a photographic artist, painters, a printer, re-touchers, shop assistants, sign writers, a solicitor, a tailoress, teachers, and wireworkers.

Hutton was also responsible for teaching drawing in district schools. He travelled as far afield as Tokomairiro, Oamaru, and Lawrence. Casts and models were purchased and distributed to the schools, and by 1879 6,038 students were receiving instruction from the art master and his two assistants. In 1883 there was a fall in the price of gold and a dramatic drop in wool prices. As a consequence, specialist instruction in the district schools was withdrawn. However, it is likely that Hutton's (188-, 1881) drawing books—the first to be published in New Zealand and written and illustrated in the South Kensington style—continued to provide much needed assistance to those classroom teachers who still taught drawing.

In 1894 the Dunedin School of Art affiliated with South Kensington. A year later nine students had gained Elementary Drawing Certificates by passing in each of freehand drawing, model drawing, drawing in light and shade, geometrical drawing, and perspective. Four students had passed all the examinations for the Art Teacher's Certificate. Among the students who submitted work for the South Kensington certificates were Hutton's children: David E., Caroline, and Nettie. South Kensington affiliation resulted in increased staff and a change of name to the "Otago School of Art and Design."

In 1879 the governors of Canterbury College in the Anglican dominated planned settlement of Christchurch, motivated by the success of the School of Art in Dunedin, considered the question of establishing a similar art school in Christchurch, then a city of less than 15,000 people. The government was convinced, and by March 1881 casts, models, and books had been shipped from London. The Agent-General in London was asked to find a suitable art master who was required to hold a certificate from the Science and Art Department at South Kensington. Forty-one applications were received.

David Blair (1852-1925) was appointed and left for New Zealand in July 1881. Blair was born in Dundee, but he soon moved to Birkenhead near Liverpool, where his father was superintendent marine engineer. At the age of thirteen David Blair was apprenticed to Thomas Brassey's Canada Engineering Works in Birkenhead. He spent three and a half years in the drawing office, eighteen months in the erecting shop, and his final year in the pattern shop. During this period he attended the Birkenhead School of Art where he obtained honors passes in such South Kensington subjects as machine construction and drawing; practical, plane, and solid geometry; and building construction. He won a scholarship enabling him to go on to the central South Kensington School and gain his Art Master's Certificate. He then became second master at the St. Thomas Charterhouse School of Art for eighteen months where he taught geometry, perspective, mechanical drawing, and related subjects. For the next two years he was Assistant Professor of Drawing at the Royal Naval School, teaching landscape, figure, and geometrical drawing. In 1876 he became headmaster of the Islington District

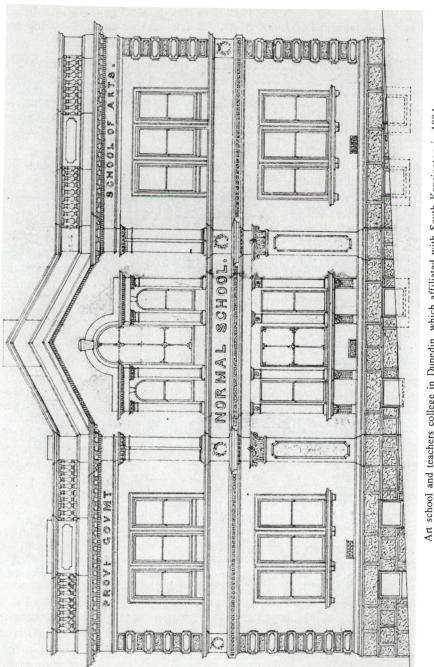

Art school and teachers college in Dunedin, which affiliated with South Kensington in 1894. (Original work in Hocken Library, University of Otago, New Zealand).

School of Art, but resigned in 1879 because "the management was of such a nature as to prevent all possibility of the School making satisfactory progress."[8] In 1880 he was appointed Examiner for Art at South Kensington.

Upon his arrival in Christchurch Blair spent several months setting up the school, which opened on March 1, 1882. His initial prospectus stated:

> The work carried on in the school has for its object the systematic study of practical Art and the knowledge of its scientific principles, with a view to developing the application of Art to the common uses of life, and to the requirements of Trade and Manufactures. (Canterbury College 1882, 5)

The art school was welcomed by a lengthy editorial in *The Press* (2 March 1882, 2) which gave insights into the way that South Kensington was perceived in the farthest colony: as a way of preserving order and discipline, fostering "progress," and with a kind of benevolent paternalism keeping the classes in their place.

In 1885 Blair was arrested for indecent exposure in a public park. Although he was not convicted, the Governors of Canterbury College gave him twelve months' notice. Blair cleverly found all sorts of things to complain about, such as lack of funds and lack of heat.[9] Thus, he resigned before the twelve months had passed. He was replaced by the Assistant Master, George Herbert Elliot (1861-1941), a Yorkshireman who held a South Kensington Art Master's Certificate. Under Elliot there was a slight move toward "fine arts," but it was not a major trend. In his 1889 report he stated; "Now, although the school is better equipped at present for teaching fine art, it must be remembered that fully 75% of our students do not come for this purpose.[10] It was not until 1897 that the school was formally affiliated with South Kensington. By that time the school had introduced classes in memory drawing and sloyd as well as "fine" art.

The North Island did not have the same planned Church-related rival settlements in which education was a priority, and it was not until 1885 that Arthur Dewhurst Riley (1860-1929) was appointed as the Wellington Board of Education's first drawing master. Riley was born in England, and "in 1874 he went to South Kensington where he studied for seven years with great success" and "obtained the highest possible awards" (*Cyclopedia of New Zealand* 1897, 374). In 1881, for health reasons, he went to Australia, becoming an art master at the Sydney Technical College and art examiner to the New South Wales Department of Public Instruction.

Once in Wellington Riley quickly convinced the Education Board to open a School of Design with himself as director. Riley stated that "Our school is not for the purpose of teaching persons to paint pretty things as an amusement . . . but to give knowledge that may be useful and practical in daily life" (Harrison 1961, 24). Although Riley's school included other courses, it had as its main purpose the training of teachers in drawing. The teachers were instructed in Riley's "scheme for primary schools" (Harrison 1961), which began with straight

lines and was similar to those initiated by fellow South Kensingtonians: Hutton in Dunedin, Blair in Christchurch and Vancouver, and Walter Smith in Boston and Eastern Canada. Like these men, Riley did much to promote his "system" and travelled widely to work with teachers in his "territory"—the southern part of the North Island and across Cook Strait to Marlborough.

In 1887 Riley went on a fact-finding mission to the Colonies of Victoria, South Australia, and New South Wales, where students could already sit the South Kensington examinations. In a way that paralleled Britain's earlier concern that it not be surpassed by other European countries in design and manufactures, he proposed, upon his return, that in order for New Zealand not to be left behind Australia:

> schools such as Wellington's and organised technical classes should be started in each main center under the control of a Science and Art Department created for the purpose. He suggested that such a Department be affiliated to the South Kensington Art Training School to get the colony the advantage of a direct English contact (Harrison 1961, 22).

The government was not prepared to implement such an embracive system. However, in 1888 Riley was able to affiliate his own School of Design with South Kensington. In 1894, a South Kensington Art Master's Certificate, entitling the holder to take charge of an art school, was for the first time awarded to someone who had studied wholly in New Zealand: Mary Richardson, a student at Riley's Wellington Technical School.

The Elam School of Art and Design was established in Auckland in 1889. It replaced a small school of design where classes were held in outline drawing two mornings a week. Edward William Payton (1859-1944), the first director of the Elam School, had studied at the Municipal School of Art in Birmingham and had travelled to Australia before arriving in New Zealand in 1883. He painted the devastation of the Tarawera eruption of 1886 and this was turned into a popular chromo-lithograph. He became well-known in Auckland. Platts (1980) suggests that Payton was "adopted" by certain prominent Aucklanders who had wind of Dr. Elam's intention to leave money for the establishment of an art school. In 1888 Payton was persuaded "to return to England to qualify as an art instructor at the South Kensington School of Art, to be ready for the position of Principal of the new School" (Platts 1980, 191). This he did, and he was Director from 1890 until 1924.

By 1892 five New Zealand Schools of Art and Design were headed by South Kensington trained art masters. Spurred on by Wellington's success, the Wanganui Technical School was established as the School of Design in 1892 and affiliated with South Kensington. David Blair, who after leaving Christchurch had given courses for teachers in many parts of the colony, was appointed the first headmaster, although at only half the salary he had earned in Christchurch.

Courses included a typical South Kensington range. The school flourished, particularly after the 1895 Manual and Technical Elementary Instruction Act, which implemented some of Riley's proposals, particularly those that had to do with subsidies.[11] Branch schools were established in Palmerston North and Hawera, and in 1900 David Con Hutton's son David Edward Hutton (1866-1946), now with his own South Kensington Art Master's Certificate, was appointed as Blair's replacement. Blair left New Zealand to perpetuate South Kensington ideas and ideals in British Columbia, Canada (Chalmers 1985).

Normal Schools opened in Christchurch and Dunedin in 1876, in Wellington in 1880, and in Auckland in 1881. Rather than appoint their own art masters they used the local art schools where, as we have seen, the influence of South Kensington was considerable. When the Training Department of the Otago Normal School opened in Dunedin, the Art School was moved to the top floor of the new Normal School. The following formula was applied to a Teacher's College art course from its inception to the mid 1920s:

> Art = Drawing
> Drawing = Illustration
> Illustration = Ability to copy Armor, Swords, Halberds, Galleons,
> Gondolas, Icebergs, Bird's feet, Kiwis
> Technique = Brushstrokes
> Medium = Blackboard
> Aim = D Certificate. (Trussell 1981, 36)

Conclusion

South Kensington views were dominant in New Zealand until the 1890s, when Blair prepared for the Education Department a series of "official" drawing books that had a strong emphasis on industrial and decorative arts and stressed practical and solid geometry and scale drawing. Ewing (1970) shows that teachers were aghast at these requirements, that they felt incapable of teaching the content as outlined by Blair, and that they were beginning to have other ideas about the nature and purpose of art education.[12, 13] The South Kensington system under which the art masters had been trained continued to exert an influence in tertiary education, but in elementary and secondary school it was forced to give way to other ideas. In 1899 the first of a series of special reports on educational subjects was published by the New Zealand Department of Education (Ewing 1973). Numbers 1 and 2 shared the views of the earlier Irish Belmore Commission on Manual and Practical Instruction, which wanted more practical, broad, and less bookish activities in elementary schools. The first report, *Manual and Practical Instruction,* extolled the advantages of various types of handwork. The

New Zealand Manual and Technical Instruction Acts of 1900 and 1902 encouraged handwork, and it resulted in a new elementary curriculum. The third special report, *Handwork for Schools: Modelling,* issued in 1901, enthusiastically promoted plasticene modelling. The introduction actually enjoined teachers to bear in mind that the most important consideration was "not the thing done but the doing" and that children should do more than copy. This was hardly the message of the South Kensington system!

However, the system was not completely replaced. In 1906 the Board of Education of South Kensington sent a comprehensive exhibit "illustrative of work in every branch of art and design" (Cowan 1910, 229) to the New Zealand International Exhibition of Arts and Industries in Christchurch and The New Zealand Schoolmaster continued to applaud the "system" for the first decade of the century. But as New Zealand changed from Colony to Dominion, teachers were also being urged not to "force a child beyond his years," but to provide experiences in open-air, imaginative, and memory drawing. To the outsider, South Kensington may have been seen as "simple, concise, methodical, and absurd" (Littlejohns 1928, 32) but to methodical colonial educators it was far from absurd.

Notes

1. For an outline of the twenty-three stages that made up the "National Course of Instruction," see Ashwin (1975, 46-49).

2. Also see Arnold (1981).

3. Carline (1968) briefly deals with this topic. There are several general histories dealing with the influence of South Kensington on art education in the United Kingdom (Bell 1963, 253-63; Carline 1968, 75-84; and Macdonald 1970, 116-268). However, it is the newer histories of the British regional art schools that are of particular interest (Herbert Art Gallery 1979; Jeremiah 1980; and Althorpe-Guyton and Stevens 1982).

4. On world maps the British Empire was frequently colored red. For the South Kensington system's impact on Canada see Chalmers (1985a and 1985b).

5. A school of art was established in Cape Town in 1864. *The Art Journal* states: "We may remark that the object which, at the outset, the managers of the school seek after, is the promotion of outline and practical drawing rather than highly finished work of pictures" (*The Art Journal* 1865, 363). Writing of the school of art in Calcutta, Caddy states: "The style is unmistakably referable to the South Kensington School of Art" (Caddy 1871, 288). From 1854 the East India Company had adopted a policy of Westernization. Carline (1968) gives a good account of the South Kensington influence in some other Indian schools.

6. For an excellent discussion of "Artisans versus Ladies" and the challenges that this presented to the South Kensington system see Althorpe-Guyton and Stevens (1982).

7. One drawing master, G.H. Elliot, served for eleven years on the Council of the Canterbury Society of Arts. D.C. Hutton was the first president of the Otago Art Society. His son, D.E. Hutton, founded the Wanaguni Art Society. Other drawing masters, such as Blair, Payton, and Riley, were also members of art societies.

8. Blair, David. "Letter of application." Registry, University of Canterbury.

9. See Annual Reports of the Art Master in *Papers Relating to the Canterbury College,* New Zealand Collection, Canterbury Public Library, Christchurch, New Zealand.

10. See n. 9 above.

11. From 1900 the teaching of art in New Zealand elementary and secondary schools was also conditioned by its association with grants for manual and technical instruction. Fry (1985) points out that the curriculum varied slightly for girls—mechanical drawing was not required.

12. The standards for the "D" Art Teacher's Certificate (for generalist elementary teachers) may not have been particularly demanding—see Runciman (1985, 218). The five branches required for a "D" Certificate were: freehand drawing, model drawing, drawing in light and shade, geometrical drawing, and perspective.

13. Osborne (1970) points out that in England, from about 1884, the South Kensington system was under attack by such Ruskin disciples as William Morris, Walter Crane, and Ebenezer Cooke. This debate probably reached New Zealand and together with the Belmore Report influenced the 1905 New Zealand syllabus. For a discussion of Cooke and Ablett's attack on the South Kensington system, which resulted in the 1896 British Alternative Syllabus, see Rogers (1987).

References

Althorpe-Guyton, Marjorie, and John Stevens. 1982. *A Happy Eye: A School of Art in Norwich 1845-1892.* Norwich: Jarrold and Sons.

Arnold, Rollo. 1981. *The Farthest Promised Land: English Villagers, New Zealand Immigrants of the 1870's.* Wellington: Victoria University Press.

Ashwin, Clive, ed. 1975. *Art Education Documents and Policies 1768-1975.* London: Society for Research into Higher Education.

The Art Journal. 1865. 27.

Bell, Quentin. 1963. *The Schools of Design.* London: Routledge and Kegan Paul.

Burke, Joseph. 1958. "Art and the Australian Community." In *Education Through Art in Australia,* edited by B. Smith. Melbourne: Melbourne University Press.

Caddy, Alex. 1871. "A Visit to the Calcutta School of Art." *The Art Journal* 33, 288.

Campbell, A.E. 1941. *Educating New Zealand.* Wellington: Department of Internal Affairs.

Canterbury College. 1882. *School of Art: Courses of Study, Lectures, etc.* Christchurch: Canterbury College.

_____. 1886. *School of Art: Courses of Study, Lectures, etc.* Christchurch: Canterbury College.

Carline, Richard. 1968. *Draw They Must: A History of Teaching and Examining in Art.* London: Edward Arnold.

Chalmers, F. Graeme. 1985a. "South Kensington and the Colonies: David Blair of New Zealand and Canada." *Studies in Art Education* 26 (no. 2): 69-74.

_____. 1985b. "South Kensington and the Colonies II: The Influence of Walter Smith in Canada." In *The History of Art Education: Proceedings from the Penn State Conference,* edited by Brent Wilson and Harlan Hoffa, 108-12. Reston, Va.: National Art Education Association.

Collins, R.D.J. 1983. *Through Fifty Years: The South Canterbury Art Society.* Dunedin: Hocken Library.

Cowan, J. 1910. *Official Record of the New Zealand International Exhibition of Arts and Industries Held at Christchurch 1906-1907.* Wellington: Government Printer.

The Cyclopedia of New Zealand. Vol. 1. 1897. Wellington: The Cyclopedia Co.

de Latour, C.A. 1877. "Technical Education for New Zealand." *The New Zealand Magazine* 2: 155-67.

Ewing, J. 1970. *Development of the New Zealand Primary School Curriculum.* Wellington: New Zealand Council for Educational Research.

_____. 1973. "Special Reports on Educational Subjects: An Early Exercise in Communication." *New Zealand Journal of Educational Studies* 8 (no. 1): 68-77.

Fry, Ruth. 1985. *It's Different for Daughters: A History of the Curriculum for Girls in New Zealand Schools, 1900-1975.* Wellington: New Zealand Council for Educational Research.

Harrison, Noel. 1961. *The School the Riley Built.* Wellington: Wellington Technical College.

Herbert Art Gallery and Museum. 1979. *Cast in the Same Mould: The Origin and History of Coventry School of Art 1834-1895.* Coventry: Herbert Art Gallery and Museum.

Hutton, David C. 198-. *The New Zealand Drawing Book.* Dunedin: Horsburgh.

_____. 1881. *Second Grade Freehand Drawing.* Wellington: Printing Branch of the New Zealand Survey Department.

Irvine, R.F., and O.T.J. Alpers. 1902. *The Progress of New Zealand in the Century*. Toronto and London: Linscott Publishing Co., and W.R. Chambers Ltd., Nineteenth Century Series.

Jeremiah, David. 1980. *A Hundred Years and More*. Manchester: Faculty of Art and Design, Manchester Polytechnic.

Littlejohns, J. 1928. *Art in Schools*. London: University of London Press.

Macdonald, Stuart. 1970. *The History and Philosophy of Art Education*. London: University of London Press.

Minihan, Janet. 1977. *The Nationalization of Culture*. London: Hamish Hamilton.

Minogue, W.J.D. 1965. "Education in a Dependent Culture—New Zealand. Some Problems Relating to the British Influence in New Zealand Education." *Comparative Education* 1 (no. 3): 203-9.

Moore, William. 1934. *The Story of Australian Art*. Sydney: Angus and Robertson.

Osborne, Harold, ed. 1970. *The Oxford Companion to Art*. Oxford: Clarendon Press.

Platts, Una. 1980. *Nineteenth Century New Zealand Artists: A Guide and Handbook*. Christchurch: Avon Fine Prints.

The Press. 1882 (2 Mar): 2.

Rogers, Anthony W. 1987. "W.P. Weston, Educator and Artist: The Development of British Ideas in the Art Curriculum of B.C. Public Schools." Ph.D. diss., University of British Columbia, Vancouver, B.C.

Runciman, James. 1885. "Art in the Board School." *The Magazine of Art* 8: 218-19.

Trussell, Bill, ed. 1981. *Auckland Teachers' College: Reflections on a Hundred Years of Higher Education*. Auckland: Auckland Teachers' College.

Williams, Henry. 1882. "Letter to the Editor." *Lyttleton Times* (30 Dec): 5.

178 Children's Ways.

of a head set on two legs, even when two arms are added and attached to the sides of the head. Indeed a child will sometimes complete the drawing by adding feet and hands before he troubles to bring in the trunk (see Fig. 8).

From this common way of spiking the head on two forked or upright legs there occurs an important deviation. The contour of the head may be left incomplete, and the upper part of the curve be run on into the leg-lines, as in the accompanying example by a Jamaica girl (Fig. 8).

The drawing of the trunk may commence in different ways. Sometimes a lame attempt is made to indicate it by leaving space between the head and the legs, that is, by not attaching the legs to the head. Another contrivance is where the space between the legs is shown to be the trunk by shading or by drawing a vertical row of buttons. In other cases the contour of the head appears to be elongated

Fig. 7 (a).

Fig. 7 (b).

First Pencillings. 179

so as to serve for head and trunk. A better expedient is drawing a line across the two vertical lines and so marking off the trunk (see Fig. 9 (a) to (d)). In

Fig. 9 (a).[1]

Fig. 8.

Fig. 9 (b).

Fig. 9 (c).

Fig. 9 (d).

[1] Fig. 9 (a) is a reproduction of a drawing of a girl of four and a half years, from Mr. Lukens' article.

The notion of "children's art" was popularized at the turn of the century. More theorists began looking at children's drawing in terms of mental development instead of simply as hand-eye coordination. These drawings are from psychologist James Sully's 1897 book, Children's Ways. (London: Longmans, Green. Collection of Brent Wilson).

III. The Turn of the Century

Walter Smith expected students to study and copy Greek moldings, ornaments, and capitals as examples of historic ornament, a precursor to instruction in design. (Smith 1887, *Teachers Manual for Freehand Drawing and Intermediate Drawing*. Collection of M. A. Stankiewicz).

Rules and Invention: From Ornament to Design in Art Education

6　　　　　　　　　　*Mary Ann Stankiewicz*

Design as Walter Smith taught it included the study of historic ornament and conventionalization of natural motifs according to principles such as repetition and symmetry. Although Ruskin had declared that design could not be taught, that ability to invent was an inherent attribute of the artistic genius, the South Kensington system took the opposite point of view. American art educators like Henry Turner Bailey drew on both beliefs. Bailey's ideas on design were also influenced by William Torrey Harris's brand of Hegelian Idealism and by the work of Denman Waldo Ross. Although Arthur Wesley Dow's theory of composition has received a good deal of attention in history of art education, Ross's theory of pure design, while regarded as equivalent to that of Dow by their contemporaries, has received little notice.

Among Henry Turner Bailey's first tasks as third state supervisor of drawing for Massachusetts was a series of lectures given to teachers in Clinton. On 5 January 1888 Bailey addressed historic ornament, its role in art teaching and methods of instruction, with a brief survey of major styles.[1] Bailey explained that some knowledge of the decorative arts of the past was necessary to good teaching of freehand drawing and that some principles of design were best studied from past exemplars. He utilized a recapitulation theory of human development to argue that young children should begin work in design by arranging straight lines, the element most commonly found in primitive ornament. Owen Jones's *Grammar of Ornament* ([1868] 1986) and Ralph Wornum's *Analysis of Style* ([1856] 1877) were Bailey's principal references for this talk, just as they had been during his courses on historic ornament at Massachusetts Normal Art School the preceding year.

Drafts of other lectures given in Clinton reveal both Bailey's dependence on his school notes and contemporary attitudes toward historic ornament and inventive design in art education. At the normal art school, ornament and design were components of the work for each of the four certificates leading to the diploma.

Among Bailey's last hurdles prior to his graduation on 24 June 1887 had been examinations in Design and Historic Ornament on June 15 and 21.

In a lecture on "The Necessity of Drawing as a Required Study," Bailey distinguished human beings from lesser primates because of their creative capacity, the touch of the Divine which led human beings to modify and improve forms as soon as they had been mastered. When children attempted to modify the geometric forms they were taught to draw, they showed the innate ability of invention or design; terms that Bailey, like his teachers, used interchangeably. The school art program sought to build on this native capacity by teaching the principles of good design: symmetry, repetition, alternation, and balance.

These principles were, according to notes Bailey took in his normal art methods class circa 1883-84, to be introduced late in the second grade curriculum. Lines could be drawn and arranged to express each principle as it was taught, or pegs, colored paper shapes, or colored splints could be arranged then glued. As instruction proceeded in later grades, children were taught to modify precut shapes by cutting curved or straight lines in them, then arranging identical units of design around a centre piece within a given space. By fourth and fifth grade, the students were taught to conventionalize (flatten and geometricize) first plant then flower forms. Inventive design was linked to geometrical problems in sixth grade and, Bailey recorded: "Rules of good design, like those of Owen Jones, are to be taught" (Bailey Papers). From sixth grade on, examples of historic ornament were introduced; by eighth grade students might be asked to apply their designs to specific objects: wallpaper, ink stands, and so on.

George H. Bartlett was head of the Normal Art School during Bailey's years there and one of his early mentors. Bartlett lectured on design, historic ornament, and theory of color as well as giving class instruction in freehand work. Bartlett, who succeeded Otto Fuchs as principal of the school, had been a member of Smith's original faculty. Like Smith, Bartlett had emigrated from England where he apparently taught at the London School of Design (Dean 1924). Charles M. Carter was Bailey's instructor for normal art methods. Carter had completed his diploma at the Normal Art School in 1879 and, like his predecessor Walter Smith, he combined his preservice teaching with the duties of state drawing supervisor.

Given these close ties to Smith and British art education, it is not surprising that Bailey's school notes on design have true South Kensington flavor. For example, Bailey noted that because a ceiling is flat the ornament on it should also be flat to express the true quality of the ceiling. While none of Owen Jones's thirty-seven propositions on design specifically mentions the doctrine of flatness, it has been used both to characterize and to parody South Kensington doctrines of design (Macdonald 1970, 229-30). One can, however, locate Jonesian doctrines in Walter Smith's *Art Education Scholastic and Industrial* (1872). Like Jones, Smith recommended ornaments that stylized natural forms rather than those that

imitated nature. Smith also carried the influence of Ralph Wornum to the United States. Wornum began his *Analysis of Ornament* ([1856] 1887) with a distinction between symbolic and aesthetic styles of ornament, the latter developed from principles of symmetry and harmony with no intention toward representation. Smith repeated this distinction in his tome on art education, using it to classify styles of architecture and art into symbolic art, which arose out of a strongly religious culture, and aesthetic art, exemplified by Greek, Roman, and Renaissance styles. While Smith wrote that the power to design may seem incommunicable, he agreed with his British predecessors that the would-be designer needed to learn natural laws of beauty and analyze standard examples of good design (1872, 188).

In his early years of teaching, Bailey clearly agreed with Smith and the South Kensington doctrine of design. During 1888, Bailey worked on an outline for what he called a logical course in historic ornament and design. Versions of this course were presented at the 1888 convention of the National Education Association, included in his first annual report to the State Board of Education in January 1889, and read before the Industrial Art Teachers' Association in Boston during that same month. Bailey argued that practical applied design belonged in public school art instruction while theoretical design did not. He wrote:

> The aim in all this work in Design should be to refine and educate the pupil's taste and to teach correct principles and their applications; not simply to obtain "Original Designs." (Bailey Papers)

While the doctrines laid down by Jones and Wornum dominated art education according to the South Kensington/Walter Smith model, another approach to design and ornament wielded an almost equal influence.[2] John Ruskin strongly opposed the conventionalization of nature in both fine and applied art, arguing that Nature herself, as God's creation, was the only standard and source of beauty. Although Ruskin (1866) did list nine laws of composition, appreciation of formal relationships had a low priority in his aesthetic theory. More important was the sign of the artist or creator, the imperfections of the human hand and the personality of the artist expressed in the work. Gombrich (1984) refers to this belief that the character of the maker could be perceived in the forms of the art object as "graphology." He links it to the development of Expressionism and the attitude found among some art educators and craftsworkers that spontaneity, self-expression, and a certain looseness were to be valued. According to Ruskin:

> The essence of composition lies precisely in the fact of its being unteachable, in its being the operation of an individual mind of range and power exalted above others. (1866, 169)

Unlike the utilitarians of South Kensington, Ruskin believed that no one could invent by rules. Their only function was to aid in the analysis of one's own work and, more importantly, the work of better artists.

As we have seen, Bailey was a product of the extended South Kensington system; however, like many other art educators at the turn of the century, he was also influenced by the writings of Ruskin (Stankiewicz 1984). He even dared draft a letter to the master asking for the best edition of his books for a new home and acknowledging his debt to Ruskin's writings. After he met William Torrey Harris in 1888, Bailey turned more and more to proponents of Romantic Idealism as sources for his personal philosophy of art education. Through Harris, Bailey was exposed to a somewhat distorted Hegelian conception of design (Stankiewicz 1987). Hegel had asserted that regularity and symmetry, conformity to law, and harmony were the three characteristics of abstract form, found in both fine art and nature. Harris deleted conformity to law, separated regularity from symmetry, and located them in psychological recognition of similar processes in spirit and matter. Thus, from Harris, Bailey learned that regularity, symmetry, and harmony were the three sensuous elements in art. Bailey therefore had at least two points of view to draw on as his interest in design developed: the rule-governed, South Kensington model for design of ornament and a Romantic Idealist model which accepted some principles of design but emphasized innate personal qualities of the artist as primary in creating good design. Both views appear in writings on design by other art educators of the day.

In his 1885 government report on education in the fine and industrial arts in the United States, Isaac Edwards Clarke called for research to discover underlying laws of the arts. He declared that until such laws were known and understood by the community, no standard of correct taste could be established. On the other hand, once such principles were acknowledged, it would be possible "to lay broad and deep the foundations of artistic development" (Clarke 1885, CCXLII). In the 1890s, editions of the Prang art education texts, written by John Spencer Clark, Mary Dana Hicks, and Walter Scott Perry, divided art education into three branches: Construction, which taught the facts of geometrical form and how to make working drawings; Representation, which focused on the appearance of form in real things and how to make pictures; and Decoration, which taught ornamentation of forms, original designs from nature, and, at the upper grades, some historic ornament. Through their texts, Clark, Hicks, and Perry claimed to cultivate the creative imagination, that faculty "directed by the heart, mind, and soul" (1898, 1). Between 1898 and 1902 when it issued its final report, the National Education Association Committee of Ten deliberated on the proper basis for elementary art education. Headed by Langdon S. Thompson, the Committee included Henry Turner Bailey, Charles M. Carter, John Spencer Clark, and other well known art educators. In the final report, design, under the label "aesthetic appearance," was more prominent than pictorial representation (Thompson 1902). Color, light-and-dark, and composition were the sources of aesthetic beauty. Ornamental designs could be composed by analytical or synthetic methods. Both historic ornament and decorative design were included in the curriculum under

the heading "Aesthetic Study and Drawing," as was picture study. In these examples, we can see continuity with earlier traditions of historic ornament and design as well as a hint of what was to come in design teaching.

In 1899, while the NEA Committee of Ten was in the early stages of its work, the first edition of Arthur Wesley Dow's *Composition* was published. Dow has long been recognized as a key figure in the history of American art education (Johnson 1934; Mock-Morgan 1976; Moffatt 1977). Graduates of his program at Teachers College, Columbia University, spread his ideas across the United States as they replaced graduates of Massachusetts Normal Art School in leadership roles within art education. As I have tried to show above, Dow's ideas on design did not enter a vacuum within the field. Rather, they developed within a receptive context of shared interests and traditional elements and principles. In England Walter Crane and Lewis F. Day, among others, wrote books on design which were used in teaching. In the United States, Denman Waldo Ross and Jay Hambidge both developed theories of design with educational applications. Hambidge did much of his work after the turn of the century; his publications followed the First World War.[3] In the remainder of this paper, I would like to focus on Denman W. Ross's theory of pure design, making some comparisons between his work and that of Dow.

Both Dow and Ross were recognized by their contemporaries as important theoreticians in design education. A 1908 survey of American art education noted that:

> A little over a dozen years ago Arthur W. Dow, in his book on "Composition," presented a treatment of design in an orderly way. The issue of this manual put into the hands of teachers some clue to a method of approach in the composition of pictures, patterns, and the printed page. A second and decided impulse was given the study of design through the work of Denman W. Ross of Harvard College, who developed a theory of design from the scientific point of view. Unfortunately, many teachers of drawing extracted from these systems the means of study and made them ends. (Boone, 192)

Dow spread his ideas through the many editions of his book and through his teaching at Pratt Institute, his Ipswich Summer School, and, from 1904 until his death in 1922, at Teachers College. Ross taught art educators, artists, and craftsworkers through his summer school courses at Harvard from 1899 through 1914; during the academic year, his courses reached future architects, art historians, and museum directors. Bailey studied with Ross at various times between August 1899 and December 1901; he took the Harvard course in the summer of 1901. Other art educators who studied with Ross included Alfred Vance Churchill of Columbia in 1900, James Parton Haney in 1903, and John Spencer Clark in 1904 and 1905 (Harvard University Archives, Catalogs). Some art educators, designers, and craftsworkers studied with both Ross and Dow. On August 14, 1901,

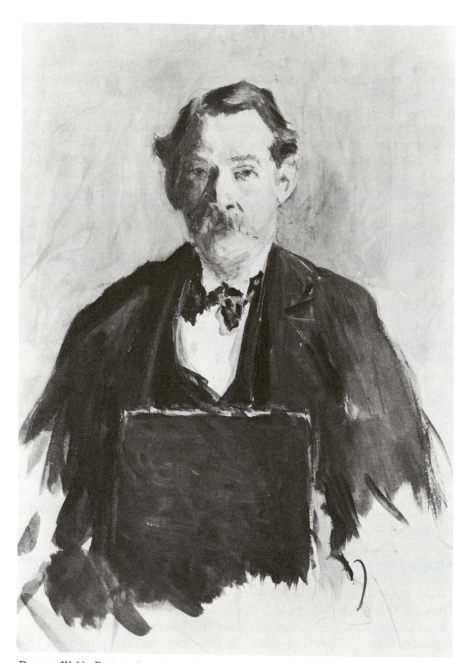

Denman Waldo Ross made order and harmony the highest goals in his theory of pure design as well as in his paintings. This watercolor self-portrait of Ross from Harvard's Fogg Art Museum is undated. (Harvard University Art Museums).

Dow with his wife and five or six other people visited Ross's class at Harvard (Bailey Papers).

The question of cross influences between Dow and Ross is a tantalizing one which may never receive a definitive answer. Moffatt (1977) cites Charles Darwin and Hippolyte Taine as possible influences on Dow, but sees Dow's friendship with Ernest Fenollosa and their joint studies in Japanese art as crucial in the development of Dow's theory of the elements and principles of design. Ross was a major collector of Oriental art who made several trips to Asia. His theory was influenced by his early experiences as a student in Charles Elliot Norton's first class at Harvard and by his reading of Ruskin. Other influences seem to have included Owen Jones, Ralph Wornum, and Gottfried Semper, a German architect who was also a part of the South Kensington circle (Stankiewicz 1988). Ross's diaries reveal that he was developing rules for art as early as 1886.[4] While Dow was open about his debt to Fenollosa and gracious in expressing his gratitude, Ross rarely cited authorities other than Plato and Aristotle. Ross did graduate from Harvard College one year after Fenollosa; the two may have known each other.

Ross and Dow were friends until Ross published his 1907 book on design. Dow visited Ross in Venice in 1896; the two sometimes painted together on the South Shore in Massachusetts. Johnson reports that Dow's heart bled when he read Ross's book and saw portions which utilized his and Fenollosa's ideas without acknowledgement (1934, 98). While one may find some similarities between the two theories, major differences in their work are more apparent.

Ross sought to develop a scientific theory; his first publication of his ideas on pure design, as he called it, was in the 1901 Proceedings of the *American Academy of Arts and Sciences*. His *Theory of Pure Design* (1933), first published in 1907, defines terms and links them by means of explanatory principles, matching common definitions of theories in philosophy of science. Ross himself described his work as a contribution to science more than to art and distinguished the artist's personality, which he equated with inspiration, from rules and principles that anyone could master. Unlike Ruskin, Ross focused his attention on the principles of design, admitting that genius could not be explained, but arguing that mastery of certain rules and study of past exemplars were necessary to the creation of fine art. In his diary, Ross wrote: "There are new things to paint but no new ways of painting" (Ross Papers). For Ross, little or no originality should be expected in formal structures or coloring. What novelty he allowed was limited to the subject matter or idea expressed.

Dow, on the other hand, shared with Fenollosa the conviction that the artist's personality was crucial. As Fenollosa wrote, art education should "draw out the aesthetic faculty in the soul" and respect "the freedom, and individuality, and inevitable mystery of the creative act" (1896, 761). Dow (1917) declared that the

Lines could also constitute design terms. In his book *Theory of Pure Design* (1907), Ross used seven lines in various arrangements to illustrate principles such as movement and rhythm. (Collection of M. A. Stankiewicz).

production of art depended upon the exercise of internal powers, not gathering facts nor developing knowledge or skill. As Moffatt put it, Dow and Ross:

> had little in common except terminology. Ross wanted to extricate composition from the impurities of intuition and religious emotion, "the accidents of vision" so crucial to the Dow-Fenollosa formulations. (1977, 91)

Even in terminology, there are immediate differences between Ross's theory of pure design and Dow's theory of composition. Dow is remembered for his emphasis on the elements of line, notan (dark-and-light), and color. Exercises using these elements preceded exercises with five principles of composition: opposition, transition, subordination, repetition, and symmetry. Proportion or good spacing was an overarching general principle. Ross, however, began with three principles: balance, rhythm, and harmony. He suggested using dots or spots to illustrate each principle. Each spot of paint had three qualities, each of which could affect the final design: tone (value or hue), measure (area), and shape. A major part of Ross's contribution to design theory was his work with color expressed in the form of set-palettes often based on works by particular masters. For Dow, color was baffling (1922, 100). Ross emphasized studying the past and applying principles derived from such study to present art, while Dow emphasized originality and personal choice. Although Dow had declared his independence from Ruskin's aesthetic when he first visited Greece in 1904 (Johnson 1934, 83), his theory was more closely related to Ruskin's "graphology" than Ross's. While Dow did show students examples of fine designs from the past, he encouraged originality in arrangement of the three elements more than reverence for past art.

As Boone acknowledged, both Dow's and Ross's theories were influential in their own day and after. A 1929 report on terminology sponsored by The Federated Council on Art Education showed that among the elements of art, "dark-light," a term closely associated with Dow's theory, was used 528 times in the 36 art books studied; "notan" was used 157 times. In the list of principles of art, "harmony," "balance," and "rhythm" topped the list with 1608, 1532, and 1122 uses respectively in the same 36 books. Clearly, these terms were not exclusive to Ross. Nonetheless, the conjunction of these three terms at the top of the list is evidence for Ross's influence, evidence confirmed by quotations from Ross within the report (Whitford, Taft, and Ensign 1929, 42-3).

As we have seen, many art educators studied with Ross during his summer school courses. Bailey strongly recommended these courses to readers of *School Arts*. Sample curriculum outlines published by *School Arts* in September 1902 and 1905 listed exercises in balance, rhythm, and harmony. From 1915 until his death in 1935, Ross served on the Drawing Advisory Committee to the Boston Public Schools. Local curriculum outlines generated during those years show clear evidence of Ross's influence on at least one public school system. Handwrit-

ten notes among Ross's papers closely match sections of the Boston curricula and committee reports. One former student of Ross's, Ernest Batchelder, utilized some of Ross's theories in his own design book (1910) and in work with the Arts and Crafts movement in California. Although traces of Ross's ideas can be found in design texts even today (Reid 1972), Ross has been virtually ignored by history of art education.

Several reasons can be suggested for this omission. Dow's was a teaching theory transmitted through books directed toward art and classroom teachers. Dow was highly praised as a teacher. His personal warmth and concern for his students' individual growth gave him a kind of charisma within the field. Ross, on the other hand, was not easy to work with. Teaching was never his full time occupation; he generally spent one academic term each year abroad studying art, collecting, and painting. He employed assistants to translate his theories to the students and continued revising his theory as long as he taught, so that what was correct one week might be wrong the next. His habit of classical references distanced him from students who did not share his Ivy League background. One former student wrote of Ross:

> His insistence on the supreme excellence of his method was a serious weakness in his teaching, for he did not encourage his disciples to think for themselves and showed no interest in their investigations and discoveries. (Hopkinson 1937, 544-45)

In many respects, Ross was opposite Dow, whose emphasis on personal choice and recognition of individuality better fit the increasingly psychological direction of art education. However, it is important to remember that Ross also encouraged self-expression for little children and Dow recommended teaching design principles at the upper grades.

As these two theories spread throughout art education, distinctions between them blurred. With increasing emphasis on art education as a means to release innate qualities in the young child, Ross's terms were even used in a discussion of design principles as inherent qualities in the paintings of Kindergartners (Cockrell 1930). This attitude allowed art specialists and classroom teachers to teach design without attention to the history of painting or ornament, both of which, as Bailey had noted in his talks to the Clinton teachers over a quarter of a century earlier, required a good deal of preparation time and information difficult to obtain.

In this paper, I have tried to show that design had been a consistent element in late nineteenth century art education according to the South Kensington model, although always secondary to linear drawing. At least two approaches to design study can be found in nineteenth century art education: the rule-based approach of South Kensington, and the Romantic Idealist approach, typified by Ruskin, which placed artistic personality above rules. By the end of the century, both approaches mingled as boundaries between fine and applied arts broke down.

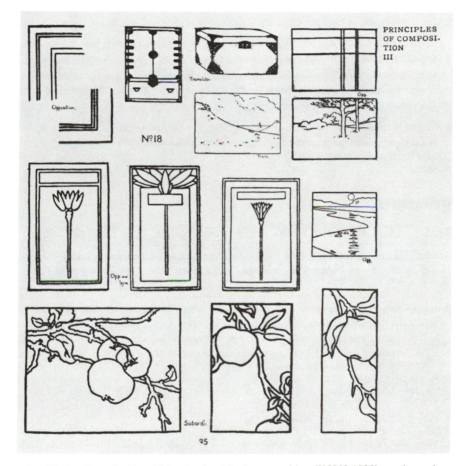

Arthur Wesley Dow, in his widely circulated book composition ([1899] 1922), taught students to begin with design elements, such as line. Principles such as opposition, transition, symmetry, and subordination were applied to recognizable subject matter. (Collection of M. A. Stankiewicz).

Notes

1. Henry Turner Bailey Papers. University of Oregon Library. Special Collections. Research on the Bailey Papers was funded by a Travel to Collections grant from the National Endowment for the Humanities.

2. For comparison of both doctrines and discussions of their influence, see Doreen Bolger Burke et al. (1986) and Wendy Kaplan (1987).

3. Harold J. McWhinnie has been researching Hambidge for several years. For example, see: "Some Influences of the Ideas of Jay Hambidge on Art and Design with Implications for Research," paper prepared for 9th Colloquium for Empirical Aesthetics at the University of Santa Cruz, August 1985.

4. Harvard University Art Museums, Fogg Museum of Art Archives, Denman Waldo Ross Papers. Research on the Ross Papers was funded by a University of Maine Faculty Summer Research grant.

References

Batchelder, Ernest A. 1910. *Design in Theory and Practice*. New York: Macmillan.

Boone, Cheshire Lowton. 1908. "Art Education in the Elementary Schools." In *Art Education in the Public Schools of the United States,* edited by James Parton Haney, 165-200.

Burke, Doreen Bolger, Jonathon Freedman, Alice Cooney Frelinghuysen, David A. Hanks, Marilynn Johnson, James D. Kornwolf, Catherine Lynn, Roger B. Stein, Jennifer Toher, and Catherine Hoover Voorsanger, with the assistance of Carrie Rebora. 1986. *In Pursuit of Beauty: Americans and the Aesthetic Movement.* New York: The Metropolitan Museum of Art and Rizzoli.

Clark, John Spencer, Mary Dana Hicks, and Walter Scott Perry. 1898. *Teacher's Manual, Part 1, for the Prang Elementary Course in Art Instruction, Books 1 and 2, Third Year.* Boston: Prang Educational Co.

Clarke, Isaac Edwards. 1885. *Art and Industry*. Part I. *Drawing in Public Schools.* U.S. Senate report. 46th Cong., 2nd sess., Vol. 7. Washington, D.C.: Government Printing Office.

Dean, May Smith. 1924. *A Brief History of the Massachusetts Normal Art School, 1973/ 4 to 1923/4.* Boston: Massachusetts Normal Art School.

Dow, Arthur Wesley. 1899. *Composition,* 2nd. ed. New York: The Baker and Taylor Co.

_____. 1922. *Composition,* 9th ed. Garden City: Doubleday, Doran and Co., Inc.

_____. 1917. "Art Teaching in the Nation's Service." *Proceedings of the National Education Association,* Portland, Oregon: 91-96.

Fenollosa, Ernest F. 1986. "The Nature of Fine Art." *The Lotos* 9 (no. 10): 753-62.

Gombrich, E.H. 1984. *The Sense of Order*. Ithaca, N.Y.: Cornell University Press.

Hopkinson, Charles. 1937. "Denman Waldo Ross (1853-1935)." *Proceedings of the American Academy of Arts and Sciences* 71 (no. 10): 543-46.

Johnson, Arthur Warren. 1934. Arthur Wesley Dow: *Historian, Artist, Teacher*. Ipswich, Mass.: Ipswich Historical Society.

Jones, Owen. [1868] 1986. *The Grammar of Ornament*. London: Studio Editions.

Kaplan, Wendy. 1987. "The Art that is Life": *The Arts & Crafts Movement in America, 1875-1920*. Boston: Museum of Fine Arts.

Macdonald, Stuart. 1970. *The History and Philosophy of Art Education*. New York: American Elsevier.

Mock-Morgan, Mavera E. 1976. "A Historical Study of the Theories and Methodology of Arthur Wesley Dow and their Contribution to Teacher Training in Art Education." Ph.D. diss., University of Maryland.

Moffatt, Frederick C. 1977. *Arthur Wesley Dow (1857-1922)*. Washington: Published for the National Collection of Fine Arts by the Smithsonian Institution Press.

Reid, William, Jr. 1972. *Introduction to Design*. Portland, Me.: J. Weston Walch.

Ross, Denman W. 1901. "Design as a Science." *Proceedings of the American Academy of Arts and Sciences* 36 (no. 21): 357-72.

_____. [1907] 1933. *A Theory of Pure Design*. New York: Peter Smith.

Ruskin, John. 1866. *The Elements of Drawing; In Three Letters to Beginners*. New York: John Wiley and Son.

Smith, Walter. 1872. *Art Education, Scholastic and Industrial*. Boston: J.R. Osgood and Co.

Stankiewicz, Mary Ann. 1984. "'The Eye Is a Nobler Organ': Ruskin and American Art Education." *Journal of Aesthetic Education* 18 (no. 2): 51-64.

_____. 1987. "Beauty in Design and Pictures: Idealism and Aesthetic Education." *Journal of Aesthetic Education*.

_____. 1988. "Form, Truth, and Emotion: Transatlantic Influences on Formalist Aesthetics." *Journal of Art and Design Education* 7 (no. 1):81-95.

Thompson, Langdon S. 1902. "Report of the Committee of Ten on Elementary Art Education." *Proceedings of the National Educational Association, Minneapolis, Minnesota:* 594-614.

Whitford, William G., Lorado Taft, and Raymond P. Ensign. 1929. *Report of the Committee on Terminology*. Boston: The Berkeley Press, The Federated Council on Art Education.

Wornum, Ralph N. [1956] 1877. *Analysis of Ornament*, 5th ed. London: Chapman and Hall.

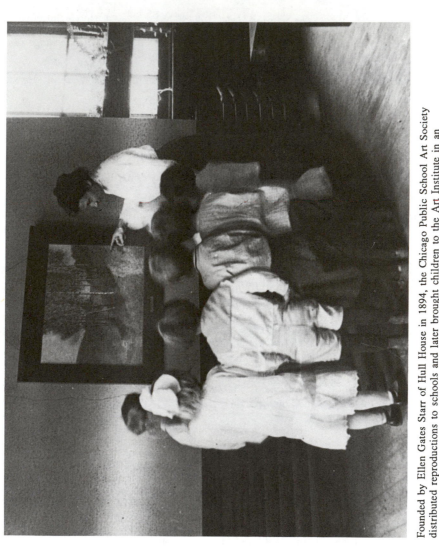

Founded by Ellen Gates Starr of Hull House in 1894, the Chicago Public School Art Society distributed reproductions to schools and later brought children to the Art Institute in an attempt to share the light of culture with the children of the poor. (Chicago Public School Art Society, University of Illinois at Chicago, The University Library, Department of Special Collections).

Culture for the Masses: Art Education and Progressive Reforms, 1880-1917

7

Patricia M. Amburgy

I

With the rapid expansion of industry that followed the end of the Civil War, American manufacturers increasingly called for a form of schooling that was more "practical" in nature than the bookish, "literary" education then typical of the common schools. Industrial drawing was an initial step toward practical education, but the addition of drawing to school curricula did not mark a change in the overall character or general purpose of common schools. A change in general purpose began to occur during the 1880s and 90s with the introduction of manual training. From the perspective of the businessmen who supported it, manual training was a form of vocational training intended to prepare workers for mills and factories. From the perspective of the educators who supported it, however, manual training had to be justified on something other than vocational grounds. Vocational training was inconsistent with the democratic ideals of the common school that was supposed to provide an equal education for all citizens regardless of their birth or future vocation in life. In much the same way that earlier educators had defended drawing as a means of improving penmanship, educators who supported manual training claimed it was a way of developing hand and eye coordination. Manual training was not "trade training," or preparation for specific kinds of work, they argued. It was part of a general education that would be beneficial to all students.

Although educators were initially resistant to the idea of vocational instruction, many of them eventually came to see not only manual training, but all public schooling as preparation for work. The purpose of literary or intellectual education was redefined in their arguments as preparation for professional occupations, and thus as a form of schooling that neglected the majority of students who would not go on to become doctors, lawyers, or teachers in later life. They argued that public schools should serve the masses as well as the elite in society,

but what they now meant by this was that the working classes should also receive vocational training. By the opening decades of the twentieth century, the central issue in American schooling had shifted from equal education of citizens to "equality of educational opportunity."

A change in educators' understanding of the purpose of schooling was what Hogan (1985) calls the "conceptual revolution" of the 1880s and 90s. During this time the idea of vocational training came to be accepted in principle by many educators; and in the decades that followed, they went on to establish the system of differentiated curricula, currently referred to as "tracking," that would make different kinds of education for different social classes an institutional reality in public schools. After the turn of the twentieth century, a broad coalition of businessmen, educators, politicians, and eventually labor unions came to support federal legislation for vocational education. With the passage of the Smith-Hughes Act in 1917, the status of vocationalism in American schooling was officially sealed.

As Cremin (1961) notes, the Smith-Hughes Act was more a confirmation of changes that progressive reformers had already set in motion than the initiation of a new direction in public schools. However, it was precisely the confirming nature of the legislation that suggests a period of time in which to place the emergence of vocationalism, and in which to examine changes in art education as part of broader developments in school and society. Just as the purpose of schooling in general was radically altered between 1880 and 1917, there were fundamental changes in the purpose of art education. The significance of the period has traditionally been recognized in histories of art education (for example, Logan 1955; Eisner 1972; Wygant 1983). At one end, the period was marked by an emphasis on industrial drawing; at the other, creativity and self-expression emerged as central concerns. At one end there were social and economic justifications for schooling in art; at the other there were psychological justifications. The period began with a form of art education that served the class interests of American manufacturers; it concluded with a form of art education that served the interests of—whom?

The central thesis of this chapter is that conceptions of art education around the turn of the century were a complex response to the new vocationalism in schooling and the changing nature of modern work. To some extent, changes in art education were a reaction against vocationalism and the increasingly fragmented, alienating conditions of industrial labor. Progressive educators set out to improve the lot of working-class children through schoolroom decoration and the study of masterpieces in art. Similarly, the gradual separation of fine art from industrial art in school curricula, the early interest in child study, and an increasing focus on art as a form of personal expression were motivated, in part, by intentions to add beauty and culture to the lives of the masses. But just as there

were many sides to progressive reforms in schooling in general, progressivism in art education was characterized by a tacit acceptance of social class divisions as well as by conceptions of social change. Although schooling in art did not become an overt means of fitting working-class children to industrial labor, as tracking was, it became a means of withholding certain kinds of knowledge that might make them dislike industrial work. Culture for the masses was conceived within certain boundaries; and like the social conditions they reflected, these boundaries changed over time.

II

Perhaps more than any other figure, Jane Addams (1860-1935) exemplified the social ideals of the progressive movement. In 1889 she and Ellen Gates Starr (1859-1940) founded Hull-House, the first social settlement in Chicago. When they moved into an old mansion in the middle of a predominately working-class, immigrant neighbourhood, they had few definite ideas about what a social settlement should do, except that it should be a way of sharing the cultural and educational advantages of the privileged with the less fortunate in society. The emphasis was to be on sharing, not charity. A social settlement, Addams would later write, "represented not so much a sense of duty of the privileged toward the unprivileged . . . as a desire to equalize through social effort those results which superior opportunity may have given the possessor" (1899, 323-24).

An important part of what they wanted to equalize were the benefits of art. They decorated the walls of the Hull-House with reproductions of paintings they had brought back from Europe, and under the direction of Starr, the settlement began a number of educational programs in art. Reproductions of masterpieces were hung low in the kindergarten nursery so that children could easily see them and talk to the Renaissance babies on the wall. For adults there were lectures on the history of art and a circulating loan collection of pictures that borrowers could take home with them for two weeks at a time. Significantly, the first building added to Hull-House was the Butler Art Gallery in 1891. The gallery held exhibits of original oil paintings, watercolors, prints, and engravings, at which neighbours cast votes for their favorite works of art. The early exhibits also included a collection of reproductions that would be appropriate for public schools. In addition to the programs within Hull-House, Starr founded the organization that became the Chicago Public School Art Society (Addams 1895, 1910).

In these and other ways, the first residents of Hull-House set out to make art a "vital influence" in the lives of their working-class neighbors (Addams 1895). Like others who promoted schoolroom decoration and picture study around the turn of the century, they believed the value of art lay in its moral influence on

people's lives. In conceiving the value of art as moral, they followed the ideas of John Ruskin and William Morris (Starr [1895] 1970; Addams 1902) as did others at the time (Stankiewicz 1984). Like Ruskin and Morris, they believed the moral nature of art was related to all aspects of life, including the character of work in contemporary society. However, Addams—and at this point it becomes important to separate Addams from Starr—understood the relationship between art, morality, and work in a way that was different from Ruskin and Morris on one crucial point. She saw art as a way of helping workers tolerate the conditions of industrial labor, rather than a means of changing the nature of the work itself.

In several respects, Addams saw the same kinds of problems with industrial labor that Ruskin and Morris had identified. Where she differed was her solution to the problems. Like Ruskin and Morris, she saw a problem in the division of tasks that modern workers performed. Instead of making, say, a watch or a coat as watchmakers and tailors had done in the past, modern workers made only one wheel of a watch or the collar of a coat. She also saw a problem in the division between workers. In a modern factory they were alienated from one another, sharing no interests or common goals. Their only connection was the mechanical process of production. Like Ruskin and Morris, Addams saw industrial labor as a division within the workers themselves, between their minds and their hands. Factory work did not require thinking or judgment, only physical labor (Addams 1902, 178-220). In one of her most astute observations, Addams noted that contemporary educators were always saying the child learns by "doing" and education proceeds "through the eyes and hand to the brain," but they seemed to have overlooked the fact that working people use their hands and eyes all the time, and do not need to have these activities artificially provided in school. The problem was not only hands to brain, but also how to reverse the process (1902, 208).

Part of Addams's solution for reversing the process was to give workers an understanding of the historical significance of their work. She argued that even more than others, the worker needed to understand the evolution and growth of modern industry in order to "reveal to him[1] the purpose and utility of his work, and . . . his proper relation to society" (1902, 206). The value of art was similar to the role of history in making factory work more meaningful. Like history, Addams argued that art could provide an "idealization" of industrial labor by depicting it in ways that would reveal its moral nature and importance in modern society. She argued that the worker, even more than others, needed someone to "bathe his surroundings with a human significance—someone who shall teach him to find that which will give a potency to his life" (1902, 219). The purpose of art was "to feed the mind of the worker, to lift it above the monotony of his task, and to connect it with the larger world, outside of his immediate surroundings" (1910, 435).

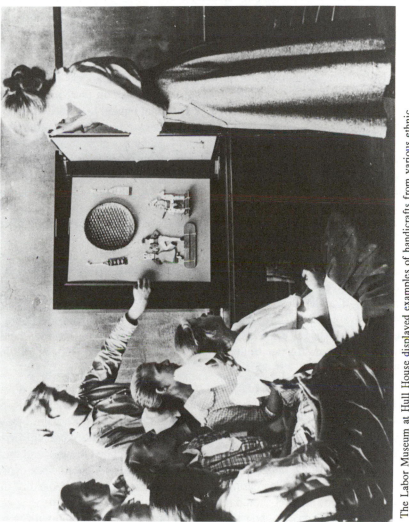

The Labor Museum at Hull House displayed examples of handicrafts from various ethnic traditions as part of Jane Addams's attempt to help industrial workers understand the proper role of work in history and culture and to make work picturesque. (Chicago Public School Art Society, University of Illinois at Chicago, The University Library, Department of Special Collections)

As Violas (1973) points out, Addams's solution to the problems with industrial labor was essentially a matter of changing the worker, not the work. Her conception of culture for the masses extended only as far as the way industrial labor was perceived by the working classes, but not to changing the actual conditions of their work. Addams was not unusual in limiting her conception of art to an "idealization" of industrial labor that would make it appear meaningful to workers. If anything, her arguments about the value of art were more sophisticated than most around the turn of the century that tended to reduce the decoration of schoolrooms to a matter of taste and the study of pictures to learning moral homilies. But despite the limitations of Addams's and others' views, their conceptions of art and morality were based on a general paradigm of the nature of art that was potentially dangerous to the privileged classes. Like others, Addams tended to view the moral nature of art as having to do with what was right and good in present society, even when actual conditions may not, in fact, have been all that right or all that good. However, this sense of "moral" as putting a gloss on things—"idealizing" them in Addams's words—was only one side of the moral nature of life and its reflection in works of art. As Ruskin and Morris argued, and as Ellen Gates Starr understood better than her contemporaries, works of art could reveal what was wrong about a society as well as what was right about it. As Starr put the matter, the moral influence of art was partly to make us "love the lovable"; but part of the value of art also lay in making us "hate for the first time as it deserves to be hated, and dread as we ought to dread it when we see it painted, the destruction of the lovable and the beautiful by the impious hand of man" ([1895] 1970, 174-75).

The idea that art was "moral" in this broader sense—that it had to do with what was right *or* wrong, good *or* bad, just *or* unjust about industrial labor—was what made it potentially dangerous as a general paradigm, or a whole way of looking at the nature of art. Even in its highly diluted versions, exemplified by the views of Addams and others, the idea that art was related to work and morality became increasingly dangerous in American society as modern work evolved into forms that could bear increasingly less moral scrutiny. In the context of these changing forms of labor, it should not surprise us that progressive theories of art education came to separate the nature of art from both work and morality.

III

The kind of idealization that characterized conceptions of art appreciation was also apparent in conceptions of art production around the turn of the century. During the 1880s, one of the common themes in educators' arguments for industrial drawing and manual training was the idea that such instruction would increase the dignity of work. Part of the problem with a literary education was that

it made students scorn manual labor, educators argued, thus perpetuating the false distinctions in society between people who think and people who work with their hands. A more practical kind of education would not only develop skills of observation and hand and eye coordination; it would also elevate the status of manual labor in the eyes of students and strengthen their moral character through the judgment, self-direction, and persistence that were entailed in developing manual skills.

Clearly, such arguments were an idealization of industrial labor in the sense of making things appear better than they actually were. But to some extent, it was also true that in the 1880s most manual work still required a certain degree of skill and knowledge, and a certain amount of judgment and self-direction on the part of workers. In the early stages of industrialization the nature of work in most trades was still closer to that of the watchmaker or the tailor in Addams's examples, than to making a wheel of a watch or the collar of a coat. Although the older type of worker was being rapidly displaced in modern industry by new technology and the division of labor, most people who worked with their hands were still artisans to some degree.

Industrial drawing, manual training, and the later arts and crafts movement in art education were all based on a conception of the worker as artisan. Like schoolroom decoration and the study of pictures, educators' theories of art production were significantly influenced by the ideas of Ruskin and Morris. In Ruskin's often-quoted dictum that "industry without art is brutality" ([1870] 1905, 93), what he meant by "art" was the exercise of skills and knowledge in manual work. Especially important in the context of the political relationship between workers and employers, he meant that manual workers should have a substantial degree of control over their own labor.

Although the political implications of Ruskin's and Morris's arguments were usually diluted in the theories of American educators, here, too, the general idea that art, morality, and work were related was potentially dangerous to the privileged classes. The whole idea that work could be—and worse yet, *should* be—a matter of exercising skills and knowledge became increasingly dangerous as industrial labor became increasingly more fragmented and controlled through bureaucratic means. With the refinement of new technology and assembly-line methods of production, the kind of "skills" that workers needed were an ability to follow orders and to perform simple, repetitive tasks. Such skills not only had little to do with a literary education; they also had little to do with a practical education in industrial drawing or the kind of hand and eye coordination that was promoted through manual training. Such skills were more a matter of affect, or a certain outlook toward one's work. After the turn of the twentieth century, progressive educators increasingly talked about promoting "industrial intelligence" in students rather than manual skills or practical knowledge. In art education, they increasingly talked about art as a form of personal expression.

Francis W. Parker (1837-1902) was one of the important transitional figures who marked a change in art education from manual skills to personal affect. In 1883 Parker became principal of the Cook County Normal School, located in what was then still a suburb of Chicago. The school offered a one-year course in elementary education that combined studies in pedagogy and psychology with practice teaching. The faculty of Cook County Normal were the teachers at the practice school, and under the direction of Parker, they applied his new theories of education to the classroom. Parker wanted the practice school to be "an influential object-lesson for the teachers of the city and the county, and for the parents and the public in general." The school was to demonstrate that "there is a science of education and an art of teaching, and . . . that knowledge and skill are means for the development of character" (Parker 1902, 757).

One of the central ideas in Parker's philosophy was that the child, as "the climax and culmination of all God's creations," should be at the center of all learning and study, and, like God, the child was creative in nature rather than a passive observer of life. Parker argued that with the exception of writing, all "modes of expressions" were spontaneously exercised by children. Singing, making, modeling, painting, and drawing—all these forms of "thought-expression" were natural. Every child was born an artist (Parker [1894], 3-24).

Every child was also born a worker, according to Parker. He argued "the foundation of education consists in training a child to work, to love work, to put the energy of his entire being into work; to do that work which best develops his body, mind and soul" (Parker [1894], 254). Like others, Parker saw education for work as a solution to present problems with manual labor. In a paper presented to the Department of Art Education of the National Education Association in 1900, he argued that "one of the fundamental weaknesses under which society suffers is careless, shiftless, indifferent work—work that falls short of its intentions." Public schooling was not entirely responsible for this, there were other causes in society as well; however, the common school was

> the one place where the whole people can engage in remedying the terrible evils of shiftlessness, carelessness, indifferent work. . . . Genuine work must have a high, noble incentive—an incentive that means putting something really good into human life. Work for a low motive is always drudgery. The best work, however difficult, carries with it enthusiasm, exhilaration, strong interest. (1900, 511)

As suggested by his references to "incentive," "motive," "enthusiasm," and "strong interest," Parker was similar to Addams in wanting to change workers' perception of their labor, rather than changing the nature of the work itself. But in principle, at least, what counted as the "best" work for Parker was determined by objective criteria as well as what he called the "personal value" of labor. In *Talks on Pedagogics* (1894) he argued that in manual work, the criterion of value was the "practical use" of the thing created. In the "conceptive" modes of expression,

on the other hand, the value of the thing created lay in communicating ideas; in making art, the primary motive was "to give to others a great controlling thought, to embody this thought in an individual concept, and to externalize that concept by skill" ([1894], 239). In 1894 Parker still included technical skill and embodiment of a "great thought" in children's art as at least part of the measure of its value, but such objective criteria came to be increasingly deemphasized in his arguments. By 1900 he claimed that

> art can never be defined except from a personal standpoint. It is entirely a personal matter. It means one's selfhood; it reveals one's best thought and emotions to others. . . . The best may be a daub, a blotch, a shapeless mass of clay, a discordant cry, but it is art if it is the best. (1900, 513)

At an earlier meeting of the National Education Association, John S. Clark had noted that there were fundamental contradictions in Parker's views. As Clark described them, the contradictions came from Parker's adopting the perspective of experimental psychology which sought to "reduce the mental phenomena to unmediated physical energies playing through matter, and so to dispense with self-activity in the intellectual life of man." There was a difference between "mere 'expression'," Clark argued, and human activity that went beyond expression to become "'creation'; that is to say, productive action—action productive of new things or new conditions." Whereas expression was a "statement of what is," the purpose of creation was "the active betterment of the world and the progressive elevation of human living." In Parker's theories there was a "great chasm" between describing art in terms of "physiological psychology" on one hand, and on the other, claiming that art transcended nature to reveal the spiritual features of human life (Clark 1895, 833-41, 851-56).

Clark was right. There were, in fact, fundamental contradictions in Parker's views. These included not only mind versus matter and moral versus psychological dimensions of life. There were conflicts between art and work, the individual and society, and the ends and means of education. At the turn of the century, John Dewey (1859-1952), a more accomplished philosopher than Parker, set out to resolve these kinds of conflicts in current educational thought.

IV

In *The Child and the Curriculum* (1902) Dewey took up the issue that had by then become the major point of contention between traditional schooling and the "new" education: whether instruction should be centered on the study of subjects or the development of children. Dewey noted that on one side there were educators who argued the child's own experience was too narrow and egocentric to be the basis of schooling. From their perspective, the purpose of education was to

reveal to children "the great, wide universe with all its fullness and complexity of meaning." Subject matter, not the child, furnished the end and determined the method of schooling. On the other side there were educators who took the child to be the starting point, the center, and the end of all schooling. For them, the primary purpose was growth and development of the child; the importance of studies lay only in their being means to this end. The goal of education was "not knowledge or information, but self-realization" (Dewey [1902] 1976, 275-77).

Dewey set out to achieve a middle position between the two extremes, modifying each in light of the other. On the side of children's development, he argued that educators should see the child's experience "contains within itself elements—facts and truths—of just the same sort as those elements entering into formulated study." On the side of formal studies, educators should interpret subject matters as "outgrowths of forces operating in the child's life" (Dewey [1902] 1976, 277-78). Dewey saw the latter modification as being especially important because it was what distinguished the teacher's approach to subject matter from the approach of specialists in a field. For the specialist, subject matter was "a given body of truth to be employed in locating new problems, instituting new researches, and carrying them through to a verified outcome" ([1902] 1976, 285). The teacher, on the other hand, was not concerned with developing new knowledge, but with what Dewey called "psychologizing" subject matter. In contrast to the specialist, the teacher's role was

> that of inducing a vital and personal experiencing. . . . [W]hat concerns him, as teacher, is the ways in which that subject may become a part of experience; what there is in the child's present that is usable with reference to it; how such elements are to be used; how his own knowledge of the subject-matter may assist in interpreting the child's needs and doings, and determine the medium in which the child should be placed in order that his growth may be properly directed. ([1902] 1976, 285-86)

The value of art in education was similar to other subjects of study. Like science and history, Dewey argued that art served to

> reveal the real child to us. We do not know the meaning either of his tendencies or of his performances excepting as we take them as germinating seed, or opening bud, of some fruit to be borne. . . . The art of Rafael or of Corot is none too much to enable us to value the impulses stirring in the child when he draws and daubs. ([1902] 1976, 281)

In contemporary arguments over "the child vs the curriculum" and "individual nature vs social culture," Dewey came down on the side of the child in the end (Dewey [1902] 1976, 274, 291). After the turn of the century, he became a major figure in the progressive movement, including progressivism in art education. His ideas were widely adopted, even though they were sometimes diluted and, as often as not, misapplied in the translation from theory to practice. But despite their misapplication, Dewey's ideas represented a new way of looking at

the nature of art and its value in education. Was the new paradigm, exemplified by Dewey's and others' views, better than older conceptions of art, morality, and work?

A social history of art education would seem to suggest it was not better, only different in the kind of boundaries that were placed on modern thought. "Psychologizing" the nature of art severed it from work and morality, so that new forms of art education did not become overt means of fitting working-class children to industrial labor in the way that tracking or industrial intelligence were. The relationship of art education to vocationalism in schooling, the nature of industrial work, and the interests of the privileged classes lay in what was omitted, rather than what was included in modern theory. What was omitted were the potentially dangerous ideas that art had to do with moral knowledge, with skilled-craft work, and with having control over one's own labor. Psychologizing art rendered it harmless, making it irrelevant to both the social realities of the modern workplace and the social ideals of a democracy.

Note

1. Addams's use of masculine pronouns to refer to both male and female workers reflects common practice at the time. In this paper I quote her and other authors' words as originally published.

References

Addams, Jane. 1895. "The Art-Work Done by Hull-House, Chicago." *Forum* 19 (July): 614-17.

_____. 1899. "A Function of the Social Settlement." *Annals of the American Academy of Political and Social Science* 13 (May): 323-45.

_____. 1902. *Democracy and Social Ethics.* New York: Macmillan.

_____. 1910. *Twenty Years at Hull-House.* New York: Macmillan.

Clark, John S. 1895. "The Place of Art Education in General Education." In National Educational Association, *Journal of Proceedings and Addresses,* 1895, 830-46, 851-56. St. Paul: The Association.

Cremin, Lawrence A. 1961. *The Transformation of the School: Progressivism in American Education,* 1876-1957. New York: Vintage Books.

Dewey, John. [1902] 1976. *The Child and the Curriculum.* Reprint. In *The Middle Works, 1899-1924,* edited by Jo Ann Boydston, Vol. 2, 271-91. Carbondale, Ill.: Southern Illinois University Press.

Eisner, Elliot W. 1972. "The Roots of Art in Schools: An Historical View from a Contemporary Perspective." In his *Educating Artistic Vision*, 29-63. New York: Macmillan.

Hogan, David John. 1985. *Class and Reform: School an Society in Chicago, 1880-1930.* Philadelphia: University of Pennsylvania Press.

Logan, Frederick M. 1955. *Growth of Art in American Schools.* New York: Harper and Brothers.

Parker, Francis W. [1894]. *Talks on Pedagogics: An Outline of the Theory of Concentration.* New York: A.S. Barnes.

_____. 1900. "Art in Everything." In National Educational Association, *Journal of Proceedings and Addresses*, 1900, 509-14. Chicago: The Association.

_____. 1902. "An Account of the Work of the Cook County and Chicago Normal School from 1883 to 1889." *Elementary School Teacher and Course of Study* 2 (June): 752-80.

Ruskin, John. [1870] 1905. *Lectures on Art.* Reprint. In *The Works of John Ruskin,* edited by E.T. Cook and Alexander Wedderburn, Vol. 20, 1-179. London: George Allen; New York: Longmans, Green.

Stankiewicz, Mary Ann. 1984. "'The Eye Is a Nobler Organ': Ruskin and American Art Education." *Journal of Aesthetic Education* 18 (no. 2): 51-64.

Starr, Ellen Gates. [1895] 1970. "Art and Labor." In *Hull-House Maps and Papers: A Presentation of Nationalities and Wages in a Congested District of Chicago, Together With Comments and Essays on Problems Growing Out of the Social Conditions,* 165-79. Reprint. New York: Arno Press.

Violas, Paul C. 1973. "Jane Addams and the New Liberalism." In *Roots of Crisis: American Education in the Twentieth Century,* by Clarence J. Karier, Paul C. Violas, and Joel Spring, 66-83. Chicago: Rand McNally.

Wygant, Foster. 1983. *Art in American Schools in the Nineteenth Century.* Cincinnati: Interwood Press.

IV. The Twentieth Century

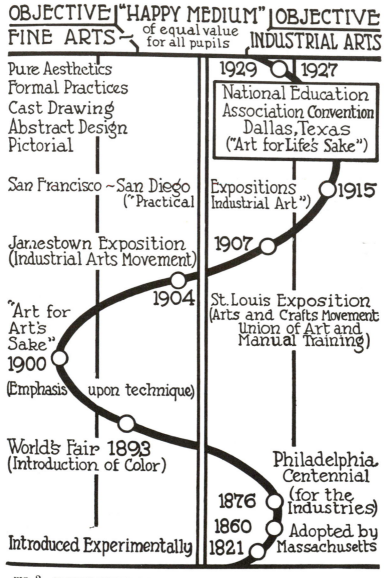

OBJECTIVE "HAPPY MEDIUM" OBJECTIVE
FINE ARTS — of equal value
for all pupils — INDUSTRIAL ARTS

Pure Aesthetics
Formal Practices
Cast Drawing
Abstract Design
Pictorial

1929 1927

National Education
Association Convention
Dallas, Texas
("Art for Life's Sake")

San Francisco ~ San Diego
("Practical

Expositions
Industrial Art") 1915

Jamestown Exposition
(Industrial Arts Movement)

1907

1904

St. Louis Exposition
(Arts and Crafts Movement
Union of Art and
Manual Training)

"Art for
Art's
Sake"
1900
(Emphasis upon technique)

World's Fair 1893
(Introduction of Color)

Philadelphia
Centennial
(for the
Industries)

1876

1860 Adopted by
Massachusetts

Introduced Experimentally 1821

FIG. 2. GRAPHIC HISTORY OF ART EDUCATION IN THE PUBLIC SCHOOLS
OF THE UNITED STATES.

In 1929, William G. Whitford portrayed art education history as a stream that meandered
between fine arts and industrial arts. In his chapter, Arthur Efland echoes Whitford's notion
by describing two art education streams that have coursed through the twentieth century.
(Whitford 1929, *An Introduction to Art Education.* F. Wygant Collection).

Art Education in the Twentieth Century: A History of Ideas

8 *Arthur Efland*

The use of history . . . is to rescue from oblivion the lost causes of the past. History is especially important when those lost causes haunt us in the present as unfinished business (Goodman 1960, 216).

In this paper I discuss a series of causes or movements in twentieth century art education. To explain these I will describe two discernible streams of influence that have coursed through the history of general education. The first is a tradition of scientific rationalism; the other is the romantic-expressionist stream. By scientific rationalism I refer not to science proper, but to ideologies finding their warrant in science. By romantic-expressionist I refer to a loosely strung set of beliefs which place the artist in a vanguard position in social affairs. Throughout the past century, one can discern discrete movements, each with its counterpart in the alternate stream (Figure 1). Some movements arose in reaction to their opposites; others were concurrent but not rivals.

Educational history could be seen as an ongoing ideological contest between liberal and conservative forces that parallel the larger social drama in American society, but there is a caveat to bear in mind. Neither stream was, nor is, totally liberal or conservative in character; both have given rise to liberal or conservative tendencies. The first has a preference for rationality, structure, and scientifically sanctioned procedures; the second regards structure as oppressive and gives greater play to concerns for beauty, or emotional expression in the curriculum. A second caveat is that this is primarily a history of influences on art education with only selected examples given of what was taught.

Time Frame	Scientific-Rationalist Stream	Romantic-Expressive Stream
1900-1918	Social Efficiency	Romantic-Idealism
1929-1940	Deweyan Instrumentalism	Creative Expression
1956-1965	Discipline-Centered	Counterculture
1965-1980	Accountability	Qualitative Inquiry
1980-	Excellence	Critical Theory

Figure 1. Historical Patterns in General Education

Romantic Idealism and Social Efficiency

In 1897 the American commissioner of education, William Torrey Harris, was able to point to the arts, music, and literature as great civilizing agencies in the school curriculum. He defined art as "a means of manifesting the Divine in material form for the apprehension of the senses and the reason." To Harris the arts were one of the three ways humans reach toward the divine, the other two being philosophy and religion. He went on to say that "we must teach drawing that we may be able to obtain keener perceptions of the beauties of nature, and that we may preserve what Mr. Ruskin calls true images of beautiful things that pass away, or which we must ourselves leave" (Harris 1897).

Harris saw art as a conservative force. It preserved the great ideals of past civilizations and human genius. Furthermore, art appreciation instilled in pupils a deep respect for social institutions and the moral ideals they espouse. This respect, Harris felt, would impose a degree of constraint upon personal action, and thus instruction in art could be harnessed by educators for purposes of social control (Stankiewicz 1984). As these ideas were popularized, picture study along with programs for the decoration of the schools with art reproductions and plaster casts of classical statuary began to be supported by public spirited groups in many parts of the country (Canfield 1899).

But Harris's conservative vision was a bulwark resisting an encroaching tide of scientific materialism. Though actually antedating Harris, the social Darwinism of Herbert Spencer began to influence educators who saw in the discoveries of science greater possibilities for social betterment than they could find in the lofty ruminations of idealistic philosophy. By the 1880s Spencer's ideas began to take hold in American educational circles. Moreover, scientists had something to say that would help with the tasks of education. By the turn of the century, the psychological ideas of William James and G. Stanley Hall were being incorpo-

rated into teacher training programs in many normal schools and colleges of education (Cremin 1964). Spencer declared that the purpose of education was to prepare the pupil for complete living which involved five categories, these being self-preservation, the ability to secure life's necessities, child rearing and disciplining of offspring, the ability to maintain proper social relations, and finally, the gratification of tastes and feelings. Survival was the first and most important category; the least was the gratification of tastes. The efficacy of schooling was to be assessed in terms of how well it enabled the pupil to discharge these purposes. Thus to the question "what knowledge is of most worth," Spencer had no doubt that the answer was science.

Macdonald (1970, 322) noted that Spencer himself actually used the theory of evolution to justify drawing based on the nature of the child, but in the United States, Spencerian thought fostered an aggressive utilitarianism in which all aspects of education were valued only by visible, practical benefits. By 1894 a committee of ten prominent educators, appointed by the National Education Association, published a report on the high school. It offered almost no mention of the arts, questioned the efficacy of a classical education for all students, and placed a greater emphasis on practical and scientific studies (Report of the Committee of Ten 1894). Art became an elective study because it was not recommended as a college entrance subject.

American educators soon began to utilize the techniques of science and business to make the schools more efficient by eliminating non-productive subjects. By 1912 there was a whole new literature on the scientific management of schooling, and indeed, school administrators increasingly began to think of themselves as managers in the business of education. Spurred by increasing criticism of the schools in the press (Callahan 1962), they attempted to measure the efficiency of teachers, curricula, and the intelligence of children, and to use these data to eliminate waste and channel pupils into courses where their innate abilities could be scientifically developed. Thus, if art found its warrant as an agent of social control, the scientifically oriented educator could claim that with procedures such as testing, control could be accomplished with greater predictability. Art had lost its raison d'etre in the school. Drawing did not disappear from the schools but it became justified as a form of nature study which could find sanction in an age of science (Bailey 1920).

A telling sign that the arts were in deep trouble appeared in David Snedden's essay, "The Waning Powers of Art" (1917). Snedden, an educational sociologist at Teachers College, Columbia, questioned the long-standing assumption that the arts were important, first noting that this assumption is usually derived from "other civilizations than our own and chiefly representing other stages of evolution." He asked whether it might well be possible that we have reached a stage of development "when the social need of art of good quality is less vital and compelling than was formerly the case" (805).

Snedden surveyed all of the uses of art in past societies and speculated that "If we possessed sufficient data . . . we would probably find that many forms of art had, during the long periods when they possessed great social vitality, a very large 'survival value'." But, he continued, "an examination of these forms of social activity which are most intimately involved in the survival and expansion of civilized societies will show an increasing dependence upon what may be called the helpings of science as contrasted with the helpings of art" (808).

Snedden's essay appeared during World War I, and though he acknowledged the value of art as a morale builder, the war itself was made into a case in point to assert that its outcome would be determined by the side with the best scientific knowledge and the material means to produce effective weapons, not by the side with the best art. However, by the time the war ended, progressive education was ready to make its debut and another philosophy of science made its appearance.

Deweyan Instrumentalism and Creative Self Expression As Rivals in Progressive Education

The factors contributing to the rise of the progressive education movement are complex and have been amply described by Cremin (1964). Suffice it to say that there was a general reaction against the excessive formalism that had been imposed upon schooling as a result of scientific management procedures. Progressivism was also part of a wider political movement that had attempted to bring reform to wretched social conditions resulting from the industrial revolution. In the past science revealed a world that operated according to certain inexorable laws that could not be changed, but with the start of the twentieth century nature's laws began to be expressed as probabilities rather than certainties. Human beings were less often pictured as passive spectators, but as creatures placed in an immensely complex environment, and because this environment is anything but static, they must modify their behavior through learning to maximize their opportunities for survival. This is the work of intelligence.

Moreover, the operation of intelligence to produce knowledge is precisely what John Dewey called scientific method. This knowledge is instrumental and interested, as opposed to the spectator mentality of the previous century. Dewey resisted the idea that there were absolute instrumentalities for dealing with changing situations. This view of intelligence was to become the cornerstone of his educational philosophy (Jones 1952, 949-52).

Dewey and his wife, Evelyn, established a laboratory school "to discover in administration, selection of subject matter, methods of learning, teaching, and discipline, how a school could become a cooperative community while develop-

ing in individuals their own capacities and satisfying their own needs" (Mayhew and Edwards 1936). The initial hypotheses were that life itself, especially those occupations and associations that serve human social needs, should furnish the ground of experience of education; that learning can be in large measure a by-product of social activity; that the main test of learning is the ability of individuals to meet new social situations with habits of considered action; and that schooling, committed to cooperative effort on the one hand and scientific methods on the other, can be of beneficial influence on the course of social progress. This laboratory school developed activities in the fine and industrial arts. These were not taught as specific subjects but as activities resulting from the exploration of broad social themes.

However, the art education most readily associated with progressive education did not originate in Dewey's thought but in the writings and practices of such artist educators as Harold Rugg, Ann Shumaker, and Florence Cane (Rugg and Shumaker 1928). The method was known as creative self-expression. The impetus for change came from the artist as a model for social reform rather than the scientist. Expressionism pervaded the arts of the time—in the dance of Isadora Duncan and Martha Graham, the painting of Max Weber and John Marin, and the photography of Alfred Steiglitz (Cremin 1964, 206).

In 1914 Caroline Pratt founded the Play School in the Greenwich Village section of Manhattan. Though it had begun as an effort to build a richer life for slum children, it was slowly transformed into an experiment in creative education. Cremin noted that the school's pupils were largely drawn from the families of the artists literati (Cremin 1964, 205).

Creative self-expression as understood by Pratt was not based upon the Deweyan concept of intelligence. Rather, its scientific sanction was derived from Freudian psychology. Freudian theory postulated that the unconscious mind is the real source of motivation, and that the task of education was to sublimate the child's repressed emotions into socially useful channels. According to Margaret Naumburg, founder of the Walden School,

> all prohibitions that lead to nerve strain and repression are contrary to the most recent findings of biology, psychology, and education. We have yet to discover ways of redirecting and harnessing this vital force of childhood in constructive and creative work (Cremin 1964, 210-11)

Throughout the 1920s the vision of an educational science that gave rise to Dewey's focus on social activity was gradually supplanted by a psychologically-based focus on the individual, but even though self-expression was the dominant mode of teaching in the leading progressive schools of the 1920s there was a reiteration of the Deweyan approach to art education with the social cataclysms of the Great Depression and World War II.

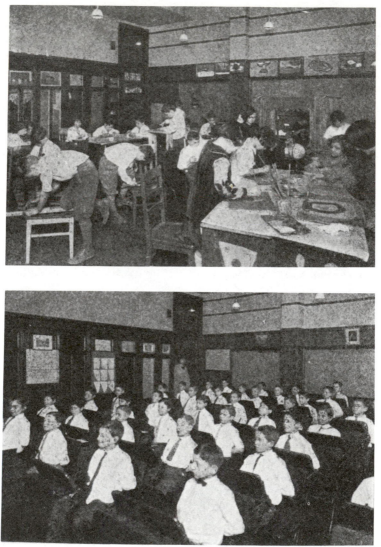

Courtesy of Miss Elizabeth Irwin, Public School 61, New York

THE NEW AND THE OLD IN EDUCATION

Above: Freedom! Pupil initiative! Activity! A life of happy intimacy
— this is the drawing-out environment of the new school. *Below:* Eyes
front! Arms folded! Sit still! Pay attention! Question-and-answer
situations — this was the listening régime.

Rugg and Shumaker's 1928 book, which included this photo, had a clear message for
progressive educators: creative self-expression required tolerant understanding and the new
child-centered education. (Rugg & Shumaker, 1928, *The Child-Centered School: An Appraisal
of the New Education.* Soucy Collection).

This is seen in the Owatonna Art Education Project which placed emphasis on community improvement through the use of the arts (Haggerty 1935). During the war years this emphasis upon the social uses of art was spurred by the demands of the war effort, but as the war came to an end, art educators once again returned to the idea of self-expression. Indeed, throughout the war some art educators had equated the self-expression of the artist with the war's object to preserve the democratic way of life (Freedman 1986, 1987).

As the war ended the writings of Sir Herbert Read and Viktor Lowenfeld were influential (Read 1944; Lowenfeld 1947). Both made the point in their widely used texts that children's art was universal in its symbolic forms, that it could serve as an instrument of peace if such art would be allowed to develop freely, without the repressiveness of society which thwarted the unfolding of the child's personal vision. The child as artist was the instrument of salvation for world civilization.

Discipline-Centered Curricula and the Counterculture of the 1960s

During the post-war era there was great increase in art teachers and public schools offering art instruction, especially at the elementary level. The fortunes of art education were rising, and self-expression was the favored method of teaching. At the same time the progressive movement was on the wane and never regained the prestige and influence it had during the inter-war years. The journal *Progressive Education* ceased publication in 1957, and in October of the same year the Russians launched Sputnik, the world's first artificial satellite. Having both events occur in the same year symbolized the extent to which the times had changed. Spurred by the Sputniks, Congress passed the National Defense Education Act which emphasized the improvement of mathematics and science teaching. However, curriculum initiatives in the sciences and mathematics had been under way for several years prior to the Russian achievements. Indeed, the movement to base the curriculum on the forms of knowledge in the disciplines came about because university scholars had become dissatisfied with the school's failure to incorporate new advances in knowledge, and to recognize the importance of these advances in the economy and society at large (Silberman 1970, 169-70).

Having the scientist and mathematician identify content made sense, for in the late 1950s scientific professionals were the cultural heroes. They had, after all, shattered the atom and built the bomb which ended the war. Nuclear technology had then promised an unlimited supply of cheap energy. Why not use their intellectual powers to reform the schools?

It was in Bruner's *The Process of Education* where most educators first discovered the term "structure of the discipline" (Bruner 1970, 19). The book reported on the Woods Hole Conference, which reviewed the reforms in mathematics and science education underway in 1959. The conference was sponsored by a number of groups, including the National Academy of Sciences, the American Association for the Advancement of Science, the Carnegie Corporation, and the National Science Foundation, with funding provided by the NSF, the US Office of Education, the Air Force, and the Rand Corporation (Bruner 1960, ix). What was lost on that generation of Bruner's readers was this unprecedented blend of federal agencies, private foundations, science organizations, and the military that sponsored this conference, lending support to the new reforms favoring the disciplines. The underlying motive was to improve national defense, a task to be accomplished by no less than a fundamental reform of general education itself. Despite this motive the long-term benefits were then felt to be inherently worthwhile and long overdue. Few regarded the movement as a partisan expression of individuals identified by President Eisenhower as the "military industrial complex."

Members of the scientific community were in a position to recommend changes in curriculum content and organization, with many serving as consultants on curriculum development projects. As the disciplines became the focus of curriculum reform, a hierarchy was established elevating some studies to the status of disciplines. Others not so designated were relegated to the status of mere subjects. Philip Phenix asserted that all "curriculum content should be drawn from the disciplines, or, to put it another way, that only knowledge contained in the disciplines is appropriate to the curriculum" (Phenix 1968). In this new environment art had to become a discipline itself or lose its legitimacy.

By 1961 the canonical nature of the disciplines was asserted in Bruner's subsequent writings (Bruner 1961). He speculated that structures of knowledge similar to those in science might be found in the social studies and humanities, demonstrating that any field might profit from the approach pioneered in the physical sciences. His *Toward a Theory of Instruction* (1965) described the social studies program known as *Man a Course of Study,* an example of a curriculum organized around concepts drawn from linguistics, anthropology, economics, and sociology. This demonstration was particularly important because social studies was a typical product of the progressive era. To demonstrate that it could be revitalized by disciplined knowledge was an important test case. But another was the reform of teaching in the arts.

How the Arts Became Disciplines

During the Kennedy presidency, support of the arts became a matter of public concern. August Heckscher served as special consultant on the arts for the

White House from March 1962 to May 1963, his principal task being that of preparing a report entitled *The Arts and National Government* (Heckscher 1963). The report dealt with all aspects of federal support for the arts, including their role in public education. In 1964 the Panel on Educational Research and Development of the President's Science Advisory Committee expressed concern "with the lack of balance in federal assistance to the arts as compared to science" and suggested that "curriculum reform, as it had developed in science education, could be applied to education in the arts." As with science education this reform should begin with ideas first identified by substantive specialists. Music was the first of the arts to adopt this approach, in an event known as the Yale Seminar on Music Education (Murphy and Jones 1978). The report *Music in Our Schools* (Palisca 1964) was its first product.

This conference assailed the preponderant emphasis upon group instruction and performance; it attacked the musical repertoire used in most school systems as being of "appalling quality, representing little of the heritage of significant music." Its participants were beguiled by curriculum methods developed for the sciences. They reported, "The music class must be recognized as a laboratory whose purpose is to teach by means of physical exposure to music and experimentation with the making of music" (Palisca 1964, 9).

In 1965 a seminar in art education for research and curriculum development was held at The Pennsylvania State University which was to have far reaching influence upon art education (Mattil 1966). This seminar reiterated the notion that art is a discipline in its own right, with goals that should be stated in terms of their power to help students engage independently in disciplined inquiry in art. In his paper on curriculum problems Manuel Barkan asked whether the visual arts and the humanities have structures like those in the physical sciences:

> Physics—that is, science—has a formal structure of interrelated theorems, rules and principles so that conceived hypotheses can be put to test rather than judgment through evaluation of relevant data. Hence there are science disciplines and scientific inquiry is disciplined. But does the absence of a formal structure of interrelated theorems, couched in the universal symbol system as in science, mean that the branch of the humanities called the arts are not disciplines, and that artistic inquiries are not disciplined? I think the answer is that the disciplines of art are of a different order. Though they are analogical and metaphorical, and they do not grow out of or contribute to a formal structure of knowledge, artistic inquiry is not loose (Mattil 1966, 244).

As with the musical scholars that met at Yale, Barkan was beguiled by the scientific model of knowledge. He struggled with the problem of finding in art the structural equivalent of the knowledge forms of science as a basis for curriculum development. For conceptual assistance in establishing the parallel between artist and scientist Barkan adopted David Ecker's notion of artistic process as

"qualitative problem solving" to help establish the parallel. Indeed, Ecker had quoted a number of artists who described their productive activities in problem-solving terms (Ecker 1963). As a result, Barkan conflated "artistic activity" with "scientific inquiry." He argued that studio activity was a mode of inquiry, but that art history and art criticism were modes as well. All three were treated as equivalent candidates for curriculum attention giving rise to a tri-partite conception of curriculum content thereby reducing the overall importance of studio activity in the art curriculum, for now the artist had to share the stage with two other actors, the art critic, and art historian.

Scientists and science educators were attempting to cope with the vast proliferation of knowledge that had occurred throughout the twentieth century. They realized that the curriculum could not expand at the same exponential rate that information was expanding. By focusing upon the representative ideas in the structure of knowledge, they hoped to be in a position to know what to emphasize or exclude, thus simplifying the task of content selection and organization. Ironically, in art it had exactly the reverse effect, greatly enlarging the content available for instruction.

Counterculture Criticism

In the same year that Bruner published *The Process of Education,* Paul Goodman published *Growing Up Absurd* (1960). Goodman argued that delinquent youths had much in common with the "beatniks" of the late 1950s, and the "organization man" as spoken of by William H. White (1956). These social types were responses to an affluent society in which individual effort and work was perceived as lacking purpose and meaning. The 1960s was a time of general protest against a prevailing status-quo that favored social conformity and suppressed individuality. In place of those who demanded basic educational skills, discipline, and rigor, there were new writers such as Goodman, Edgar Friedenberg, George Leonard, Jonathan Kozol, and Charles Silberman calling for greater humaneness in schooling. They complained that the educational establishment had alienated a generation of American youth and that education was no longer perceived as having any relevance in their lives. They perceived the emphasis on the disciplines as excluding the student.

By late 1960s a new vocabulary began to appear with such terms as "counterculture" (Roszak 1969) and the "me generation." The activism of the civil rights movement, which spoke of political and economic freedoms, became translated into a rhetoric of personal liberation, with individuals demanding freedom from traditional norms, especially in the realm of sexual behavior and through the use of hallucinogenic drugs. Freedom was asserted by living alterna-

tive lifestyles that have become the legacy of the decade. This rhetoric was reminiscent of progressive writing after World War I, except that in the 1960s much more was made of the culture of youth as a driving force in its own right. One of the results of this ferment was the rise of alternative schools which promised a greater degree of freedom and independence for children (Leondar 1971).

The Arts-in-Education Movement

A movement with tendencies at variance with the discipline orientation began to take shape in the arts. It had its origins in the Arts and Humanities Program of the U.S. Office of Education and began to have an especially strong impact upon programs in the arts supported by federal funds. The Arts and Humanities Program was directed by Kathryn Bloom in the years between 1962 and 1968 (Remer 1980). The projects funded by AHP initially reflected the discipline orientation, which was evident in the Yale and Penn State seminars. With the passage of the Elementary and Secondary Education Act in 1965, federal funding policy began to shift toward programs having a strong social agenda as typified by President Johnson's war on poverty.

By the late 1960s and early 1970s these general social purposes were used to justify arts in education programs and began to be evident in such projects as the Arts Impact Program, which granted funds to develop special offerings in the arts in five school districts including Eugene, Oregon; Columbus, Ohio; and Troy, Alabama. In 1968 Bloom became director of the Arts in Education Program of the JDR 3rd Fund, a position she held until the program's termination in 1979. Many of the same policy characteristics that emerged in the latter years of the AHP were also to be found in the projects supported by the Fund. This foundation was active in public schooling between 1967 and 1979, granting 5 1/2 million dollars to school districts, state departments of education, arts councils, and educational laboratories.

Characteristics of the Arts-in-Education Movement

The first characteristic was its emphasis upon arts in the plural. "Arts education" and "arts-in-education" were terms typical of the movement. Barkan had initially conceived of a center for research and curriculum development in art, but by the end of the Penn State Seminar there was a clear signal from Harlan Hoffa, then on the staff of the Arts and Humanities Program, that funding policy favored the concept of "arts education" or "aesthetic education" (Mattil 1966, 399). As a result, the curriculum development proposal submitted by Barkan was phrased in

terms of "aesthetic education," where several arts would be treated rather than separate programs in each of the arts.

A second was the tendency to seek solutions to educational problems outside of the school, and indeed, to regard the school itself as part of the problem. In one sense, the arts-in-education movement paralleled the discipline movement's use of scientists as curriculum consultants: it used professional artists as resource persons in the schools. But arts-in-education project directors tended not to use artists as curriculum resources; they used them directly as actors, poets, or musicians in school situations. They strove to enliven the school environment by introducing the excitement of the arts into its midst.

A third was its tendency to involve community agencies such as arts councils and museum persons as resource persons for arts-in-education programs affecting the schools. Networking among arts agencies and interested schools was used to provide publicity, and to raise funds for procuring resource persons in arts endeavors affecting the schools (Bloom and Remer 1980).

One of the most notable attempts to organize community involvement for the arts was undertaken by the group known as The Arts, Education and Americans Panel, headed by David Rockefeller Jr., which resulted in the widely distributed book *Coming To Our Senses* (1977). The panel consisted of such nationally prominent personalities as Raye Eames and James Michener. The object was to use these persons to focus national attention on the importance of the arts in education. Though the effort was well intentioned, it shunned the use of educators as resource persons on problems affecting the teaching of the arts and, as a result, tended to alienate many of the groups it purported to help (Chapman 1978; Smith 1978).

A fourth may be described as a performance bias. Though it is possible to learn about the arts in a variety of ways, through the study of their history, for example, the prevailing tendency was to have students involved in art production or performance. Action as opposed to contemplation was the prevalent mode of instruction. The annual reports of the JDR 3rd were typically illustrated with action pictures of dancers or painters or musicians in rehearsal.

A fifth was the tendency to justify activities by such rationales as: improving the child's self-concept, improving school morale and boosting school attendance figures, furthering inter-disciplinary teaching by relating the arts to each other and to other subjects, involving the community in schools through artist-in-the-schools programs, accommodating to the special needs of the gifted or handicapped, and even using the arts as a general strategy for changing the schools (Remer 1980).

Criticism of the Arts-in-Education Movement

Unlike the discipline movement which started with university people dissatisfied with the ways their subject was taught, the arts-in-education movement took place in the world of federal agencies and private foundations. It blended old and new ingredients. In its premises one can find ideas that go back to the progressivism of the 1930s, especially in its attempt to integrate the arts into the fabric of school life. The older movement also saw the arts as instruments for personality development or social improvement.

Yet, it was a child of its own time, which is seen in its strong anti-establishment bias, a rhetoric of social activism characteristic of the 1960s, and in its tendency to eschew schools and educators in favor of artists and performers, in the naive hope that the very presence of these individuals would serve as a catalyst to change a moribund educational system. Yet, it had its positive aspects in that it was able to draw public attention to the arts as neglected subjects in the curriculum. As the accountability movement began to be felt in the early 1970s arts-in-education programs enjoyed a good press, reminding people that the arts also belonged in the school.

Accountability and Qualitative Inquiry as Rival Movements

By 1973 the Vietnam war had ended, political conservatism was on the rise, and the need for scientific knowledge, the cause celebre of the last decade, had subsided. The Arab oil embargo precipitated an energy crisis which resulted in the fear that economic opportunities were declining, and that students would have to compete for fewer positions at the top of the social ladder. Also contributing to the movement was the continued rise of educational costs in spite of a marked decline in the school age population as the post-war baby boom came to an end. This increased the resistance of the tax paying public toward educational spending. In addition, anxious parents were increasingly concerned about test scores as measures of schooling effectiveness, especially as such scores underwent a serious decline from 1964 through the mid 1970s. Uncertainty over future economic prospects made educational accountability a perceived social need.

As accountability became the new watchword, curricular affairs shifted from considerations of content to the identification of effective devices for evaluation and measurement. Popkewitz, Pitman, and Barry (1986) described this in terms of a shift from the "productive" aspects of knowledge, with its focus upon inquiry and discovery, to the "reproductive" aspects of knowledge, with emphasis on the monitoring of student performance to measure mastery of existing facts.

As the 1960s drew to a close, a gradual, almost imperceptible shift from curriculum initiatives inspired by "the structure of the discipline" to ones based upon precise formation of instructional objectives and cost-accounting measures of efficiency began to occur. The change was so gradual that proposals for curriculum reform based on the disciplines often incorporated procedures calling for the preparation of highly specified objectives. For example, in 1966 Asahel Woodruff dealt with the problems that would have to be faced by art educators attempting to specify the behaviors taught in a visual arts curriculum based on the disciplines (Mattil 1966, 259-72). Thus the language and procedures that characterized the accountability movement were beginning to enter the picture by the middle 1960s, and indeed, for many individuals, the precise formulation and measurement of objectives was taken to be a characteristic of discipline oriented curricula.

Only through hindsight had the incompatibility of the "productive" and "reproductive" aspects of the curriculum become clear. By the late 1960s the rhetoric concerning instructional objectives was ubiquitous, and by the middle 1970s much literature in art education was devoted to instructional objectives, competency-based teacher education, and evaluation.

One would have predicted resistance to this new emphasis upon precise instructional objectives, and indeed, one can find evidence in works such as Ralph Smith's anthology entitled *Regaining Educational Leadership* (Smith 1975) and in Elliot Eisner's formulation of "expressive objectives," which allowed for those educational situations where outcomes cannot be predicted, where they are discovered after the fact (Eisner 1967). Nevertheless, there was a remarkable acceptance of this regimen in the arts. Perhaps the explanation is that a new generation of art educators was ready to move their field from the woolly tradition of creative self-expression. This is seen in their general embrace of empirical research in such areas as psychological creativity, visual perception, and in their zeal for objectives in behavioral terms (Davis 1976). Another factor contributing to the widespread adoption of instructional objectives was that it was mandated by law in many states.

The accountability movement rested on the assumption that behavioral objectives and cost-accounting methods are essentially value-free technologies, and that these are merely means for providing the best education for the least cost. Writing behavioral objectives was merely an application of behavioral control technology, and since these were based in scientific procedures, they also were presumed to be value-free. This assumption has since faced many critics such as Dennis Nolan (1974), who noted that:

> A particular technology at a given stage of development will not be equally efficient at accomplishing all goals. In the absence of an independent basis for specifying goals, the technology is likely to dictate those goals which it can most efficiently accomplish. Such goals are not necessarily ethically neutral. (160)

Phenomenology, Tacit Knowledge, and Qualitative Research Methods

While behavioral objectives were widely adopted, an independent group of educators began moving in quite another direction. William Pinar (1975) identified these by the label "reconceptualists." They resisted behavioral objectives as a curriculum planning device. One of these, James Macdonald, had observed that "no matter what we thought we were attempting to do, we can only know what we wanted to accomplish after the fact, [that objectives are] heuristic devices which provide initiating sequences which become altered in the flow of instruction" (Mattil 1966, 261). Other members of this group included Ross Mooney, Paul Klohr, Herbert Kliebard, Philip Phenix, and Maxine Greene. They tended to share the following characteristics: they held holistic or organic views of people and their interdependence with nature; they conceived of individuals as agents in the construction of knowledge; they valued and relied heavily upon personal knowledge; they recognized pre-conscious knowledge, they drew upon a broad array of literature from the humanities; they valued personal liberty and higher levels of consciousness; and finally, they valued diversity and pluralism (Schubert 1986, 323-24).

The concept of tacit knowing as discussed by Michael Polyani (1966) was also important for the reconceptualists. Tacit knowledge recognizes that knowing involves more than can be told in words, indeed, more than individuals are conscious of, and that without tacit knowledge one would have difficulty making sense of explicit information. From their point of view no matter how precisely instructional objectives were stated, they would not enable teachers to grasp the essence of the learning situation. For phenomenological writers behavioral objectives would not reveal the "lived experience" or the deeper meanings that lie behind it.

By the latter half of the 1970s there was a shift away from empirical research methodologies in favor of those identified by labels such as qualitative or participant-observer research. For example, Elliot Eisner's *The Educational Imagination* (1979) developed the idea of educational connoisseurship and criticism based on methods of art criticism, while a number of Eisner's former students such as Gail McCutcheon and Thomas Barone used vivid artistic portrayals of instructional situations to help teachers become better connoisseurs of their own educational situations (Schubert 1986, 310).

There has not been a widespread tradition of phenomenological inquiry in art education. Among those who have worked in this tradition are Kenneth Beittel and his students. Other art educators have applied phenomenological description as a method of aesthetic analysis and art criticism, basing their work on the philosophy of aesthetics of Eugene Kaelin.

Excellence and Critical Theory as Rival Movements

As the 1980s got under way there was a renewed concern for excellence in education. A number of reports were issued such as the widely publicized *A Nation at Risk* prepared by the National Commission on Excellence in Education (1983). A second was *The Paideia Proposal: An Educational Manifesto* by Mortimer Adler (1977); a third was Ernest Boyer's *High School: A Report on Secondary Education in America (1983)*. The themes in these reports had a familiar ring, echoing concerns of the late 1950s and early 1960s. Then the problem was the concern over our ability to maintain technological superiority in the face of Soviet competition. The current interest is triggered by rising economic competition, as dramatized by the popularity of Japanese-made automobiles.

The conclusion drawn in *A Nation at Risk* was that for too long we were willing to get by with a minimum of effort. "We find that for too many people education means doing the minimum work necessary for the moment, then coasting through life on what may have been learned in its first quarter" (472). If people were less satisfied with doing the minimum to get by, the problems faced by schools and industry alike would not exist.

In his analysis of the excellence movement, Smith (1986) noted that the idea of excellence enjoyed brief currency in the 1960s and he observed that these earlier discussions "centered on improving the teaching of scientific, mathematical, and technological subjects," while the current discussions of excellence are at least more balanced, with a number of reports stressing the ideal of "a common, general education that features not only the sciences and mathematics but also the arts, humanities, and foreign languages."

In 1982, the same year that *A Nation at Risk* appeared, the J. Paul Getty Trust and seventeen art educators held discussions with a view toward establishing a center for education in the arts. In the following year the Center for Education in the Arts was founded, headed by LeLani Lattin-Duke. Soon after, it began its work by holding the first of a series of summer institutes in the Los Angeles area. The institute staff is headed by W. Dwaine Greer. Greer (1984; Clark, Day, and Greer 1987) noted that the current view of discipline-based art education was derived from ideas that first surfaced in the 1960s, though current theory added the teaching of aesthetics to the art production, criticism, and history proposed by Barkan and Eisner in the 1960s.

Critical theory reflects on the tendency of educators to take for granted the socioeconomic class structure and claims that curriculum reproduces and maintains these structures. Thus, critical theorists attempt to penetrate and expose social relationships based upon the dominance of one social group over another. Until now critical theory has had less of a direct impact upon art education than phenomenology and tacit learning. Vincent Lanier's writings, decrying the ten-

dency of art educators to impose elitist conceptions of art upon students, while ignoring popular, folk art forms, come close to exemplifying this critique.

Summary and Speculation on the Future of Art Education

In this paper I have tried to show that throughout the century art education was strongly influenced by developments affecting general education. Fads, fashions, movements, and causes came and went, arising in two main streams of influence, one that harbored a scientific rational tendency while the other, labelled as a romantic-expressionist tendency, preferred freer modes of thinking and action. These streams of influence have coursed through the history of education contributing ideas that were responsive to prevailing social circumstances.

It is also clear that earlier movements never really die out. The social efficiency movement antedating World War I reappeared as the accountability movement in the 1970s. The current concern for excellence recalls the discipline reforms of the 1960s. Creative self-expression and art-in-daily-living themes of the progressive era returned in movements inspired by the counterculture, such as the arts-in-education movement.

Moreover, there are influences that flow across the streams as well. Dewey's problem-solving approaches are resurrected in the discovery learning advocated by Bruner as disciplined inquiry. The literature on excellence often uses terms that suggest a commerce with an existential concern with lived experience and tacit knowing.

One wonders if we, like Sysiphus, are destined to repeat these cycles. Would it not be possible at some future point to strike a balance between these two tendencies—between the forms of knowing embodied in sciences with those found in the arts. Science makes a virtue of objective detachment and precision, while the arts, by contrast, make a virtue of affective engagement and participatory learning. The history of past movements is strewn with the wreckage of foiled attempts at reform, and the error has been the tendency to limit forms of thought to those found in one stream to the exclusion of the other. The task of general education, and art education within it, will not be served by separating living thought from feeling and action, as has been the case throughout the century, but by giving play to all the forms of engagement through which reality may be experienced and understood.

References

Adler, Mortimer. 1977. *The Paideia Proposal: An Educational Manifesto.* New York: Macmillan Co.

Arts, Education and Americans Panel. 1977. *Coming to Our Senses The Significance of the Arts for American Education.* New York: McGraw-Hill Book Co.

Bailey, Henry Turner. 1910. *The Flush of Dawn.* New York: Atkinson, Mentzer, and Grover.

Bailey, L. H. [1903] 1920. *The Nature Study Idea.* New York: Macmillan.

Bloom, Kathryn, and Jane Remer. 1980. "A Rationale for the Arts in Education." In *An Arts in Education Sourcebook: A View from the JDR 3rd Fund.* New York: McGraw-Hill Book Co.

Boyer, Ernest. 1983. *High School: A Report on Secondary Education in America.* New York: Harper and Row Co.

Bruner, Jerome. 1960. *The Process of Education.* Cambridge: Harvard University Press.

_____. 1961. *On Knowing: Essays for the Left Hand.* Cambridge: Harvard University Press.

_____. 1965. *Toward a Theory of Instruction.* Cambridge: Belknap Press of Harvard.

Callahan, Raymond. 1962. *Education and the Cult of Efficiency.* Chicago: University of Chicago Press.

Canfield, Flavia Camp. 1899. "Women's Clubs." *Perry Magazine* 2: 26-28.

Chapman, Laura. 1978. "Coming to Our Senses: Beyond the Rhetoric." *Art Education* 31 (no. 1): 5-9.

Clark, Gilbert, Michael Day, Dwaine W. Greer. 1987. "Discipline-Based Art Education: Becoming Students of Art." *Journal of Aesthetic Education* 21 (no. 2): 129-93.

Cremin, Lawrence. [1961] 1964. *Transformation of the School.* New York: Vintage Books.

Davis, Donald Jack. 1976. *Behavioral Emphasis in Art Education.* Reston, Va.: National Art Education Association.

Ecker, David. 1963. "The Artistic Process as Qualitative Problem Solving." *Journal of Aesthetics and Art Criticism* 21 (no. 3): 283-90.

Eisner, Elliot. 1967. "Instructional and Expressive Educational Objectives: Their Formulation and Use in Curriculum." Stanford University. Mimeo.

_____. 1979. *The Educational Imagination: On the Design and Evaluation of School Programs.* New York: Macmillan Co.

Freedman, Kerry. 1986. "A Public Mandate for Personal Expression: Art Education and American Democracy in the 1940s and 1950s." *Arts and Learning Research* [American Educational Research Association] 4: 1-10.

_____. 1987. "Art Education and Changing Political Agendas: An Analysis of Curriculum Concerns of the 1940s and 1950s." *Studies in Art Education* 29 (no. 1): 17-29.

Goodman, Paul. 1960. *Growing Up Absurd.* New York: Vintage Books.

Greer, W. Dwaine. 1984. "A Discipline-Based Art Education: Approaching Art as a Subject for Study." *Studies in Art Education* 25 (no. 4): 212-18.

Haggerty, Melvin. 1935. *Art, A Way of Life.* Minneapolis: University of Minnesota Press.

Harris, William Torrey. 1987. "Why Art and Literature Ought to be Studied in our Schools." *Addresses and Proceedings of the NEA*: 261-80.

Heckscher, August. 1963. *The Arts and the National Government: Report to the President.* Washington, D.C.: Government Printing Office.

Jones, W.T. 1952. *A History of Western Philosophy.* New York: Harcourt, Brace and Co.

Leondar, Barbara. 1971. "The Arts in Alternative Schools: Some Observations." *Journal of Aesthetic Education* 5 (no. 1): 75-91.

Lowenfeld, Viktor. 1947. *Creative and Mental Growth.* New York: Macmillan Co.

Macdonald, Stuart. 1970. *The History and Philosophy of Art Education.* New York: American Elsevier Press.

Mattil, Edward, ed. 1966. *A Seminar in Art Education for Research and Curriculum Development.* University Park, Pa.: The Pennsylvania State University.

Mayhew, Katherine, and Anna Camp Edwards. 1936. *The Dewey School: The Laboratory School of the University of Chicago.* New York: Atherton Press.

Murphy, Judith, and Lonna Jones. 1978. *Research in Arts Education: A Federal Chapter.* Washington, D.C.: U.S. Department of Health, Education and Welfare.

National Commission on Excellence in Education. 1983. *A Nation at Risk.* Reprinted in Communication of the ACM 26 (no. 7).

Nolan, Dennis J. 1974. "Freedom and Dignity: A Functional Analysis." *American Psychologist.*

Palisca, Claude. 1964. *Music in Our Schools: A Search for Improvement.* U.S. Office of Education. OE-33033, Bulletin 1964, no. 28. Washington, D.C.: U.S. Department of Health, Education and Welfare.

Phenix, Philip. [1962] 1968. "The Use of the Disciplines as Curriculum Content." In *The Subjects in the Curriculum: Selected Readings,* edited by Frank Steeves. New York: Odyssey Press.

Pinar, William, ed. 1975. *Curriculum Theorizing. The Reconceptualists.* Berkeley, Calif.: McCutchan Publishing Corporation.

Polyani, Michael. 1966. *The Tacit Dimension.* Garden City: Doubleday and Co.

Popkewitz, Thomas, Allan Pitman, and Arlene Barry. 1986. "Educational Reform and Its Millenial Quality: The 1980s." *Journal of Curriculum Studies* 18 (no. 3): 267-83.

Read, Herbert. 1944. *Education Through Art.* New York: Pantheon Press.

Remer, Jane. 1980. *Changing Schools Through the Arts: The Power of an Idea.* New York: McGraw-Hill Book Co.

"Report of the Committee of Ten." 1894. *Report of the Commissioner of Education for the Year 1892-1893.* Vol. 2. Washington: Government Printing Office.

Roszak, Theodore. 1969. *The Making of a Counter Culture. Reflections on the Technocratic Society and Its Youthful Opposition.* Garden City: Doubleday and Co.

Rugg, Harold, and Ann Shumaker. 1928. *The Child-Centered School.* Yonkers on Hudson: World Book Co.

Schubert, William. 1986. *Curriculum: Perspective, Paradigm and Possibility.* New York: Macmillan Company.

Silberman, Charles. 1970. *Crisis in the Classroom.* New York: Random House.

Smith, Ralph. 1975. "Educational Criticisms and the PPBS Movement in Education: Introduction." *Regaining Educational Leadership.* New York: John Wiley and Sons.

_____. 1978. "The Naked Piano Player: Or What the Rockefeller Report 'Coming to Our Senses' Really Is." *Art Education* 31 (no. 1): 10-16.

_____. 1986. *Excellence in Art Education: Ideas and Initiatives.* Reston, Va.: National Art Education Association.

Snedden, David. 1917. "The Waning Powers of Art." *American Journal of Sociology* 22 (no. 6): 801-21.

Stankiewicz, Mary Ann. 1984. "'The Eye Is a Nobler Organ': Ruskin and American Art Education." *Journal of Aesthetic Education* 18 (no. 2): 51-64.

White, William H. 1956. *The Organization Man.* New York: Anchor Books.

·LINE·&·FORM·
·BY·WALTER·CRANE·

·LONDON : GEORGE·BELL·&·SONS·
1908

In his book, *Line and Form*, Walter Crane distinguished between two types of art: one that drew on the <u>inner vision</u> of the imagination, and the other that depended on an <u>outer vision</u> to faithfully reproduce an external source. (Title page. Soucy Collection).

Above: "One-look memory" drawing by R. Catterson Smith's students. Smith believed that visual memory would be improved by this practice. Below: "Shut-eye" drawing by Birmingham student. Drawings done between 1912 and 1920. (Birmingham School of Art Archive).

Memory Drawing and Visualization in the Teaching of Robert Catterson-Smith and Marion Richardson

9 *John Swift*

Nineteenth century art and design education in England and France paid considerable attention to visual memory and its most usual manifestation, memory drawing. In England, memory drawing had been incorporated into three stages of the National Course of Instruction of the Department of Science and Art almost from its inception in 1852, and in France it had been promulgated by Horace Lecoq de Boisbaudran's book, *L'Education de la Memoire Pittoresque* in 1847, reprinted with additional text in 1879, and translated into English as *The Training of the Memory in Art and the Education of the Artist* in 1911. The English National Course of Instruction was mandatory at all schools of design or art; de Boisbaudran's book was widely used and many of his ex-students achieved influence as either artists or educators. The two examples above are chosen to represent a growing belief that memory drawing was important in the education of artists and designers; however, this is not to suggest that the role of the visual memory was uncontentious.

Visual memory, like memory itself, was seen as serving two distinct purposes: one was observing, recording, and memorizing in a factually precise manner where memory drawing replicated the original source; the other was being aware of, remembering, and reconstructing where memory drawing reflected a personal evaluation of the stimulus. In 1900 Walter Crane in *Line and Form* made an analogous distinction between "outward and inner vision." By outward vision he meant "faithful portrayal" and by inner vision, "imaginative conceptions, decorative designs and pattern inventions." The former relied upon the perception of Nature and the fidelity of the drawing to the source, the latter consisted of:

> unconscious impressions and memories which are retained and recur . . . which are similar but never the same as the objects they reflect. (Crane [1900] 1908, 220-22)

This distinction between re-presenting and re-creating is essential to the pedagogic ideas of Robert Catterson-Smith and Marion Richardson and is evident in their distinction between memory drawing and visualisation.

Walter Crane in common with other prominent Arts and Crafts persons attacked what they saw as the monotonous stranglehold of the National Course. Mostly they disliked its reluctance to allow students to design with actual materials, but they also questioned its view of drawing.

The Birmingham School of Arts and Crafts began practical design classes in 1887, and five years later became the leading English school in challenging the orthodoxy of design methods by its introduction of "art laboratories" (practical workshops). The headteachers, Edward R. Taylor from 1877 to 1903 and Robert Catterson-Smith from 1903 to 1920, were both ardent Arts and Crafts people, as were the staff they appointed. Both head teachers were convinced of the importance of visual memory as may be deduced from their respective publications (Catterson-Smith 1921; Taylor 1890, 1893) and the students' work in the School of Art Archives.

Taylor had extended the use of memory drawing to all levels and activities in the art school in the belief that drawing from memory exercised mental concentration more than objective drawing alone. He taught many ways of memorising, ranging from remembering the whole object, parts of objects, the principles of proportion rather than the appearance, to the order and direction of lines in the evolution of a drawing. Irrespective of the methods, Taylor's criterion for a good memory was consistent with that of the Department of Science and Art—one of precise replication.

Taylor was a significant figure within one of the largest provincial schools, an exhibiting painter, known for his publications on drawing and design, and the first president of the Society of Art Masters formed in 1888. When he retired his successor, Catterson-Smith, was appointed to continue the Arts and Crafts tradition.[1] Like Taylor, he was also interested in educational methods and drawing.

Catterson-Smith was born in Dublin in 1853, the son of a well-known Irish portrait painter, and had studied at the local art school before being apprenticed to Henry Foley RA, a sculptor. Catterson-Smith painted and exhibited at the Royal Academy and produced black and white illustrations for press publication. In the 1890s he began to study metalwork, assisted William Morris and Edward Burne-Jones at the Kelmscott Press, taught drawing and designing at the Central School of Arts and Crafts in London, and was appointed art inspector for the London County Council Technical Education Board in 1898. He was appointed to Birmingham in 1901, initially at Vittoria Street School for Jewellers and Silversmiths and later as headmaster of the whole Birmingham Art School in 1903. He was a member of the Art Workers Guild and the Arts and Crafts Exhibition Society and had been involved in proposals to co-ordinate the teaching of drawing in London secondary schools from 1898.

His early views on drawing were influenced by Thomas R. Ablett, founder of the Royal Drawing Society, and by a report on art teaching in primary schools in

Paris: both had argued for the educational role of memory drawing. Catterson-Smith's 1899 report, *Suggestions for the Teaching of Drawing in Secondary Schools* (U.K. London 1898-1902), was widely circulated and both Ablett and Taylor responded. Ablett commented on the similarity of Catterson-Smith's views to his own, but stated that the aims were too trade-based and insufficiently educational and psychological. Taylor's response was detailed but only minor in its range—he made no fundamental criticism (U.K. London 1898-1902).

On his appointment to Birmingham, Catterson-Smith had two roles to play. He was principal of the art school and therefore responsible for all the Department of Science and Art's courses and examinations for pupils of eleven and older (more usually twelve or thirteen), the training of art teachers, and the provision of classes for artisans and for middle-class leisure pursuits; he was also responsible for the teaching of drawing and art in all secondary schools in the Birmingham area under the aegis of the newly constituted Board of Education.

Catterson-Smith extended memory drawing at Birmingham further than Taylor in range and frequency. It became a necessary part of almost all lessons, a means of examination for scholarship entry to the school, and the subject of locally awarded prizes. However, it was not until 1910 that he "discovered" his distinctive approach: visualization or shut-eye drawing. In the earlier years at Vittoria Street and the Birmingham School, his memory drawing methods showed their debt to Ablett and Lecoq de Boisbaudran, and were similar to those of Taylor before him, apart from a greater emphasis on live animals as source material. The approach of all four men to memory drawing could be classified under Crane's term "outward vision": to reveal knowledge by the accurate duplication of the original source. Despite theoretical claims for "inner vision" it is difficult to see from the remaining student works where this ambition was realised.

However, Catterson-Smith's emphasis on memory drawing did not go unnoticed; it aroused the suspicion of the U.K. Board of Education. In its *Suggestions* of 1905, the Board had incorporated some of Ablett's and Catterson-Smith's uses of memory drawing—that it should be practised throughout the whole school course and should normally be undertaken during the last ten minutes of each drawing lesson. The Board saw it primarily as a means to test what had been remembered from the earlier lesson, and also as an encouragement for original observations reflecting interests and preferences. The *Suggestions* re-opened national debate on the purpose of memory drawing, and this was a feature of the growing awareness of the distinctiveness of different levels of education. Whilst Infant Schools tended to follow a Froebelian system, Elementary or Secondary Schools were caught between the legacy of the Department of Science and Art and the new ideas of the Board of Education. Generally, the more junior the level of education, the more visual memory was seen as personal; the more advanced the level, the greater the emphasis on knowledge regurgitation.

The different emphases may be seen by comparing two conferences held in London in 1908 and 1914. A series of papers was given in 1908 and published by London County Council four years later as *Reports of a Conference on the Teaching of Drawing in Elementary and Secondary Schools*. Although the majority report was fairly conventional, it suggested that memory and imaginative work should be evaluated on the originality of personal observation and thought, rather than on verisimilitude; the minority report argued for a more child-centered, self-expressive principle to be applied to all education, especially at elementary level.

Partly as a result of the *Suggestions of 1905* and the Teaching of Drawing Conference report, and partly as a result of growing interest in the whole educational field, the topic for the annual conference of teachers in London in 1914 was that of memory drawing (U.K. London County 1914).

The two major speakers were L.D. Luard, the translator of de Boisbaudran's book into English, and R. Catterson-Smith.

The chairperson, Selwyn Image, Slade Professor of Fine Art at Oxford, wished to distinguish between de Boisbaudran's and Catterson-Smith's method by suggesting that the former placed things in the mind, whereas the latter extracted things from it. Despite the ambiguous claim, both Luard and Catterson-Smith agreed that their memory drawing methods would make students more accurate, certainly equally as accurate as study by observation alone; that the storing of memory would incite imaginative ideas; and that the visual memory could be improved by training. Catterson-Smith had by this time "discovered" visualisation and spent some time explaining the method and showing examples. He claimed to be suspicious of too high a standard of imitative skills which might inhibit creativeness by establishing a transcribing habit. Nevertheless, when challenged by Clausen, Catterson-Smith defended his methods by arguing that his students could make more accurate copies because of their visualisation training than students raised on copying alone (U.K. London County 1914, 46). Clausen, Luard, and Catterson-Smith, despite their claims concerning the connections between visualisation and imaginative excitation, believed that accuracy of rendition formed the core of the teaching of drawing and that this pertained to memory drawing also.

Catterson-Smith's position of 1914 is repeated in 1921 when his book *Drawing From Memory and Mind Picturing* was published, but the reasons for his apparent dichotomy over memory drawing are traceable from the beginnings of his Birmingham headship.

As a stalwart of the Arts and Crafts movement, Catterson-Smith tended to welcome examiners who reflected this emphasis. Some of the earliest examiners to defend his approach to the Department of Science and Art and the Board of Education were Henry Wilson, silversmith and metalworker, and W.R. Lethaby,

architect. In the second decade of the century, William Rothenstein, painter, also advocated and supported the visual memory emphasis.

Wilson was the most powerfully articulate devotee of visual memory work, but his view of its capacity was far in advance of that of Catterson-Smith and certainly influenced the latter's thinking. In one sense Catterson-Smith was trying to find pedagogic means to achieve Wilson's claims, yet both men had some conceptual difficulty over the precise role of memory in drawing and art. As early as 1904, Wilson argued that memory left to its own devices would subconsciously correct errors of observation if the original object was visualised. He also stated that memory would reveal "racial as well as individual characteristics."[2] Nevertheless, the following year he partly contradicted himself by suggesting that the memory studies were so realistic and vivid, "that they might also have been made from the objects themselves," yet within the same report he argued that subconscious knowledge informed all conscious activity and that the most important quality was "virgin vision"—the individual mode of seeing the world possessed by the uneducated and the child.[3] This direct reference to the naturalness of children's art is reinforced by Wilson's paper given at the 1908 Conference on the Teaching of Drawing where he stated:

> criticism of the work of any child is . . . impossible, suggestion is dangerous, and interference is damnable. . . . For the child . . . discloses the palimpsest of its being. . . . memory does everything. (U.K. London County 1912, 47-48)

Wilson's persuasive view of the value of "natural" and visualised imagery influenced Catterson-Smith, and it is tempting to see his implementation of visualisation or shut-eye drawing as a technical response to meet Wilson's claims. In 1910 Catterson-Smith began his new method, according to the earliest dated visualisation drawings in the extensive archival holdings for this period. It attempted to free memory drawing from the recollection of previous drawings and all their potential faults, by concentrating attention on the source alone, and by preventing the observable act of drawing interfering with the recall of the memorised source.

The basic procedure is relatively easy to describe. The students were shown an object (two or three dimensional, inanimate or live) and asked to study it closely until they could clearly picture it in their mind's eye. On a small piece of paper (typically no larger than six inches square) they drew the mental image with their eyes closed. The object and the shut-eye drawing were removed, and the students produced an open-eye drawing from memory, referring to their mental image if and when necessary. This method was added to later as Catterson-Smith strove to find further ways of encouraging fluency and remanipulation of mental images.

The problem identified by Crane's outward and inner vision revealed itself in evaluating the results. The shut-eye drawings were typically of two kinds: one

with rapid, curvilinear, bounding lines which echoed the main shapes, rhythms, and directional flow of the object; the other a more slowly rendered, patient addition of lines which attempted to produce a more literal recall. Catterson-Smith preferred the latter approach. When the shut-eye drawing was contrasted with an open-eye memory drawing the problem of evaluation was increased—was it to be judged by its relationship to the shut-eye drawing (that is, the mental image), or to the original source? The evidence suggests that Catterson-Smith believed the latter. Thus, the open-eye memory drawing was evaluated for its likeness to the original source, and whereas this allowed some room for the altera-tion of detail, it tended to demand a high degree of replicatory emphasis overall. The lively and virile qualities of most of the shut-eye drawings were converted into rather staid and typical open-eye drawings which showed little direct refer-ence to the former's qualities. Catterson-Smith became aware of the rather dull quality of many of the open-eye drawings, but this was much later in 1918. By this time, Wilson considered that Catterson-Smith had found the correct method to release the dynamic, imaginative memory he had proposed:

> Catterson-Smith's method enriches and develops the personality of each student. . . . this method of teaching is the only one which follows natural lines . . . nurtures inborn creative faculties.[4]

Wilson doubted whether Catterson-Smith's methods were widely known by educationalists and suggested touring lectures and exhibitions of drawings and models should be arranged by the Board of Education. In fact, some of the work had already toured the British Isles and continued to do so after this date.

Although Catterson-Smith's precise methods found relatively few faithful adherents outside Birmingham (they did spread through his ex-students and were retained in all Birmingham schools until the mid 1940s), the general principles of the visualisation technique were far more widely used. The latter diffusion was assisted by four factors: the publishing of his book *Drawing from Memory and Mind Picturing;* the development of similar ideas by Roger Fry in *Transforma-tions* published in 1926; the inclusion of the method in the Board of Education's *Handbook of Suggestions* in 1927; and the growing effect of the teaching methods of one of his ex-students, Marion Richardson.

Marion Richardson had been a student of Catterson-Smith's at a very inter-esting period, 1908-1912, that is two years before he instituted shut-eye drawing, and for the initial two years of experiment. As such she was well placed to gauge the shifts of claimed emphasis from outward to inner vision and to consider the relative value of the two positions. She had studied from the beginning as an art pupil teacher and was especially ready to absorb, store, and eventually use suc-cessful teaching techniques. Initially, the consequences of Catterson-Smith's teaching can be seen clearly, but there is also growing evidence of Marion Richardson's ability to reappraise.

Within three years of her first teaching appointment at Dudley Girls High School in 1912, she had introduced her first Drawing Syllabus. Despite the restrictive examinations of the Board of Education, Richardson included methods of teaching derived from her Birmingham studentship. Training the memory and the visual faculty were integral to all drawing of standard subjects such as geometrical models, objects, and the figure. Whilst it is not certain that visualisation exercises preceded all lessons, being used to reinforce the subsequent open-eye drawings, she certainly used the shut-eye procedure for patterns.[5]

In 1917, in a written introduction to an exhibition of art work at the school (MRA: Drawing Syllabus 1917, np), she described her methods and aims more boldly (Swift 1986, 54-55). She dispensed with many of the standard lesson subjects and moved more surely towards a child-art, child-centred position. Her views on visualisation reflected this:

> To attempt to teach visual drawing, and at the same time to reject any genuine visual effort is both contradictory and dangerous. (MRA: Drawing Syllabus 1917, np)

Richardson was making a distinction between outward and inner vision. She was criticising the disadvantages of Catterson-Smith's methods where replication was the measure of success. Instead, she was suggesting that a "genuine visual effort" might lead to an image which was not derived from one observable source, or even from *any* observable source. Her pupils' work shows that she was laying the foundation for visualisation to function in the manner that Henry Wilson had argued for at Birmingham, that is, from unconscious sources that were by definition deeply personal (as well as collectively racial).

Her principal means of encouraging pupils to find their inner expressiveness were the mind-picture, the word-picture, beauty tours or hunts, colour and media exercises, observational study, creating a suitable physical and mental environment, encouraging the pupils' ability to evaluate their own and others' work, and extending art work into craft and design. The mind-picture was central to the creative and technical success of the other types of work (Swift 1986, 50-59). Whereas all the other areas used visual memory to recall or recreate from a given or directed verbal or visual stimulus, the mind-picture did not necessarily stem from any external source.

The mind-pictures were achieved through an almost meditative quietness where the pupils sat in a circle with closed eyes, and allowed images to rise to consciousness. Once such an image could be "held" (even if it was internally unstable, for example, pulsating, going in and out of focus, or altering scale), the pupil would return to her place and commence painting. No previous shut-eye drawing was made: the pupil worked from the immediacy of the mental image and referred to it by closing the eyes if and when necessary. The mind-pictures were predominantly non-figurative and showed a wide variety of technical handling, degrees of finish, and a tendency towards either a random-seeming aggre-

Marion Richardson prompted paintings like this by having her students close their eyes and imagine the scene while she gave a verbal description. They would then open their eyes and paint. (Marion Richardson Archive, Birmingham, 7.88, B. Roberts VVB, 17 Sept. 1925).

gation of shapes, or a more pre-determined pattern-like quality. A minority showed representational images. The quality of the result was then related to the inner vision. All pupils were asked to write comments on the relationship of the mind-picture to the internal image (usually below the actual painting), and the results of the group as a whole were openly discussed, evaluated, and marked through consultation. The pupils became adept at spotting a forced, incomplete, or unresolved mind-picture.

Richardson retained this teaching system to achieve her aims throughout her teaching at Dudley Girls High School, and carried them by theory and example into her advice and instruction as a lecturer at the London Day Training College and eventually as an art inspector for London County Council.[6]

Marion Richardson's ideas became extremely widely known. This was partly due to her identification with the child-centred, progressive movement, her work on handwriting, and a mistaken concept of a Richardson style of art. Her views were spread by her own articles published from 1919 onwards; her extensive lecturing around the British Isles and her visits abroad to Sweden, Finland, Russia, Austria, France, and Canada; an increasing number of articles concerning her ideas; the organisation of children's art exhibitions, the larger of which toured Canada, U.S.A., South America, and France; the publication of her book *Art and the Child* which was widely read in England and abroad; reference to her ideas in others' books, for example R.R. Tomlinson ([1934] 1950, 1944; Tomlinson and Mills, 1966), Margaret Bulley (1935), and William van der Eyken (1969); and finally by word-of-mouth by her devoted former students. Ironically, the wide public awareness of her ideas did not lead to a clearer understanding of precisely what she believed and practised. Considerable confusion existed, and arguably exists, concerning her influence on art education. Her posthumously published book (1948) was written during her terminal illness, is littered with inaccuracies, and suffers from a rather unfocussed viewpoint. Her unpublished writing was vital, purposive, and clearly revealed her developing thinking throughout her active art educational career.

However, it is her distinctive use of visual memory in terms of inner and outward vision that is important here. Her changes in approach arose from a position of knowledge. She was fully conversant with de Boisbaudran's book (her 1914 second edition copy is extensively annotated); she had been taught by Catterson-Smith during the exciting period of discovery of shut-eye drawing; she had studied his book published retrospectively in 1921; and she had remained in contact with him, as the letters in the archive demonstrate, until 1929 (MRA: Items 525, 677, 892). She was conscious of having moved in a different direction (Richardson 1948, 12), and Catterson-Smith was equally aware that she had extended and developed his ideas (MRA: Item 3169). Whilst she continued to advise her students at the London Day Training College in the late 1920s to read

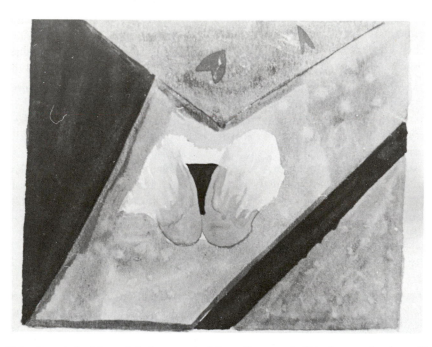

Richardson derived her mind-picture method from Catterson-Smith's shut-eye drawings. This work was done by one of Richardson's students at the Dudley Girls High School. (Marion Richardson Archive, Birmingham, No. 4931, K. Dews LV, ca. 1920).

the books of both men, it was also the case that her own thinking and practice had superseded their limitations.

She had divorced the two types of memory for pedagogic purposes, and recognised that the replicatory "outward-vision" would never capture the personal and private mental images by the means advocated by de Boisbaudran and Catterson-Smith. She had taken the bold step of allowing the "inner-vision" to surface, not by directing attention to the outside world, but by reflection within. The results, known as mind-pictures, were startlingly revolutionary. Children of eleven to sixteen were producing non-figurative, abstract paintings. The case is even more extraordinary when one considers that this was taking place in a girls' high school in a small industrial town on the outskirts of Birmingham, and that both the activity and the results are in advance of any British painter's attempts to move in that direction. The growth of personal self-confidence and sense of uniqueness engendered by the mind-picturing process, coupled with the technical skills necessary to recreate the mental image's qualities, permeated the pupils' approach to all other forms of picture and pattern-making.

Marion Richardson had understood, and realised in practice, the distinctive qualities of memory drawing and visualisation, and had used the latter to upset the orthodoxy of English art education by challenging the "tyranny of the object."

Notes

1. Catterson-Smith's references for the Birmingham position included some of the most eminent Arts and Crafts people: Edward Burne-Jones, painter, illustrator, and stained-glass designer; Philip Webb, architect; William De Morgan, encaustic tile designer; Walter Crane, designer, illustrator, and author; and T.J. Cobden-Sanderson, book designer and binder. (Birmingham Municipal School of Art Management Sub-Committee Minutes 1900-1901 Vol. 23 Attached 212.)

2. Vittoria Street School Minutes 1901-1907, 198.

3. *Ibid.* 222.

4. Birmingham School of Arts and Crafts Sub-Committee Minutes 1916-1921, 209.

5. Marion Richardson Archives: Drawing Syllabus 1915-1916 np, and item 4056. The Marion Richardson Archives are held at Birmingham Polytechnic, U.K., and are hereafter referred to as MRA.

6. Marion Richardson taught full-time at Dudley Girls High School from 1912 to 1923 and part-time from 1923 to 1930. During the latter seven years she worked in a variety of other schools around the country and held her own private art classes. From 1924 she worked part-time at the London Day Training College (now The Institute of Education, London University). In 1930 she was appointed as an inspector for the London County Council, a position she held until 1942 when increasing ill health forced her premature retirement.

References

Boisbaudran, Horace Lecoq de. 1911. *The Training of the Memory and the Education of the Artist*. Translated by L.D. Luard. London: MacMillan.

Bulley, Margaret. 1925. *Art and Counterfeit*. London: Methuen.

_____. 1937. *Art and Understanding*. London: Batsford.

Catterson-Smith, Robert. 1921. *Drawing from Memory and Mind Picturing*. London: Pitman.

Crane, Walter. [1900] 1908. *Line and Form*. London: Bell.

Eyken, William van der, and Barry Turner. 1969. *Adventures in Education*. U.K.: Penguin.

Fry, Roger. [1926] 1956. *Transformations*. New York: Doubleday and Anchor.

Richardson, Marion. 1948. *Art and the Child*. London: London University.

Swift, John. 1986. "Marion Richardson and the Mind Picture." *Canadian Review of Art Education Research* 13: 49-62.

Taylor, Edward R. 1980. *Elementary Art Teaching*. London: Chapman and Hall.

_____. 1893. *Drawing and Design*. London: MacMillan.

Tomlinson, R.R. [1934] 1950. *Picture and Pattern Making by Children*. London: Studio.

_____. 1944. *Children as Artists*. U.K.: King Penguin.

Tomlinson, R.R., and John Mills. 1966. *The Growth of Child Art*. London: London University.

U.K. Board of Education. 1905. *Suggestions for the Consideration of Teachers and Others Concerned in the Work of Public Elementary Schools*. London: His Majesty's Stationery Office.

_____. 1927. *The Handbook of Suggestions for Teachers*. London: His Majesty's Stationery Office.

U.K. London County Council. 1898-1902. *Art Teaching in Secondary Schools*. Miscellaneous Minute Book 2, Technical Education Board. London.

_____. 1912. *Reports of a Conference on the Teaching of Drawing in Elementary and Secondary Schools*. London.

_____. 1914. *Report of the Proceedings of the Annual Conference of Teachers*. London.

11

151

THE DAILY COLONIST, VICTORIA, B.C., THURSDAY, AUGUST 2, 1934

Supervisor of Art In London Schools Addresses Teachers

Miss Marion Richardson, Visiting Canada for Canadian National Gallery, Gives First of Three Lectures at High School

"CHILDREN'S art is the first direct way of getting an understanding of adult or mature art. This is one of the reasons why we should be at some pains to study children's art. I believe if people are interested in art at all, they will do well to study it from its simple beginnings as seen in the work of children, peasants, and primitives rather than in the elaborate finished products of trained adults," said Miss Marion Richardson, supervisor of art in the London County Council schools, in the course of her illustrated lecture to a big audience of Summer School students at Victoria High School, yesterday.

Here in the course of a Dominion-wide tour that she is taking under the auspices of the Canadian National Gallery, Miss Richardson is to give two more lectures, both free and open to the public, one on "The Teaching of Picture Making," to be at the High School at 10 o'clock this morning, and the third lecture to-morrow afternoon at 2 o'clock on "The Making of Patterns."

"The adult cuts himself off from art by making it a complex thing. He becomes too interested and over-impressed by the skill implied in art, and in so doing misses the emotional message that exists in art," she told her audience.

OBJECTS DEFINED

School handbooks, until recently, had missed the point of the object of teaching art in the schools. Miss Richardson, to illustrate this view, quoted from a handbook first published in 1905. This same handbook devoted just ten times the space to defining the aims of art instruction. In the earlier edition the principle had been laid down that the aim of teaching drawing was to enable the scholar to represent accurately any given object, by copying, or faithful imitation, "attained only after long and continuous practice." The 1927 edition, on the other hand, held that the object of teaching art was to provide the child with a means of expression and a means of reproduction. The end of art

As an evidence of this craving for art expression, she told the story of her own pioneer efforts sixteen or seventeen years ago in Birmingham. From the prison authorities there she secured permission to give classes in embroidery to a group of "abnormal" adults, who responded wonderfully to the lessons, and in many ways showed their appreciation of the occupation and the creative outlet provided. The women, from the beginning, had created their own designs.

From this experiment the work developed out into many sections of the prison, including that where juvenile first-offenders were kept. Today handicrafts and other forms of art expression were almost general throughout the prisons of England, particularly in the city prisons, the instructors being partly paid, partly volunteer.

A STIMULUS

"The object of these classes was not to provide a pleasure or indulgence for the prisoners, but to supply them with a stimulus, to eduate them rather than merely punish them," she explained. In dealing with difficult and unhappy children it was found that drawing would give them peace and poise.

The lantern slides, which accompanied the talk, were of great interest. Particularly noticeable to a British Columbia audience was the difference in subject matter chosen by the children—a visit to Southend,

VICTORIA

SUPERVISOR OF ART LECTURES

Miss Marion Richardson, London Instructor, Addresses Summer School

In undertaking the study of art it should not be considered from the elaborate finished product of the trained adult, but it should be studied from its simple beginning as evidenced in the work of children, peasants and primitives, Miss Marion Richardson, supervisor of art in the London County Council schools, told an audience of summer school students at the Victoria High School yesterday.

Miss Richardson is in Victoria making a lecture tour under the auspices of the Canadian National Gallery and illustrated her address with a number of excellent lantern slides.

She spoke again this morning on "The Teaching of Picture Making," and to-morrow afternoon she will discuss "The Making of Patterns."

In studying art the adult missed its emotional message by making it a complex thing and becoming too interested and over impressed by the skill implied in arts, she said.

Miss Richardson thought school handbooks, until recently, had missed the point of teaching art in schools, by laying down the principle that the

In 1934, Richardson made a lecture tour of Canada and the northeastern United States. These clippings are from her stop in British Columbia. (Marion Richardson Archive, Birmingham, No. 3315).

152

Simple equipment to facilitate the placing of models and nature specimens in the classroom.

Part of box as substitute for stand.

This could be made by any senior grade boy in the manual training shop.

about 22"

Tear two slits in a sheet of paper. Insert stem and rest against a book.
Once made these are always ready for use.
Tie rubber bands through holes.

Light card folded upon dotted lines Convenient size about 5" x 7"

Hints for art teachers from W. P. Weston's 1933 school art text for British Columbia. Although this book was authorized for use in various Canadian provinces, it is difficult to assess how many teachers were able to follow Weston's practical suggestions. (Weston, *A Teachers' Manual of Drawing*. Soucy Collection).

Art Education Curriculum in British Columbia Between the Wars: Official Prescription—Unofficial Interpretation[1]

10 *Anthony W. Rogers*

"We used red inner tubes to make pencil cases and purses. They were punched as for leather and had rubber thonging. They even had snap closures." So recalled a teacher about his art lessons in a rural school during the 1930s (Fred Flick, Interview, May 1983). This activity did not appear anywhere in the official *Programme of Studies,* nor was it taught at the Normal School, yet it was typical of much "art" that went on in the public schools.

Such an example illustrates the gap that can exist between what actually happens in the schools and what is prescribed. Too often, curriculum history is a history of policy rather than of educational practice. So too is art education history. If we ignore how policy is translated into practice, we ignore reality; yet, if we concentrate on practice, we ignore official prescription. As official curriculum represents what is valued by the policy maker, this paper first examines the official curriculum for art education in the schools of British Columbia (B.C.) during the interwar years. It then discusses how that curriculum was interpreted at the two Provincial Normal Schools. Finally, it looks at how teachers translated the official policy and their training into practice.

While the paper is a study of school art education in one Canadian province, similar discrepancies between what was advised and achieved might be found across the country. The B.C. official art curriculum, after 1924, was wedded to school art education notions that had been current in Britain at the turn of the century. That in Ontario owed more to American theory, while New Brunswick remained in the iron clutches of the outmoded copy book. Nevertheless, what went on in their schools probably had much more in common than did those provinces' diverse curricula.

With a much higher than average percentage of British immigrants in B.C., it was hardly surprising that the educational hierarchy in the province was dominated by British concepts. In art education this led to a public school curriculum that reflected the fundamental British belief in natural form as the basis of design

and beauty. In particular, the curriculum, after 1924, owed much to the results of the comprehensive restructuring of the British syllabus that had occurred between 1895 and 1905.[2] One could concoct complex theories why British notions of art education suddenly reappeared in British Columbia a quarter of a century later, but the reason is probably quite simple. Many of the British immigrants had come as part of the great wave of immigration to the province that occurred in the first ten years of the century. They had brought their British training an experience from that time with them as part of their cultural baggage. By the 1920s the more able, or more ambitious, British teachers had reached positions of influence in the educational hierarchy and so could impose their own notions. In effect, two Scots and an Englishman held the art education reins. John Kyle was provincial Director of Technical Education. He had great influence generally in the Department of Education and also ran the summer school for teachers. Charles Scott was Supervisor of Drawing for the Vancouver School Board. Very ambitious, Scott played a major role in agitation for an art school in Vancouver, managing to become its first director in 1925 and to hold onto the position for twenty-seven years. Bill Weston was Art Master at the Vancouver Normal School, the larger of the two such institutions in the province. The three men were close friends. The wide demands of Kyle's civil service position, and Scott's growing preoccupation with the rapidly expanding art school, in time led to Weston assuming the major responsibility for the provincial curriculum.

As soldiers returned and the province resumed normal life after World War I, there was a general feeling of confidence in the future. In education this was expressed in a number of ways. The official Course of Studies changed from a three grade to an eight grade system in 1923, reflecting the growing number of large schools; a largely unsuccessful attempt was made to replace small rural schools with larger "consolidated schools" to which students could travel by bus; there was an increasing clamour for a comprehensive assessment of the first fifty years of public education in B.C.

An Art Education Text for British Columbia

In art education, the government, probably at Kyle's instigation, decided that the time had come for B.C. schools to have a home-grown art text. Scott and Weston were asked to write it. They agreed, bringing in Spencer Judge, a Vancouver teacher and friend, as third author. Their book, *A Manual of Drawing and Design,* was published by Thomas Nelson and Sons in Toronto on behalf of the B.C. government in 1924. Up to that time the recommended texts for art education had been an ill-assorted grouping of English, American, and Canadian texts and copy books. They were instantly discarded and the new book became the only text, providing a cohesive programme for the first time. In fact, it became

virtually the curriculum, with an official Programme of Study being rewritten to indicate this. The approach it advocated would hold sway officially for thirty years.

Although Scott was listed as the senior author, Weston actually made the major contribution to the book and, when it was later rewritten in 1933 as *A Teacher's Manual of Drawing,* Weston did this alone. In 1936 a complete overhaul of the province's curricula was made by the Department of Education. Weston was chairman and sole government appointee to the committee that wrote the new elementary art curriculum. At a glance the curriculum looked new, for Weston couched it in the language of the progressives. In fact, the ideas and philosophy remained unchanged and Weston's manual continued to be the official teacher text. This 1936 curriculum survived until 1954.

The 1924 *Manual* represented a new approach to art education in B.C. It introduced the term "design" to the curriculum for art and it expanded the role of drawing, particularly at the lower grades. Drawing from nature had a central role, with skill in drawing being seen as the basis for all art. The text gave the teacher more freedom to introduce new ideas to the class and it assumed that, while not all might be artists, all could learn to draw adequately. All of these notions could also be found in the British 1901 art syllabus. The *Manual* did not follow British practice quite so closely in its attitude to memory drawing. At times it was advocated, but at others it was cautioned against. This ambivalence would seem to have resulted from disagreement between Weston and Scott on the matter. Weston held the traditional British view of its value, Scott did not. In the 1933 edition Weston removed the ambiguity and stressed the value of the practice.

In addition to seventy-four pages of illustrations the *Manual* had forty pages of instructional text. Of these, twelve were devoted to a discussion of design and were written by Weston alone. For him design was not invention, but simple arrangement or composition. It was ornament.

> Ornament may be described as everyday art. It may be seen on every object with which our daily doings bring us in contact. . . . It would seem reasonable that people in general should know something of the common principles underlying the construction of good ornament. (Weston 1933, 73)

He believed that children would develop a sense of order, arrangement, and construction as a result of a study of design. Although his system relied to a large extent on copying and rearranging before eventually producing more original designs, at the same time he saw it as essential that children should go beyond the copying stage. Copying was merely a teaching device. The creative instinct would grow along with skills and both would "stimulate a sense of the beautiful in form and colour" (73). This was a British concept of art education and, in such an approach to ornament, the *Manual* showed its affinity with even older ideas than those expressed in the 1901 British syllabus.

W. P. Weston was largely responsible for the 1924 B. C. *Teachers Manual,* from which this plate comes. Weston and his colleagues believed that students' artistic confidence would come from learning good techniques. (Scott, et al., *Manual of Drawing and Design.* Soucy Collection).

The *Manual*'s affinity with the 1901 British syllabus could be seen in detailed suggestions as well as in broader aims. The British syllabus stressed drawing with both firm and flexible points, it emphasized drawing from nature, it dealt with analysis and comparison of form. So too did the *Manual*. Both suggested that the work should progress from drawing in outline with straight lines, to the use of curved lines, then to an appreciation of light and shade and to the use of colour. More than anything it was the clear logical progression in skill development that marked the *Manual* as being in the British tradition.

The view of art education propounded by Weston and his colleagues may seem alien to some art educators today. Whether or not this is so, it is important to understand their reasoning if we are to have any true understanding of the curriculum. The authors of the *Manual* felt that if children learnt good techniques and skills, their confidence in their abilities would give them freedom to express their creativity. Design provided for the appreciation of that creativity and for the recognition of design as it exists in the natural world.

The book was full of examples of the application of nature to design problems. Much use was made of conventionalized forms. Colour harmonies were discussed and the use of analogous and contrasting colours were explored. This was all tied in with the development of geometric forms and the book was dotted with examples of pattern. Even more examples would be given in the 1933 text.

Art Education in the Normal Schools

If the official curriculum was British in intent and form, what was the approach taken at the normal schools in Vancouver and Victoria? In the mid-twenties, seventy-eight percent of all the province's teachers were trained at the two institutions with two out of three attending the school in Vancouver.

In Victoria the Art Master was Harry Dunnell. He had originally been brought out from England in 1900 to set up the Manual Training program, moving to the position of Art Master at the Victoria Normal School when it opened in 1915. On his retirement in 1931 he was replaced by Canadian-born John Gough whose only art training had been as a student of Dunnell's some years earlier. Gough resigned in 1942. Gough considered himself a misplaced Social Studies teacher and it is perhaps significant that, in a taped reminiscence of his days at the Victoria Normal School, he completely forgot to mention he had been the Art Master. Although all students took art as part of their program, in interview after interview in later years, ex-students failed to remember much of either art teacher or art classes. Those students who did remember something of his courses had few highlights to recall. "I think we were taught how to go about teaching children art," mused one, "how to set out paper and so on. Nothing elaborate."

A photograph of Gough's art room at the Normal School taken some time after 1938 shows some of the work done by his students. Most notable are the posters done for the Victoria Music Festival. As the posters are dated we know that Gough gave exactly the same assignment for at least four consecutive years. With a single exception they are all remarkably similar. On a dark background, the art work is contained neatly within a light border line. The lettering is clear and simple with each poster having a single bold decoration. They fit exactly the criteria for posters given on page 107 of *A Teacher's Manual of Drawing*. Similarly, the other work in the room looks as though it was dictated by the same manual. There are student produced charts of analogous colours, complementary colours, and colour harmonies; there are wash drawings and mass drawings; there are conventionalized designs; there are travel posters. All in all, this remarkably clear picture suggests that the art course consisted of everyone doing the same thing at the same time, based upon the same official text.

This was confirmed by Gough's successor, A. Wilfred Johns. Himself a student of Dunnell's in 1922, he found that Gough was still teaching the same course in the same way as Dunnell had then.

> I don't know what [Dunnell] expected, but the point is that everyone did the same thing. Everything was just so. You followed a little book and you found out exactly what you should do and that was it. . . . In penmanship, in art, everyone had to do the same thing and both of these went against my grain.[3]

It is clear that teacher education at the Victoria Normal School closely followed the curriculum. Student-teachers received a careful training in some specific skills which would enable them to go out and have students produce conventional images. They were not encouraged to create wildly original work, but they would be able to produce bold simple images and clear simple display alphabets. That may be all that should have been expected from a fairly short course which had to take entirely untrained young people and have them ready within one school year to assume complete responsibility for a class of children in up to eight grades. The fault of the program was that it lacked excitement and did not encourage students to go beyond what they were taught. Students were taught methods but they were not taught to think about art.

At the Vancouver Normal School a different situation existed. There the Art Master, from 1914 to 1946, was Bill Weston. Although he was the author of the official text, and did indeed use it quite widely in his course, the results were dissimilar from those in Victoria. For one thing, both Weston and his teaching seem to have been remembered by his students, and with enthusiasm and affection. "He was just It!" one former student still enthused almost forty years later, and her comment was echoed by the others.[4] His teaching went beyond the exercises of the printed page to extol the ideas behind them. He was a charismatic teacher with the ability to inspire. Today he has been somewhat forgotten by the

public, but during the 1930s "W.P. Weston" was at the forefront of the new western Canadian art. A charter member of the Canadian Group of Painters and the first B.C. artist to be elected to the Royal Canadian Academy, his artistic standing gave him added stature with his students. A member of the Vancouver School Board in the mid-thirties, who had reason to visit his classes, described him in these words:

> I remember feeling that [Weston] was much superior to many others that I had come in contact with . . . and being quite impressed with him and his own work as well as with the teaching. . . . [He allowed] more scope for creativity, encouraging students to express their own feelings through their art and to reach out to understanding the basis of their art and the interpreting of art. Not just a picture that you looked at, but what was behind it and so on. (Mildred Fahrni, Interview, February 1983)

Her comment summed up much of the essence of Weston's success as an art educator. Weston encouraged his students not only to develop their skills but also to push beyond what they considered their limits to explore new ground. Although the formal content in his course did not break new ground, he made students think about art and he helped them develop confidence in their own abilities.

I have stressed the difference between the art teachers at the two Normal Schools because it was their personal qualities that made the difference between the two courses. In Victoria students were presented with the material by teachers who had no great interest or belief in it. In Vancouver students learned from a man who had a passionate belief in what he taught. He had the training both as artist and teacher to provide grounding in technique and to inspire in others the confidence that he was right. This is not to suggest that he was overconfident. Rather those who knew him suggest he was a very humble man. As far as the students were concerned he was a great success because he met each one at his or her own level of ability and started from there.

Inspirational though Weston may have been, his course followed straightforward lines. Nevertheless, students thought his course unique. It as not just his personality that impressed them. Rather, it was that he encouraged students to go beyond the formal course to develop their own talents and creativity. In his insistence that skills must be developed along with, or possibly in advance of, creative ideas, Weston's system went right back to his own training in England at the turn of the century. The challenge he presented to students was his own good teaching. As a fellow teacher summed it up:

> He seemed to be able . . . to bring forth the timid. . . to find some facet in art that would interest each person . . . to help them choose an area where they had some latent ability.[5]

The Normal Schools were not the only way in which the curriculum could be interpreted for teachers. The other major way was through the art courses at the annual Summer School for Teachers at Victoria. Art courses at the summer school were always popular and while courses in some subjects would flourish and disappear, the art courses were always offered. As constant as the courses was one instructor, Bill Weston. He was by no means the only art instructor, but he was the only one to go regularly. It gave him both a new audience for his ideas and an old audience to reinspire. His courses covered much the same material as did his winter course, but in a much more relaxed atmosphere and with a good deal of outdoor sketching.

The differing experience of students at the two Normal Schools suggests that caution must be exercised by historians when writing of curriculum matters. Both schools were training students to teach the same art curriculum and both covered similar ground. Yet the outcomes were very different. The reason for the difference seems to lie in the differing personalities and effectiveness of the instructors. In Victoria students were taught the methods; in Vancouver they were inspired by the theory behind the methods. Although educators know that teaching is a very personal art, it is often hard for educational historians to give sufficient account of it. It is an art that is not recorded and it takes place in the closed environment of the classroom. Nevertheless, it must be taken into account in any history of curriculum that claims to reflect what was taught.

Theory Into Practice in Provincial Schools

Turning from the two Normal Schools to look at how the art curriculum was translated into practice in the schools of British Columbia, the matter becomes even more complex. From two institutions and one persistent enthusiast, who dominated the scene with little competition, we must now consider a thousand or more schools and several times as many teachers.[6] In the majority of schools each teacher was responsible for his or her own art program and, even in the few large urban schools, there were not many specialists. In 1929, for example, 540 teachers out of 1147 in the 66 Vancouver schools were teaching art.

Nevertheless, there did seem to be a clear division between art as it was taught in urban schools, particularly in Vancouver, and art as it was taught in rural areas. Often, in rural schools, the official curriculum was little followed, whereas in Vancouver it was followed too slavishly. One reason for the difference may have been that Vancouver employed a Drawing Supervisor, S.P. Judge, who had been the third author of the 1924 *Manual* and who frequently visited teachers' classrooms, whereas rural teachers were irregularly inspected.

Although not directly involved with the Vancouver schools, Weston did visit them. All too often he was disappointed by what he saw and complained that

teachers did no more than have students copy the textbook. In part this may have been the result of Judge's influence and in part it may have resulted from the security that following a text gave the teacher who felt inadequate in art, especially when inspection was frequent. However, it may also have resulted from Weston's own technique of teaching the skills through copying before leading the student into more creative fields. He seems to have overlooked consistently that his own methods relied so heavily on copying, and the specific instructions in his text unintentionally may have done much to discourage creativity in the schools. In his own hands the system of teaching art was effective, but, without his enthusiasm and special understanding, the system perhaps did not work so well. It would probably not be unfair to suggest that art education in Vancouver schools was but a poor imitation of the desired curriculum.

Turning from the sixty or so Vancouver schools, which served one-third of all the children in the province, to the thousand which served the remainder, we find a somewhat different situation. In the rural schools there was a constant movement of teachers for a variety of reasons. In some cases teachers saw the one room school as a stepping stone to a more desirable job in a city school. The unwritten, yet rigid, rule that a woman retire on her marriage constantly opened up teaching positions. Often though, teachers just sought a change. Even during the worst part of the Great Depression, when the poor economic situation made jobs more difficult to get, there was a surprising movement of teachers from place to place. This meant there was very little continuity in programs.

When we look at what was actually taught in the rural schools, at first glance there seems to be few common patterns. Nevertheless, Friday afternoon was definitely the popular time for art in the rural school for many reasons. It could bring the week to an end on a less structured note. When well taught, art was a popular subject and so ended the week on an upbeat; even when not, teachers thought art a useful time-filler when everyone was tired. For a few teachers it brought to a conclusion art activities that had been commenced throughout the week, but for many it was the only time that art activities were encouraged or allowed. In some cases art was relegated to Friday afternoon so that if work in other subjects took longer than expected, such work could be finished during the Friday afternoon without disturbing anything that the teacher considered important.

These motives may suggest that art was often considered less important than other subjects in the rural school. Talking to retired teachers about their art programs, a very strong impression is given that this was indeed the case. By and large those who talked about their art considered it important, but in every case the informant felt that he or she was unusual and that teachers in other schools did not teach much art, while some taught none.

If some taught no art and a few taught a lot, what did the majority teach? In some cases they tried to follow the curriculum. The problem was that the official curriculum referred the teacher to the official text. Alone, it provided too brief an overview of the program to be useful. While the provincial education department definitely bought enough of the teachers' texts to supply all schools, in many cases these books did not seem to reach their destination. Of nine retired rural teachers whom I asked specifically about art texts, only one could recall having seen or used any. Some teachers relied on their Normal School notebooks and the skills they might have learned there, but as often as not they relied on their own ingenuity.

In most rural schools money for supplies was very limited, so bought materials, such as paint and construction paper, were precious. Such lack of funds was not, however, a phenomenon of the Depression. Schools throughout the inter-war period were short of funds. In fact, when the price deflation of the thirties is taken into account, schools generally had more adequate funding then than they had had during the previous decade.[7] It was the individual who suffered from the Depression, not the institution of education.

Art projects were often dictated by what could be scrounged. The teachers used gunny sacks, lard pails, old tires, and the Eaton's catalogue, or whatever they could acquire free. Not only did art projects have to rely on the materials available, but they had to be suitable for children of widely different ages. It was impractical to have a separate project for every grade in a one room school. The range of art projects relied to a great extent on the ingenuity of the teacher. Perhaps among the most inventive was the "leatherwork" unit using old inner tubes, referred to at the beginning of this paper.

The most useful and widely used free art supply, however, would seem to have been the Eaton's catalogue. Its pictures could be cut out to make collages, to decorate greeting cards, or to convert a glass jar or bottle into a vase. Suitable illustrations could be found to illustrate a point in a poster. Should there be any colored pages they would be cut into strips to help make the endless paper chains essential to the celebration of Christmas.

Gunny sacks were invaluable too. Even the most clumsy could embroider some kind of decoration on them with wool from home, or possibly with raffia if the school could afford it. Decorative mats were relatively easily made by selectively drawing out the threads and many a cardboard model house had sacking for drapes and carpet.

If local clay was available then the ware could be fired in the school's potbellied stove. Many pots never made it to completion, but those that did brought a great sense of satisfaction. In one of its few articles on art projects, the teachers' journal, the *B.C. Teacher,* carried full instructions, but the project remained a difficult one (Bradley 1937).

The list could go on. Many of the projects were craft rather than art, but drawing and painting did have their place. Posters and murals based on seasonal themes, such as Hallowe'en and Christmas, were always popular and gave the opportunity to teach some colour theory. Geometric designs were considered worthwhile exercises and could be used to help decorate a poster. Some picture-making as an adjunct to other subjects might also be done. However, in many schools drawing was not a creative endeavour, but simply a copying exercise from an object or picture. In some, the subject was not even attempted.

Conclusion

The question of how the curriculum was translated into practice allows no single answer. In rural schools the various situations were diverse and the isolation of teachers from each other discouraged many common themes. However, whether teaching art well or badly, rural school teachers rarely used any prescribed text and found the prescribed curriculum alone to be inadequate. In city schools art was definitely taught, but with such close adherence to the text that the creative intent behind the exercises was lost.

Where a successful art program was offered, it was the result of the ability and enthusiasm of the teacher, perhaps one who had been stirred by Weston's example. Some, at any rate, attributed their success in art to him. A curriculum was officially laid down, but overall its success relied on how what was prescribed was adapted, changed and presented and in how the student was inspired and motivated to perform.

An examination of the art curriculum in B.C. between the wars demonstrates how, in urban schools, too close an adherence to a prescribed curriculum often defeated the intent behind that curriculum. In rural schools, it also demonstrates how too brief an explanation of the curriculum could defeat the purpose of the prescription. It also underlines the fact that in art, as in other subjects, the rural school situation was markedly different from that in the urban school.

The art curriculum of the interwar years was, in many respects, a failure. The chief reason for this may well have been the lack of adequate explanation for the intent behind the curriculum, rather than the curriculum itself. It leaves begging the questions of whether any official curriculum will be successfully put into effect or whether in fact this matters at all if the intent is achieved in some way or other.

Notes

1. My thanks to Drs. J. Donald Wilson and Gillian Weiss for their helpful comments on an earlier draft of this paper.

2. For a detailed examination of the "revolution" in British art education around 1900 see A.W. Rogers, "W.P. Weston, Educator and Artist: The Development of British Ideas in the Art Curriculum of B.C. Public Schools" (Ph.D. diss., University of British Columbia, 1987), pp. 49-128.

3. A. Wilfred Johns. Interview with Judy Windle on 27 November 1978. University of Victoria archive. Accession No. 78-t-25.

4. Interview with Violet Sketchley at Vancouver, March 1983. See also interviews with Winnifred Weir (June 1983), Marjorie Clark (November 1982), Nina Lorimer (February 1983).

5. Elmore Ozard in interview with Cal Opre in Vancouver, April 1974. Tape in possession of W.P. Weston's daughter, Doris Wood.

6. For example, in the 1922-23 school year, 3,118 teachers taught in 1,044 schools; by 1937-38, 4,092 teachers taught in 1,172 schools.

7. See Rogers, "W.P. Weston, Educator and Artist," for a wider discussion of B.C. school finances in the nineteen-thirties.

References

Bradley, R. Kenneth. 1937. "Pottery-making in the Rural School." *B.C. Teacher* (June): 498-500.

Scott, Charles, W.P. Weston, and S.P. Judge. 1924. *A Manual of Drawing and Design.* Toronto: Thomas Nelson and Sons.

Weston, W.P. 1933. *A Teacher's Manual of Drawing.* Toronto: Thomas Nelson and Sons.

A complex image consisting of multiple prints of a single, rectangular lino block, bearing successive, accumulating incisions. The result is a compelling image in its own right, which also contains an in-built, frame-by-frame record of its process of origination. (From R. Hamilton, T. Hudson, V. Pasmore, and H. Thubron. 1959. *The Developing Process*, London, ICA; by permission of the University of Newcastle-upon-Tyne and the Institute of Contemporary Arts, London).

Transmutations of circular and rectangular forms, openly revealing the logic in its stages of transmutation, and also exploring positive and negative effects. (From R. Hamilton, T. Hudson, V. Pasmore, and H. Thubron. 1959. *The Developing Process*, London, ICAA; by permission of the University of Newcastle-upon-Tyne and the Institute of Contemporary Arts, London).

Educating in Contemporary Art: The First Decade of the London Institute of Contemporary Arts

11 *David J. Thistlewood*

The Institute of Contemporary Arts was established in London in 1947 with the express purpose of creating a highly informed nucleus of individuals practising contemporary arts and deeply committed to their theoretical development. It was confidently expected that this would effectively inform the mass of the population through widening circles of communication. The ICA encompassed all the visual, plastic, and performance arts, including photography, film, poetry, drama, and architecture. But its most notable achievements were in the realms of painting and sculpture, then affected by an astonishing ignorance of artists more recent than Cézanne or Rodin. The ICA still exists, of course—it is Britain's foremost exhibition forum for experimental creativity. But throughout its first decade it was self-consciously a proselytizing institute, and it is this aspect of its work, allied to the subjects of contemporary painting and sculpture, that is the focus of this paper.[1] This is not a systematic history, however; it is too selective to chart an extremely complex organization properly. Rather, it concentrates on the issue of introducing "ordinary" individuals to "avant-garde" creative practice deliberately without reference to any of art's entrenched conventions. It highlights how certain creative idioms were believed to be more teachable than others, and therefore to offer the general public more promising insights into practice.

Among the principal founders of the ICA were the poet, art critic, and theorist Herbert Read and the Surrealist Roland Penrose, friend of Picasso and Matisse. Penrose's interest in the ICA was that of the artist, keen to widen the breadth of participation in art. Read's was that of the educational theorist, the venture providing his first serious opportunity to implement ideas only recently advanced in his book *Education Through Art* (Read 1943). The problems they addressed must have seemed almost insuperable, crystallizing in the possibility that the ICA's target membership—a cross-section of the educated middle classes weighted towards those involved in art by vocation—would have had fixed expectations of the nature of art and of the institutions necessary to dignify it.

These preconceptions may be glimpsed by recalling that the remnants of the Victorian *National Course of Instruction* were still effective in Britain's art colleges in the 1940s (Macdonald 1970), and that this country had no institutions devoted specifically to the husbanding of contemporary (that is, emergent) art. It no doubt surprised many potential members that the ICA was not to be an academy, a concept too tainted with daunting conventions. Instead it was to be more closely related to the museum, a type no less affected by fixed expectations except in respect of its educational purposes.

Britain has a very sparse history of museum-directed, popular education in twentieth century art, involving anything other than lecturing. Prior to the ICA, there is no evidence that any major museum instigated public programs in handling, making, or emulating modern art. Art museums were then, as now, concerned with being popular, and measured this property by attendance totals. But they traded principally in the act of witness, and were indifferent as to whether this was informed or uninformed. What was "real" in the realm of art to the ICA's potential membership was likely to embrace such things as line engravings after Constable or Turner and sepia photographs of Impressionism. The works themselves, the original subjects of such disfiguring interpretation, would have seemed about as "real" as they were "modern," for their "reality" would have been determined in relation to poor copies. These copies, however, would have been boosted with a great deal of contextual explanation about intentions, technique, and credibility-enhancing incident. Original works of art on the walls of museums would have seemed familiar but with distinctly unfamiliar aspects. This unfamiliarity would have been both visual and conceptual, for the customary cataloguing and labelling would have been (as again it still so often is) geared much more to provenance than promulgation. The only good portents for the ICA were these rather negative ones: there were few fixed expectations about how a museum might educate its public; and most art of the twentieth century was unpublished in reproduction, had not been rendered unreal in this way, and remained capable of being realized through education.

For a potentially appreciative circle in Britain in 1947 *contemporary* art meant phenomena originating in continental Europe, cultural "imports," and acquired tastes. Impressionism had taken root in Britain during the first decade of the century and was still being practised. Roger Fry's famous expositions of Post-Impressionism had been derided in 1910 and 1912. This idiom was popularly considered the art of deranged individuals, and Fry's interest explained as the late eccentricity of a once-respected scholar (Spalding 1986). International Surrealism had been exhibited in London in 1936,[2] inexplicable and unexplained. International Constructivism had followed a year later,[3] accompanied by a public information program which, at the opposite extreme, had almost overdone its apologia. The wartime works of Picasso and Matisse had been exhibited at the Victoria and Albert Museum in 1946, outraging polite good taste. Bauhaus prin-

ciples, on the other hand, had become well-accepted. Many of its major figures had taken refuge in Britain before the war and had earned their livings in architecture, film design, photography, and typography. But its main manifestations—geometricism, functionalism, truth-to-materials—had largely been admitted into design while having been excluded from art.

The only mass-circulation publication to give column-space to contemporary art, the BBC's weekly journal *The Listener,* had dwelt almost exclusively on influences such as these and had thereby presented a selective sampling. Individuals whose reading included periodicals such as *Architectural Design* or *Architectural Review,* however, would have had a more comprehensive appreciation, encompassing such movements as Futurism, Russian Constructivism, and De Stijl. Critics and theorists had laboured to attach the avant-garde of British art to European tendencies. Among the few to offer an alternative view had been Herbert Read, who had stressed a native Surrealism in English literature, a native Constructivism in the national characteristic feeling for organic Nature, and a tendency to combine and interrelate these themes consistently in English painting and sculpture (Thistlewood 1984). But Read's arguments were barely published at this stage, and in the sociocultural groupings where the ICA would trawl for its members there was a predominant belief that important aesthetic developments had originated abroad.

Vorticism, the one notable exception to this rule, was largely forgotten by 1947, more than thirty years after its sudden and intense eruption in London (Cork 1976). Wyndham Lewis, its founder and self-proclaimed "Enemy" of the establishment, had lapsed into a fashionable portraiture that had camouflaged his continuing, serious aesthetic writings. But his Vorticist mechanical abstraction had survived in something like its original form in an unlikely quarter, the Royal College of Art. William Lethaby had been the founding Professor of Design at the RCA, and though he resigned in 1918 he had left a profound legacy in the conviction that modern designs should be *precise, smart, and hard.* The most authentic models of these qualities consisted in Vorticist reproductions surviving from 1914.[4] Consequently, following familiar practice, the RCA had addressed images reduced in scale, conveyed in monochrome, overlaid with the aesthetic properties of print, and (in this case) devoid of the great creative anger and aggression which had focused themselves in the movement. Nevertheless, a derivative of Vorticism had continued to be practised in the Design Department of the RCA until the birth of the ICA, contributing however slightly to the Institute's potential for attracting an informed membership.

The other two principal modern art movements pursued in Britain before 1947 were Surrealism and Constructivism. Their announcements had been strictly defensive, however, through lack of any contextual support that might have flowed from Vorticism. When, in 1936, Surrealism made its first grand

appearance its adherents put so much effort into deflating conventional values that it became known as a force for destruction. Its essentially positive message concerning the potential enlargement of aesthetic awareness by responding to unconscious, unconventionalized imagery was distorted. By 1947 memories of Surrealist objects and images shown in surroundings the artists had actually despised had in effect neutered the original concepts. In 1936 Surrealism was merely put on display and, assisted only by lectures and performances which were deliberately difficult and impenetrable, and by scandal-seeking, unexplained happenings (for example, a *Flower-Headed Woman*'s occupation of Trafalgar Square), the London public was required to cope as best it might with a closed system of ideas (Robertson et al. 1986). Not unexpectedly, the result was offended incomprehension, reinforced by the message of the popular press that modern art was a deliberate insulting of the people.

Lessons were learned from this by the Surrealists' aesthetic protagonists, the Constructivists. Their first major London exposition in 1937 was intentionally didactic, emphasizing the movement's accessibility to ordinary perception. The origins of Constructivism were carefully described, and theoretical connections were made with phenomena already in the general consciousness, such as Stonehenge, modern bridge engineering, recreational architecture, and the structures of plant organisms (Martin, Gabo, and Nicholson 1937). It would be wrong to say that by this means Constructivism became a popular movement, but it did not arouse the hostility Surrealism provoked in Britain. In fact, it achieved a modest acceptability that might have been enlarged by a prominent museum. This was not the case in America. There New York's Museum of Modern Art, in particular, set examples, later emulated by the ICA, in promotion, sustenance, and education—examples which proved that public participation in contemporary art could be cultivated.

New York's Museum of Modern Art:
A Prototype for the ICA

The Museum of Modern Art was founded in 1929 in circumstances that were unprecedented yet, to British experience, strangely familiar. Just as London had been the principal centre of interest in Classical art in the eighteenth century, an occurrence which had given rise to the British Museum and its descendant institutions, and as it had also been one of the main centres where the French nobility liquidated its Renaissance masterpieces in times of revolution, creating a founding collection for the National Gallery of Art besides countless private *cabinets,* New York in the 1920s had the most intense concentration of early modernist drawings and paintings outside Paris. It boasted numerous enthusiasts for Impressionism, Post-Impressionism, and Cubism. The extreme wealth of these collec-

tors would have given them access to any other art markets had they not *preferred* their Manets, Seurats, Gauguins, van Goghs, and Picassos. The Museum of Modern Art was created to give public expression to this localized phenomenon, expressly to make the city the world's best centre not merely of accumulation but also of scholarship in modern art.

The trouble was—as had been the case in London with regard to Post-Impressionism and Vorticism before the First World War—there was much public misunderstanding, even hostility, deliberately encouraged by the popular press. The *Armory Show* in 1913 and the Metropolitan Museum's *Modern Art Exhibition* of 1921, while stoking the interest of private collectors, had alienated the unprepared. The public's main guides to interpretation and evaluation were sensational newspaper accounts of modern art's degeneration, distortion, and disfigurement, and of its conspiracy to depress and undermine the cheerful confidence of American capitalism. So while the success of these exhibitions, measured in attendance, had been enormous, in some respects they had harmed the cause of popularism because many thousands came merely to be scandalized. These and other major expositions of modern art, such as those in London, were designed to saturate the public awareness with images and objects. But they offered little advice as to how they should be taken into consciousness, and this exposed modernism's vulnerability to disinformation, and highlighted the vital necessity for authentic instruction.

It was in this sense that the MOMA trustees realized from the outset that their creature had to be substantially a teaching institution. At a time when there were no general educational courses featuring modern art, and when degree programs stopped short at David, Ingres, or Delacroix, the only models for apprehending modern art were individuals' experiments in self-education. Alfred Barr, MOMA's first Director, was appointed precisely because he had followed the twentieth century "grand tour" of London, Paris, Amsterdam, Dessau, and Moscow (Lynes 1973). In 1927 he was with Wyndham Lewis, who provided him with contacts throughout Europe, and impressed on him the dangers of neglecting to sustain the avant-garde with public information. Barr then visited Picasso and Le Corbusier in Paris, Jacobus Oud in Holland, Gropius, Klee, Kandinsky, and Feininger at the Dessau Bauhaus, and finally, in Moscow, representatives of contemporary Russian art, architecture, theatre, and motion pictures.

Barr's own apprehension of modernism, therefore, was first-hand. It ranged far beyond Post-Impressionism and Cubism (the purview of most of New York's interested collectors), and involved an interrelationship of painting, sculpture, and the design of graphics, industrial products, architecture, film, and theatre. In his first few years at MOMA he gradually drew the New York public towards an appreciation of modern art, carefully preserving contact with movements it would find less mystifying, and also offering constant references to related concepts in

the more familiar realms of architecture and product design. The Museum's inaugural exhibition was devoted to *Cézanne, Gauguin, Seurat, and van Gogh*—subjects which were hardly avant-garde in 1929, especially to Barr. But this show encouraged an informed awareness of Post-Impressionism and established its worth as an idiom to be taken seriously. It formed an anchor for presentations of subjects such as Redon, Klee, Matisse, Rivera, and Leger—frequent references back to Post-Impressionism ensuring that modernism's acceptability was never stretched too far.

At the same time Barr made the point that modernism was neither unprecedented nor unique. He presented Aztec, Mayan, and Incan paintings in an exhibition entitled *American Sources of Modern Art* (1935); and in the exhibition African Negro Art (1935) he reviewed the influential significance of primitive art. He widened the scope of his public's appreciation by exhibiting modern architecture and product design.[5] He broadened this still further by performing possibly his most difficult task (considering that Americans had been conditioned to believe modernism exclusively a cultured, European phenomenon): drawing modern American art into the history of the avant-garde and demonstrating its consistency with folk art.[6]

All of this may be seen as clever orchestration of acceptability, beginning with one of the most easily understood facets of modernism, attaching to it examples of mildly increasing extremism, proving it to be both universal and indigenous, and demonstrating it to be not esoteric but within everyone's grasp in the shape of buildings and artifacts in everyday currency. It was also an approach by stealth to what are now seen as having been MOMA's most important seminal exhibitions, *Cubism and Abstract Art,* and *Fantastic Art, Dada, Surrealism.* These confronted a by-now relatively knowledgeable public in 1936, the year in which, by contrast, the *International Surrealist Exhibition* so shocked an entirely unprepared public in London. They also initiated standard practices for which MOMA became renowned: publishing exhaustive supporting information rather than perpetuating mystique; and presenting exhibits in sympathetically designed settings, instead of environments suited to other aesthetic purposes and times. Barr put the entire results of his European fieldwork at the service of information. He wrote extensive bibliographies and catalogues that were among the first, in any language, to attempt to encompass all perceptible constituents. He also illustrated a large proportion of exhibited works, and substantiated them with wealths of incidental detail concerning artists' lifestyles, locations, contacts, and objectives.

This enterprise was the first large-scale attempt at placing fresh research immediately into the public realm, and, of course, it entailed the necessary risk of inaccuracy. In this respect it may be noted that Barr harboured two preconceptions. His evident supposition that contemporary abstraction was chiefly a European phenomenon, with few pioneering achievements having been made by

Americans, has been discredited (Levin 1980). So too has the widespread practice, to which he conformed, of interpreting art as a continuous, evolving phenomenon ruled throughout by cause and effect. Barr saw two such streams of events in his European researches. The first was a sequence initiated by Cézanne, encompassing Cubism and experimenting with a closed range of geometric forms. The second originated with Gauguin and engaged improvisation, amorphousness, and imprecision (Barr 1936a). This latter observation led Barr to speculate that a biomorphic abstraction would constitute the next serious plane of modern art's development. This phase would require artists to be alive to Surrealist spontaneity, to recognize fortuitous accidents, and to use mechanical and biological forms in fantastic combination (Barr 1936b). There is little doubt that this assumption of Barr's influenced the founders of the ICA, and that with the benefit of a decade's hindsight the two principal, originative movements were interpreted as "Constructivist" and "Expressionist" abstraction.

The Founding of the ICA and the Basis of Its Education Program

In its early years the ICA mirrored MOMA's version of modern art's development, and its exhibition policies (Melville 1951). It also encouraged Barr's two specifically-modern idioms, and shared MOMA's original purpose of creating an informed audience for modernism as a first step towards wider propagation. Among its founders were Roland Penrose (a veteran of the 1936 *International Surrealist Exhibition*) and Herbert Read (a principal participant in both this and the *International Constructive Art* exhibition of the following year). Read had enjoyed a practical involvement in MOMA from 1942, and had begun regularly to lecture there on visits to New York. Penrose was a close friend of Barr's and probably MOMA's most enthusiastic admirer in Britain (Penrose 1981). They looked upon the ICA as an opportunity to remedy popular misconceptions that had arisen in 1936 and 1937; and, considering their connections, it is not surprising that their methods bore striking resemblance to MOMA's programs in its initial phase almost twenty years earlier.

Apparently this was not at first intentional, for the ICA's *Outline Policy Statement* (ICA 1947) paid tribute to MOMA's achievement but professed its own aim to be different, namely to engage contemporary, rather than retrospective, art (even if this was of recent retrospection). But in practice the ICA had to present a survey of modern art's history because of the poverty of general understanding. Hence it was didactic from the start. Its inaugural exhibition *Forty Years of Modern Art* (1947) offered a perspective very similar to the MOMA's *Cubism and Abstract Art*. And its much more ambitious sequel *Forty Thousand*

Years of Modern Art (1948) presented arguments about precursors and the permanent validity of certain aesthetic precepts in an exactly similar fashion to MOMA's *American Sources of Modern Art and African Negro Art.*

This was done deliberately in order to present a history while shunning retrospection. Historicism, it was reasoned, deals with contemporary art by attaching it to the past, anchoring it to outmoded meaning and thus distorting its significance here and now. Contemporary art is presented as a series of logical *outcomes* of past styles, which may have arisen from fundamentally different circumstances. This encourages crude categorizations, in the face of which appreciators must labour to discover original meaning. The distillation of meaning would occur so much more spontaneously if historians were not principally motivated towards immediate logical interpretation. Contemporary art will lend itself to logical explanation *eventually* (it seems always to have done so in the past), but its earliest verbal attachments will be speculative, tentative, often inaccurate, and unconvincing. There is a recognized delay before contemporary art becomes intelligible to the general public: the Monets which were indecipherable in their day are now on every sitting-room wall. What cannot be conveyed in words, however, may be apprehended in *practical* dialogue. The most productive way of identifying with contemporary art is to effect forms of *critical* practice featuring emulation, deconstruction, and creative response.

Forty Thousand Years of Modern Art presented modernism as an attempt to engage universal creative principles, which had been potent in prehistoric times and lost in the cul-de-sac of Renaissance naturalism, but which had survived in the primitive and were capable of emulation in current practice. Great store was set by Gauguin's having rejected naturalism in favour of Tahitian imagery, and also by the fact that certain artists—Matisse, Vlaminck, Derain, Picasso, and others—had collected primitive sculptures at around the turn of the century. A culmination of recognition and respect was said to have occurred in Picasso's *Les Demoiselles d'Avignon* (1907), the first European work "to resemble negro art in general style" and to afford it "the supreme homage of imitation" (Archer and Melville 1948). Barr had been unable to exhibit this work in *Cubism and Abstract Art* but had shown preparatory studies. He had nevertheless reproduced it in his catalogue because of its seminal importance in uniting primitive and modern, and bridging back from Cubism to Cézanne. It also possessed the great propagandizing virtue of formal crudity, conveying the essential message that modern art's practices would be accessible to all who were willing to externalize their most elemental emotions, irrespective of whether they had undergone what was previously considered indispensable, an academic training. The ICA displayed this painting—in 1947 now owned by MOMA and loaned to provide the ICA with the most fitting symbolic beginning—in position of honour, the manner of its presentation (artificially lit below ground level) arousing a sense of reception into contemporary art.

What astonished initiates even more than the image was the revelation that it was forty years old, announcing a subsequent history which required apprehension before genuinely-contemporary imagery could be understood. Thus, the ICA's second inaugural exhibition defeated the intention not to be retrospective. It also gave rise to a paradox its officers did their best to resolve: that while authentic expression is timeless, authentic *contemporary* expression conforms to a pattern of progressive development. Herbert Read's assertion was that contemporary art was evolving in the sense of unfolding or revealing, rather than perfecting itself (Read 1951). The strategy adopted by the Institute, therefore, was to stress the constancy of art's eternal concepts. By no mere coincidence the concepts identified for this purpose were those which had been proclaimed at the MOMA—Constructivist and Expressionist Abstraction.

This, of course, was highly selective, especially in view of a preponderance of Surrealists in the founding membership, but it was seen as one of a number of simplicities necessitated by the general poverty of understanding. It was simplistic to say that before the modern period art had well-understood, entrenched purposes. But it was convincing to maintain that before Impressionism there were few determined attempts—in ways which had become common even by 1947— to explore aesthetic concepts so radical that they would initiate far-reaching changes of thought and conduct. Renaissance naturalism had held primacy for around five hundred years, the essentially "open" nature of its form and content ensuring its intelligibility. It was equally simplistic to describe avant-garde art of the twentieth century as obscure. But (in spite of artists' professions to be addressing people in the mass) the tendency to originate creative themes in private research had resulted in idioms and symbols that had remained "closed" to general appreciation for considerable periods.

These had been unproductive intervals, preventing rapport between those who were compelled to express particular visual and plastic concepts and those who might reasonably have been expected to be receptive. The infant ICA, then, accepted the twin tasks of encouraging emergent excellence and disseminating its principles through education. To these ends it rejected Naturalism as having been superseded by Surrealism. Surrealism itself was seen as needing to divest itself of realistic representation (which was anchoring it to outmoded conventions); and its principal role in the mid twentieth century was identified as enriching unconscious, expressionist abstraction by raising the perceptibility of "accidental" marks and images. "Conventional" Surrealism, therefore, was employed for its propensities to shock, and as a means of heightening the membership's collective imagination towards a structured, experimental creativity that welcomed fortuitous, accidental effects. And just as Barr had cultivated a new audience for modernism through the accessibility of works by Cézanne, Gauguin, Seurat, and Van Gogh, the ICA exploited Paul Klee's approachable creativity to establish several important precepts.

Both of these works, respecting the organic principle, are meant to reveal their creative logic openly. <u>Top</u>: Students were asked to arrange a collage of larger white shapes on a black ground, and then to deploy a collage of smaller shapes in recognition of a spatial flow from left to right across the ground and around and between the larger shapes. The result is constructive, dynamic, and organic in the sense of revealing its creative logic. (Reproduced by permission of the Trustees of the National Arts Education Archive, Bretton Hall, Wakefield, W. Yorkshire, U. K.). <u>Right</u>: A space-filling exercise, the result of observing the reactions of a drop of cholesterol in water. Students were required to "oppose the natural tendencies of the human hand to repeat configurations—and to defeat calligraphy specific to a personality." (From R. Hamilton, T. Hudson, V. Pasmore, and H. Thubron. 1959. *The Developing Process*, London, ICA; by permission of the University of Newcastle-upon-Tyne and the Institute of Contemporary Arts, London).

The first of these was the principle of progressive development, the cherished hallmark of authentic contemporary art. Klee's work was relevant here in two senses. It was recognized as being in the forefront of an effort to regain primitive (that is, constant) symbolic significance; and Klee himself had proclaimed each of his works to be an act of self-revelation, the graphic elements moving through sequences of dimensional shifts to reveal forms just beyond the artist's previous experience. Visual expression begins with the point, which moves, creating line; this in turn moves laterally, describing plane; and plane moves similarly, creating volume. This simple doctrine provided both the initiate with a means of entry into constructive abstraction, and the more practised with an analogous concept— organic formation—to hold as the main criterion of authentic creativity.

The ICA's exhibition *Growth and Form* (1951), designed by Richard Hamilton, was devoted entirely to natural subject-matter. Scientific specimens, juxtaposed with diagrams of molecular structures and microscope-photographs of organic growth, revealed an inner world of abstract images conforming to an evolutionary logic. Corresponding debates conveyed the message that these were not to be imitated except in principle, for example by respecting the positive and negative extension and diminution of shapes, allowing each mark or form to "suggest" a subsequent addition or erasure, building into the work a record of its own originative processes, the counterpart of those that science had found detectable in natural organisms. This was the Institute's answer to the problem of "closed" contemporary expression: each work respecting the organic principle would thus reveal its creative logic openly. Successions of such works would present frame-by-frame chronologies of aesthetic research in the recommended fields of Constructivist and Expressionist Abstraction.

Now these two idioms may not have seemed particularly related—indeed Barr had identified them as strict alternatives—yet it was recognized at the ICA that they possessed a common fundamental principle which served to unite them: they were process-dominant. Creative direction was determined neither by technical expertise nor inside knowledge of art's great themes. Instead, form was divined in each work as it progressed and thus revealed itself. The term "organic" was especially relevant here, helping to rationalize a way of working in which images or forms would seem to appear, and to take on symbolic characteristics, with little specific pre-intention on the part of the painter or sculptor (Thistlewood 1981). It is not true that end-products were completely ignored, but more accurate to say they were allowed to take care of themselves, the means becoming the focus of attention. This left open, of course, the question of what informed or motivated each individual judgement in the orchestration of a spontaneous, organic work of art. Here too Klee was instructive.

In 1953 the ICA presented *Wonder and Horror of the Human Head,* a survey of the vast range of possible symbolic meaning attachable to depictions of heads

and faces. This exhibition was calculated to superimpose an awareness of the potential emotional content of contemporary art over the by-now accepted principles of organic formation. Statements by Read and Penrose in an accompanying publication (Penrose 1953) barely disguised their concern at the prospect of having encouraged art of authentic form but lacking significant content. The exhibition's purposes were to "give courage to those who find our Present an impenetrable chaos," to "stimulate poetic reflection upon our human condition," and to "act as a mirror or a window for the imagination"—in other words, to accentuate the importance of irrational symbolism besides developmental logic.

The human head was a peculiarly appropriate subject-matter in this regard, composed as it was of a few ostensibly-simple features, capable of expressing the full complement of human feelings by minutely subtle changes in their spatial relationships. The head itself might symbolize other conceptions—the sun, the earth, the creative wellspring, life or death. Therefore, the unpractised painter or sculptor, looking for some sense of purpose in simple mark-making or shape-making, might profitably study this phenomenon to gain some inkling of how a dot might become a gazing eye, of how a line might smile or grimace, of how the elevation of a plane might indicate arrogance or humility, and a volume convey the summation of a personality.

Such complex emotional expression, a constant feature of Klee's art, was easily overlooked when following his disarmingly simple mechanical directives. Klee, of course, was not the only model: Leonardo had "seen" facial expressions in stains on walls; Max Ernst had found similar phenomena in rubbings of floorboards, leaves, and stones; for Tanguy strange oneiric faces had appeared unbidden in the mists of his Surrealist images; and both Masson and Sutherland had discovered faces in their depictions of landscapes and natural forms. Acceptance of this sense of identification was to argue that very little mark or shape-making was necessary to suggest facial images conveying the most complex of human emotions, ranging from wonder to horror. As these emotions were latent in the elements of visual expression (rather than their styles or cultural affinities), it could be argued also that they were realizable in Constructivist and Expressionist Abstractions. The underlying message was that images of such emotional potency could be achieved without conventional expertise. Indeed, expertise might be a hindrance if it prevented recognition and adoption of powerful imagery as it emerged in the processes of drawing, painting, or constructing.

This rationale for entering the flow of contemporary art on the part of the previously-uninitiated, downgrading technical expertise and familiarity with art history's great themes, and instead emphasizing raw emotional expression and constructive sensibility, proved to be so compelling that within a decade of its original airing at the ICA it had been carried into formal art college programs and was enshrined in government policy.[7] The early 1960s witnessed a widespread

popular participation in contemporary art (inconceivable in 1936 and 1937), the outward manifestations of which included bohemian dress and discriminating affection for modern jazz and other forms of expression at once emotional and cerebral. This is not to say that the ICA was responsible for creating a national mood, but to recognize that it did anticipate and condense a popular necessity. Its great achievement, at the start of its existence, was to popularize an appreciation of contemporary art featuring practical, creative strategies that were accessible to the untutored. Constructivist and Expressionist Abstraction possessed teachable virtues in their processes, which also released an unselfconscious Surrealism. Almost incidentally, therefore, the ICA also encouraged something which has not yet received general recognition—a synthesizing of the principal movements of the previous avant garde art of the twentieth century.

Notes

1. The author wishes to thank the *Royal Society of Arts/W.J. Parker.* for its generous funding of research recorded in this paper.

2. *The International Surrealist Exhibition,* New Burlington Galleries, London, 1936.

3. *The International Constructive Art Exhibition,* The London Gallery, 1937.

4. *A Dancer* by Henri Gaudier-Brzeska, in *The New Age,* 19 Mar. 1914, 625; *Chinnereth* by David Bomberg, *ibid.,* 2 Apr. 1914, 68; *Study* by William Roberts, *ibid.,* 16 Apr. 1914, 753; *The Chauffeur* by Charles Nevinson, and *The Farmyard* by Edward Wadsworth, *ibid.,* 30 Apr. 1914, 814-15.

5. In *A Brief Survey of Modern Painting* (1932) and its sequel Modern European Art (1933).

6. In *Modern Architecture International Exhibition* (1932), *Objects 1900 and Today* (1933), and *Machine Art* (1934).

7. In response to recommendations in *The First Report of the National Advisory Council on Art Education* (the so-called "Coldstream Report"), 1961.

References

Archer, William, and Robert Melville. 1948. *Forty Thousand Years of Modern Art.* New York: Museum of Modern Art.

Barr, Alfred Hamilton. 1936a. *Cubism and Abstract Art.* New York: Museum of Modern Art.

_____. 1936b. *Fantastic Art, Dada, Surrealism.* New York: Museum of Modern Art.

Cork, Richard. 1976. *Vorticism and Abstract Art in the First Machine Age.* 2 vols. London: Fraser.

ICA. 1947. *Outline Policy Statement of the Proposed Institute of Contemporary Arts.* London: Lund Humphries.

Levin, Gail. 1980. "The First American Experiments with Abstract Art." In *Abstraction: Towards a New Art,* 113-20. London: Tate Gallery.

Lynes, Russell. 1973. *Good Old Modern: An Intimate Portrait of the Museum of Modern Art.* New York: Atheneum.

Macdonald, Stuart. 1970. *The History and Philosophy of Art Education.* London: London University Press.

Martin, Leslie, Naum Gabo, and Ben Nicholson, eds. 1937. *Circle: International Survey of Constructivist Art.* London: Faber.

Melville, Robert. 1951. "The Exhibitions of the ICA." *The Studio* 161 (no. 697): 99-100.

Penrose, Roland. 1953. *Wonder and Horror of the Human Head.* London: Lund Humphries/Institute of Contemporary Arts.

_____. 1981. *Scrap Book 1900-1981.* London: Thames and Hudson.

Read, Herbert. 1943. *Education Through Art.* London: Faber.

_____. 1951. *Art and the Evolution of Man.* London: Freedom Press.

Robertson, Alexander, Michel Remy, Mel Gooding, and Terry Friedman. 1986. *Surrealism in Britain in the Thirties.* Leeds: City Art Galleries.

Spalding, Frances. 1986. *British Art Since 1900.* London: Thames and Hudson.

Thistlewood, David. 1981. *A Continuing Process: The New Creativity in British Art Education 1955-1965.* London: Institute of Contemporary Arts.

_____. 1984. *Herbert Read: Formlessness and Form: An Introduction to his Aesthetics.* Boston: Routledge and Kegan Paul.

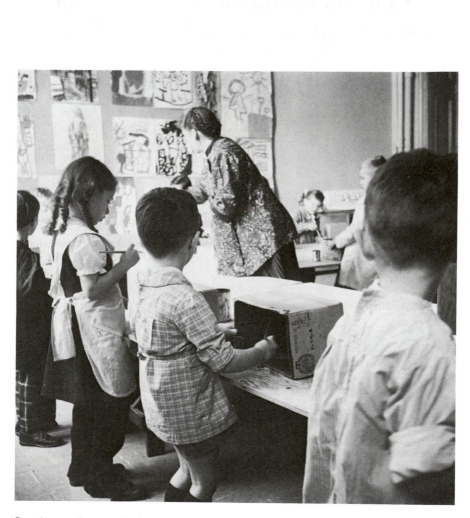

Saturday art classes at Ecole des Beaux-Arts de Montreal during the 1950's and 1960's were under the direction of Irene Senecal. The classes were a laboratory to go beyond drawing by exploring three-dimensional and collective art works.

Cultural Factors in Art Education History: A Study of English and French Quebec, 1940-1980

12 *Suzanne Lemerise and Leah Sherman*

Quebec is a Canadian province with a unique history and identity. A Francophone enclave in the North American continent, its society comprises two main linguistic groups: a majority whose cultural identity is rooted in the French language, and a minority that finds its cultural identity in the English language. The educational system sustains the existence of the two language groups, as the schools are effectively separated along linguistic lines by a complicated parallel school structure whose origins go back more than 150 years.

This paper examines the development of public art education in Quebec public schools from 1940 to 1980. During these years, the "new art education," with its humanistic, creative, and personalized approach to the teaching of art in the schools had, by and large, replaced the philosophy associated with the utilitarian goals and academic traditions of the late nineteenth century. We attempt to show that French and English art educators during this period had similar goals and imported the same ideologies, but that the implementation of these goals was affected by the different social and cultural forces acting upon each group. The adoption of the new philosophy of art education took separate paths in French and English schools.

We analyze the internal and external factors which account for the changes in educational objectives and school programs in the context of a bicultural society in a period of major social change.

The principal historical questions to be addressed include: Who were the individuals who prepared the ground for the changes to take place? What did they do and when? What was the relationship between the two linguistic groups in the professionalization of art education? How did enlightened art educators relate to the larger movements in art education between 1940 and 1960? How did the social and institutionalized change which shaped Quebec society from 1960 to 1980 affect the process of change in the two cultures?

Before 1950: The Individuals Who Prepared the Ground

In the years between the wars, 1918 to 1940, the seeds of the new art educa-
tion were planted in Montreal. Changes in philosophy and teaching practice
developed first in the English milieu. By the end of the nineteenth century, the
English population had well-developed cultural institutions and access to current
ideas from England and the United States. The English Protestant school system
functioned independently from the French Catholic system, and its school boards
had free rein in curriculum matters. Although there was no training program for
art specialists, and art was not a priority, it was possible for individual art teach-
ers, with the support of school principals, to develop innovative programs.

One of these teachers, Anne Savage, was to be an important influence in the
development of art education in the province. Savage, who taught at Baron Byng
High School in Montreal from 1922 to 1948, was a practicing artist whose teach-
ing was energized by her identification with the emerging field of Canadian paint-
ing. She was an early proponent and practitioner of new methods of teaching art,
influenced by such writers as Marion Richardson, Herbert Read, Belle Boas, and
Ralph Pearson. The effects of her teaching were far-reaching, and she inspired a
large number of students. Two of them, Leah Sherman and Alfred Pinsky, were
later to be instrumental in the institutionalization of art education at the university
level.

At this time, the French system's curriculum was established by the Départe-
ment de l'Instruction publique, and its application was overseen at every level by
provincial supervisors. In 1922 the Ecoles des Beaux Arts de Montréal and de
Québec were founded. They were oriented towards training teachers who would
be capable of influencing the artistic taste of the people of Quebec (Couture and
Lemerise 1980) and resulted in the hiring of qualified artists in a few high
schools. But the public school system, controlled by religious authorities and a
conservative political regime, was not very fertile ground for innovative ideas.

A strong stimulus for a new approach to art education in the 1930s and 1940s
came from outside the school system. Several of the painters involved in the
changes in the art world found child art consistent with their aesthetic and social
goals. Artists such as Arthur Lismer, Fritz Brandtner, Jean-Paul Lemieux, and
Paul-Emile Borduas[1] conducted classes for children and were inspired by the
spontaneity and authenticity of children's paintings.[2]

It was Arthur Lismer who was the most influential in the field of the new art
education in the province as a whole. An international pioneer in child art, he
came to Quebec in 1942 to take over the educational program at the Montreal
Museum of Fine Arts. In his children's art classes at the Museum, he demon-
strated the new teaching methods and trained art teachers for extracurricular
classes.

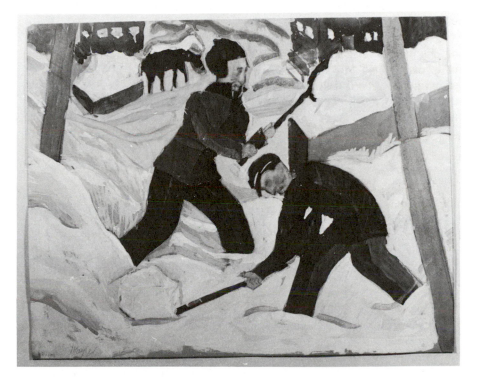

Poster paint, (18" x 24")—workmen removing snow from Montreal streets. Painting was done by a junior high school student of Anne Savage at the Baron Byng High School, circa 1930.

Irène Senécal, an art teacher at Ecole des Beaux-Arts in Montreal and in public schools from 1930 to 1968, was another dominant figure in the new approach to the teaching of art. In the 1930s she was already conscious of the difficulties children were having when faced with the official curriculum. In the mid-1940s she experimented with new pedagogical approaches in the Saturday morning workshops of the children's libraries. She found in R.R. Tomlinson's small book *Children as Artists* (1944) answers to her numerous questions and experiments. The curriculum Senécal proposed for the Lachine and Montreal Catholic School Commissions in 1950 was influenced by Tomlinson, Read, and Lowenfeld. At the same time, she had also convinced a few young teachers to experiment with her new pedagogical approaches. Senécal was tolerated by the school system, unlike artists like Borduas, who were considered subversive because they were identified with the contemporary art movement. She and her small group of active followers nonetheless remained a minority, meeting with a great deal of resistance and rejection throughout the 1950s. The new art education did not take hold in the schools until art teachers began to group themselves into professional organizations.

The 1950s: Beginnings of Professional Associations

INSEA and CSEA/SCEA

In 1951, at the Bristol conference on art education where the creation of the International Society for Education Through Art (INSEA) was proposed, Canada's representation included Charles Dudley Gaitskell from Ontario and Louise Barette-Charlebois from Quebec. The role that Gaitskell played in the founding of INSEA and of the Canadian Society for Education Through Art (CSEA/SCEA) is well known (MacGregor 1979). The role of Louise Barette-Charlebois is less known. In retrospect, her presence can be seen as significant and as hardly accidental; it was symptomatic of Canada's bicultural nature and of the political need to include the "French fact" in a national organization. The founding meeting of CSEA/SCEA took place in Quebec City in 1955, and Barette-Charlebois worked closely with Gaitskell in the association's early days. However, the goal of a bilingual association at the national level proved difficult to implement. A close look at the history of the interaction of the two language groups in Quebec provides some reasons for the problems encountered.

The Child Art Council

Also in 1955, Anne Savage and a group of twenty-three art teachers met in Montreal to form the first provincial association of art teachers in Quebec. The

Child Art Council (CAC) drew its membership from the community as a whole, French and English, from extracurricular art classes, and from the school system, and was the beginning of the professionalization of art education in the province. There were eighteen Anglophone and five Francophone teachers at that first meeting. The aims of the CAC were:

- to bring together for discussion all those engaged in the teaching of art to young people;

- to aid community groups in promoting the development of an art program;

- to make information about art education available;

- to stimulate interest in the teaching of art. (*Child Art Council* 1959)

The CAC published a bulletin and held meetings to promote the new ideas in art education. The problem of translation for unilingual members raised functional problems which were to handicap future attempts at cooperation and joint efforts between the two language groups. The CAC's solution was the publication of two versions of its bulletin, one in English and one in French, in which contributions from both English and French members were translated.

The common enthusiasm for reform in teaching practice overcame language problems and, as the contents of Volume 1 (*Child Art Council* 1959) indicate, the Bulletin became a small but significant voice for the new ideas. Leaders of both language groups contributed articles on creativity and the role of the teacher in creative teaching, and reviews and bibliographies of the important American and English books in the field. Leah Sherman, a former graduate student at New York University and a member of D'Amico's Committee on Art Education[3] used the Bulletin to reprint material from the latter's newsletter and to share her recently acquired concepts of teaching.

It was a logical move for the CAC to become the Quebec Society for Education Through Art (QSEA/SQEA) and to affiliate with CSEA/SCEA in time for the latter's Montreal meeting in 1959. Monique Brière, who was to remain an active member of CSEA/SCEA and QSEA/SQEA through their ups and downs, saw this move as providing the CAC with the opportunity to "widen its field of actions and gather an important number of both French and English art teachers together, from all the principal centres in the province of Quebec" (Brière 1960).

The new association continued and enlarged its bulletin. By this time the task of translation had become too onerous and a single booklet was published containing French and English sections, with a note from the editor stating that translations of individual articles were available on request. By 1962, QSEA/SQEA had a membership of 160 and functioned as two sections which held separate and joint meetings.

The value of the visual Arts
in Education for the development
of the whole individual is being
realized more fully everyday
as Herbert Read says ⁓
" Expression is as important as
impression or repression."

This is a survey of experiences
from Grds I -VII showing some
approaches to creative teaching
The effort has been to develop the
Design sense through the use
of the elements - subject: line: space
colour · texture · dark-light - planes
- - - - - - and · form -
and its application to intuitive
expression

Hand-lettered cards by Anne Savage introduced an exhibition of elementary school art that she organized during her term as art supervisor for the Protestant School Board of Greater Montreal. (1948-1952).

Teacher Training

The approach to art education supported by QSEA/SQEA needed to influence the training of art teachers before it could be implemented in the schools. In the French system, Irène Senécal made initial advances in the field. In 1955 she organized a few special classes at the Ecole des Beaux-Arts based on the new ideas of art teaching. She initiated negotiations in order to obtain official recognition for her program as preparation for the specialist's certification, but it was not until the 1960s that this recognition was granted.

In the English Protestant system, McGill University in Montreal had the traditional and exclusive responsibility for teacher training. Betty Jacques, a former student of Arthur Lismer's in Toronto, joined the staff of the McGill Normal School in 1945 and fought hard to bring the "new art education" to bear on the curriculum. Despite her efforts, art remained peripheral and an elective, even after the Normal School was absorbed into the university in 1958 (Jacques 1978). An attempt to offer a Bachelor of Fine Arts degree in the Faculty of Arts was short-lived (1948-1952). In the conservative academic climate of McGill, studio-based studies were suspect. Although the studio and art education components of the program were offered in cooperation with Lismer's art school at the Museum, the program was discontinued and fine arts at McGill remained housed in the department of art history.[4]

In the 1950s a small number of art educators worked hard to promote change in the schools. The two linguistic groups shared common values; and what is remarkable about these years is the will they had to work together and to establish ties at both national and international levels. While art educators were joining forces, important changes were occurring in Quebec society.

The Quiet Revolution[5] and the Parent Commission

Political change in the 1960s gave form to French Quebec's nationalistic aspirations, and the desire to develop the province's economic and natural resources. The traditional school system was not up to the task. Quebec engaged in an ambitious project of social and political reform, including a fundamental reform of the educational system. The traditional separation of education and politics gave way to a state-run educational system which was seen as the principal instrument of national policy.... The years between 1961 and 1968 were dynamic ones, starting with the report of the Parent Commission. This was a royal commission set up in 1961 to inquire into all formal education in Quebec and to gather the latest information from school systems in the U.S., Europe, and the U.S.S.R. (Sherman 1980, 45)

The activities of the QSEA/SQEA culminated in a presentation to the Parent Commission. Although there was agreement in principle on the objectives of art education, "owing to the particular needs of the two educational systems," the association found it "advisable to present two separate briefs that complement each other."[6]

Both briefs emphasized the value of art in education and criticized the existing conditions for the teaching of art in the schools. They agreed that art should be a compulsory subject at all levels of schooling and that it should be taught by teachers well trained in art. They agreed as well on the appointment of a provincial director of art. Their main differences related to the way in which art specialists should be trained. The French brief asked for the recognition and extension of the existing system of preparing art teachers at the Ecole des Beaux-Arts de Montréal, while the English section, with no course for the certification of art specialists in place, asked for the establishment of art departments in the universities. In addition, the authors of the French brief saw the Commission's hearings as an opportunity to promote human and artistic values for the renewal of the cultural life of the French people, and the brief's conclusion confirms this interpretation.

The recommendations of the Parent Commission, many of which were implemented immediately, resulted in far-reaching changes, ranging from the reorganization of school administrations to the adoption of modern teaching practices and a greater emphasis on scientific and practical education. In terms of art education, the Commission's final report followed many of QSEA/SQEA's recommendations, although it was felt by many that it did not go far enough in establishing art as an essential part of the school curriculum. The need for art in the schools was recognized, but it was afforded a relatively minor place. The report recommended the appointment of a provincial coordinator, the use of art specialists in secondary schools, and expansion of the teacher training section of the Ecole des Beaux Arts.

The Parent Commission's report helped art education in other ways. Its hearings provided one of the first opportunities for bringing art education to public attention. With its emphasis on the activist, child-centered approach to teaching, it confirmed the values that art educators were trying to foster in the schools.

> What became different after 1960 is that new ideas and projects, until then ostracized and pertaining to a minority, are now recognized as valuable by a majority of citizens, and will serve as outlines for a new prevailing ideology. (Monière 1977, 309)

The Commission's report provided a structure within which long-awaited changes could take place. One of these was the recognition of Senécal's teacher training program for art specialists. The art teacher was no longer a marginal figure or an intruder in the schools, but a full-fledged educator.

The Institutionalization of Art Education in Universities

In the 1960s and 1970s the leadership role that the English minority had exerted in the community and the schools was diverted to the university level. It was at Sir George Williams, the new, growing and flexible university, that the arts found a facilitating environment. Leah Sherman joined the faculty in 1960, followed by Alfred Pinsky in 1961. By 1966 a B.F.A. with a major in art education and an M.A. in art education were in place. In 1969 the pedagogical component for teacher certification was added to the undergraduate degree, and a comprehensive teacher training program in a fine arts context was finally available in the English system.

From its inception the art education program at Sir George Williams, which filled an urgent need in Quebec for university-level studies in fine arts and in art education, attracted a large number of Francophone students. As a result of the Parent Commission report, a system of public junior colleges had been set up and the art teachers in these colleges required academic qualifications. In addition, the colleges offered a range of art options, and graduates of these programs were ready for university art programs.

In the French system the established universities would not recognize Ecole des Beaux-Arts credits as university equivalents.[7] French art educators seemed blocked in their efforts to go further. Those who went to France to study found that its universities were out of touch with North American developments; language and economic factors posed problems for those who might have gone to the United States. There was a need for a Quebec university to provide the link with the growing field of art education in North America.

As a relative newcomer to the university scene, and with a multicultural orientation, Sir George Williams University was itself marginal relative to the university establishment in Quebec. Its infrastructure was flexible enough to accommodate new ways of doing things, and it was possible for the new graduate program to recognize the studio components of the art school diploma as university credits. From 1967 to 1980, 34% of the students enrolled in the M.A. in art education were Francophone.

French students at Sir George Williams found themselves in a relatively bilingual situation. They were able to write their papers and theses in French, and some of their professors and fellow students were bilingual. As one of the M.A. students, Monique Brière, said in a recent interview (1987), "We are conscious of our identity at Sir George Williams University; Francophone students always felt they were Francophones; being confronted with a group speaking a different language helped us to define ourselves."

The interaction of French and English art educators at Sir George Williams University was beneficial for both groups and had far-reaching effects. While the

Francophone students were affirming their own identity, the Anglophone faculty were defining their role in and finding ways to identify with the new social realities. Canadian and Quebec interests merged in the desire to develop a unique approach that was aware and abreast of developments in the United States, but independent and selective in their application. American faculty members who came to Sir George Williams in those days found themselves in a bewildering but dynamic situation in which their preconceptions about art education faced the challenge of a different cultural mix.

In the early 1970s the links between the French and English cultures were strengthened by the presence at Sir George Williams of Hélène Gagné, a former student of Irène Senécal who had earned a doctorate at Teachers College, Columbia University. Gagné had taught at the Ecole des Beaux-Arts and was instrumental in the updating of its curriculum. A ceramic sculptress, rooted in the art-making experience and with a strong philosophical background, she was an important influence in the conceptualization of the Ph.D. program initiated in 1977 at Concordia University (as Sir George Williams had been renamed). The program's original goals, which proved difficult to implement, reflected a recurring dilemma of the field of education: how to ground research in art education in the experience of art-making without neglecting the theoretical fields where educational practice takes its roots. With the introduction of doctoral level studies, the institutionalization of art education in Quebec was ensured. Art education had gained academic respectability, and Concordia served as a model for the acceptance of art in the university structure, paving the way for similar developments in the French universities.

Formation of Unilingual Associations

The Sir George Williams/Concordia University experience reflects only one aspect of a general situation defining relationships between Francophones and Anglophones. The experiences of QSEA/SQEA demonstrated the continuing problems in communication between unilingual Quebecers from both language groups. In the 1960s and 1970s the different rates of social and educational change occurring in Quebec and in the rest of the country further hampered the association's members. Its history can only be understood in the context of these social changes.

The INSEA meeting in Montreal in 1963 was hosted by the co-presidents of QSEA/SQEA, Alfred Pinsky and Claude Vidal. There was a joint meeting of the English and French sections of QSEA held in May of that year. However, strains in the relationship with the national association were beginning to show, and there were difficulties in the organization of the CSEA/SCEA conference in 1967 (MacGregor 1979, 31-32).

By the middle of the decade, the results of the educational reforms of the early 1960s became apparent. Art, though still marginal, was recognized by authorities as a legitimate subject, and Francophone art teachers were gaining rights and power within their school system. The need for English and French art educators to support each other ideologically was less urgent, and membership in QSEA/SQEA declined. Several French educators tried to explain the dissolution of the association: Serge Valcourt (ca. 1967) mentioned differences in attitude between the two linguistic groups; Ulrich Laurin (1974) preferred to call it a progressive desertion on the part of the Anglophone members; Monique Brière, in an interview in 1987, described the difficulties encountered by unilingual members, but clearly indicated that both linguistic groups deserted the association. The dissolution of QSEA/SQEA was hardly noticed, as educational reformers in both school systems were turning their attention to different problems.

As early as 1965, many school commissions began hiring art coordinators to implement the new regulations resulting from the recommendations of the Parent Commission. These coordinators became members of committees formed by the recently appointed provincial director of art, Louis Belzile, to write and implement the art curriculum. In order to exercise political influence in the educational bureaucracy, the coordinators (many of them former leaders of QSEA/SQEA) found it necessary to form their own unilingual professional association, Association des responsables de l'éducation artistique au Québec (AREAPQ) (Belzile 1983).

The new bureaucracy, which was virtually unilingually French, replaced the old autonomous structures which had controlled and separated English and French education in the province. The English minority struggled to adjust to their changing roles as a small group in a large system, where their needs were not always recognized. Around 1969 a small group of Anglophone art teachers formed their own association, the Provincial Association of Art Teachers (PAAT) and affiliated themselves with CSEA/SCEA.[8] In a document issued by PAAT (1969), Louis Belzile mentioned the difficulties related to the coordination of the bilingual committees responsible for writing the art curriculum. It became obvious that Anglophones were facing a new set of rules in a centralized educational bureaucracy.

Generalists Versus Specialists

In the dynamic and volatile climate of the 1960s, all professional groups faced unpredictable challenges. In the French milieu, the art specialists trained in fine arts departments encountered opposition from conservative forces in the schools. This opposition was expressed in the rivalry for control of the art educa-

tion between two groups, the generalist teachers trained in the normal school system and the art specialists. The underlying issue was the old controversy about the position of the specialist in the schools.

In 1968 a second Francophone association was formed in Quebec City. It consisted primarily of generalist teachers who had taken in-service courses in art education in a few centres throughout the province. The Association des professeurs d'arts plastiques du Québec (APAPQ) was officially recognized by the Ministry of Education. The art specialists and consultants, the majority from Montreal, found themselves disenfranchised as a group and decided to become members of the new association. For a short time in the life of APAPQ, a few bilingual Anglophone members of the art education faculty at Sir George Williams were part of its executive committee, and helped the French specialists to gain control of APAPQ.

Leon Frankston, a professor at Sir George Williams, took charge of *Vision*, the association's publication. *Vision*'s first two issues contained articles originating from both linguistic groups. Two articles written by Anglophones emphasized the necessity to unite in order to promote a common goal: "In our joint plight to improve the state of art education everywhere (and particularly in the Province of Quebec), I urge you to examine with a vision for roots and wings the direction which we must take" (Frankston 1969, 3). David Paterson, president of PAAT, commented on the existence of the two linguistic groups in the following terms: "It is not my intention to elaborate on why rational and irrational fears cause differences to develop. . . . Our aims must be very largely the same, and our methods are without doubt similar, except in one particular aspect—the language of instruction" (Paterson 1969, 4-5).

In 1969, at the second general meeting of APAPQ which took place at Sir George Williams University, the problem of language recurred. Unilingual members attended separate sessions and there was little interaction between the two language groups.

Subsequently, negotiations between PAAT and APAPQ broke down. There are several possible explanations for this. There was a lack of common language of communication between the two groups, and the need for compromise no longer existed. By the 1960s Senécal's message and the "new art education" which had found support in the English milieu in the 1950s had been institutionalized; thus, there was no longer a need for French educators to speak English. Finally, the English minority was fearful of losing its identity in the larger French association and was not yet bilingual.

Conclusion

This study has traced the development of the "new art education" in Quebec from 1940 to 1980. We have seen the initiative move from individual reformers centred in Montreal to professional associations, and from the English milieu to the French.

In the 1950s English and French art educators joined forces to promote the new ideas. In the 1960s the art education movement was affected by the fundamental changes occurring in Quebec society. The ideology which inspired the movement was officially accepted by a reformed and restructured educational system, and Francophone art educators gained strength in numbers and in influence. With the goals of art education no longer in question, social issues became more dominant, and the group took on a life of its own, responding to the current of events in the society as a whole. The status of Anglophone educators in Quebec changed from that of an independent and progressive group to a minority in a large state-run system. This shift was reflected in a new balance between the two groups of predominantly unilingual art teachers in the professional associations.

The energies of the French association were directed toward establishing art in the reformed educational system. There was no need to function as a bilingual group, and there was no meaningful link with the national association (CSEA/SCEA). The issue of the language of communication became a key vehicle in the drive for autonomy, cultural identity, and social organization by the majority, and the two language groups were isolated from each other. The lack of a common language of communication reinforced their differences and led to a separation of the two groups at the level of professional associations. In spite of their common goals and philosophy, both groups of unilingual Quebecers were unable to remain aloof from social change, and were unable to share in the effects that social change had on each of them.

This isolation continued until the 1980s, when the "back to basics" movement affected the place of art in the schools. Art programs were cut back and jobs for art teachers were in jeopardy. The gains of the 1960s and 1970s have proved to be illusory, and art, as defined by the advocates of the humanistic and creative approach of the 1940s 1950s, is still seen as marginal to the essential needs of society. The common failure to implement the teaching of art in the schools has encouraged a renewed association between English and French art educators.

The 1985 joint conference of CSEA/SQEA, PAAT, and AQESAP[9] in Montreal was an example of the sharing of ideas that is possible today. This sharing is facilitated by the rise in bilingualism among the English population in recent years (Rudin 1985, 285).

The separation was not as distinct at the academic level. At Sir George Williams University the liaison between the two groups was sustained. It was beneficial for both language groups to do so. As a new educational institution in a changing social reality, Sir George Williams was defining itself and its place in a Francophone Quebec. The French-speaking students needed a university degree to become legitimate members of the new intellectual elite. The language issue was secondary to these larger goals.

We believe that this joint study is further evidence of the beneficial effects of collaborative efforts between the two cultural entities in Quebec. As the first of its kind in the history of Canadian art education, we hope that it has provided a more balanced view of the development of art education in Quebec and has demonstrated a new approach to research in the field.

Notes

1. Borduas, a professor at the Ecole des Arts appliqués in Montreal, was the initiator of the Automatist group, an avant-garde movement which promoted abstraction. In 1948 he published, with his group, the "Refus Global" manifesto, whose general philosophy and artistic involvement radically opposed established social and artistic order. As a result of this publication, Borduas was fired from the Ecole: the education system could not tolerate rebels.

2. In 1945 Maurice Gagnon, a writer on Quebec art, published a book on contemporary painting in Quebec, a whole chapter of which is devoted to a new approach in the teaching of drawing (Gagnon 1945, 45-66). In order to give more weight to his claims about the necessity of a renewed art teaching, Gagnon mentioned these artists, who were working in private schools or art schools.

3. The committee on art education was sponsored and hosted by the Museum of Modern Art, New York, and led by Victor D'Amico, the education officer of the Museum. It was organized in 1943 and functioned for nearly twenty-five years, bringing together some of the most active and effective teachers of the visual arts at the time. Its members included many art educators who became leaders in the field, and it served as a role model for other professional groups. Irène Senécal attended a meeting of the Committee on Art Education in New York in 1949.

4. An almost similar situation prevailed in the Francophone circle. Robert Elie and Edmond Labelle, directors of the Ecole des Beaux-Arts in Montreal, tried to integrate fine arts into the structures of the University of Montreal. For reasons that can be compared to the ones at McGill, the integration proved impossible within that institution (Couture and Lemerise 1980).

5. "The phrase 'Quiet Revolution' refers to a series of reforms initiated in Quebec between 1960 and 1966. It was a cleaning-up and catching-up operation on institutional, political, and ideological levels" (Monière 1977, 310).

6. Brief presented to the Parent Commission by the French Section of QSEA/SQEA in 1962.

7. It was only in 1969 that the Ecoles des Beaux-Arts of Quebec and Montreal were incorporated into the university system, and M.A. studies were introduced in 1977 at the Université du Québec in Montreal.

8. The relations between the English minority and the French majority were drastically altered by the shift to state control of education. The two separate school systems reacted differently to these reforms (Rudin 1985, 246, 247). From a powerful autonomous minority, the English became an actual minority in a multidimensional system, controlled by the French majority. The new system was shaped by the aspirations and needs of this majority.

9. AQESAP, the Association Québécoise des éducateurs spécialisés en arts plastiques, is the result of a merger between the AREAPQ and the APAPQ in 1980.

References

Bezile, Louis. 1983. "En autant quer je me souvienne." *Vision* 33 (April): 33-34.

Brière, Monique. 1960. "Introduction." *Bulletin of the QSEA/SQEA* 1: 1.

Child Art Council. 1959. *Bulletin of the Child Art Council* 1: 1.

Couture, Francine, and Suzanne Lemerise. 1980. "Insertion sociale de l'Ecole des Beaux-Arts de Montréal." In *L'Enseignement des arts au Quebec*, 1-69. Montréal: UQAM.

Frankston, Leon. 1969. "Vision: Roots and Wings." *Vision* 1 (Spring): 3.

Gagnon, Maurice. 1945. *Sur un état actuel de la peinture canadienne*. Montreal: Société des Editions Pascal.

Jacques, Betty. 1978. "Art Education in the Public English Protestant Schools in Quebec." *Art Education in Quebec, Presentations on Art Education Research*, Vol. 1, 32-38. Montreal: Concordia University.

Laurin, Ulrich. 1974. "D'où venons-nous? Qui sommes-nous? Où allons-nous?" *Vision* 14 (Spring): 3-4.

MacGregor, Ronald N. 1979. *A History of the Canadian Society for Education Through Art* (1951-1975). Lexington, MA: Ginn Custom Publishing.

Monière, Denis. 1977. *Le Développement des idéologies au Québec, des origines à nos jours*. Montreal: Québec-Amérique.

Paterson, David L. 1969. "Toward a Possible Merger." *Vision* 1 (Spring): 4-5.

Rudin, Ron. 1985. *The Forgotten Quebecers: A History of English-Speaking Quebec, 1759-1980*. Quebec: Institut québécois de recherche sur la culture, Bibliothèque nationale du Québec.

Sherman, Leah. 1980. "Education in Quebec: Forecast for the 1980s." In *Canadian Art Education for the 1980s: An Appraisal and Forecast,* edited by Ronald N. MacGregor, 44-50. N.p.: The Canadian Society for Education Through Art.

Valcourt, Serge. [ca. 1967]. La Société du Québec d'Education par l'Art.

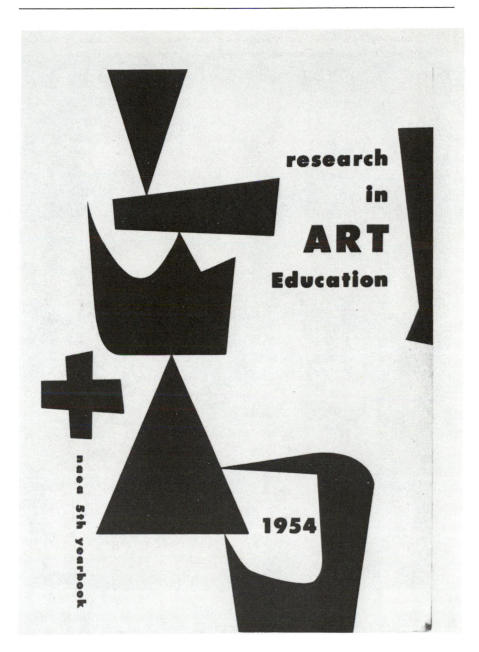

The 1950's witnessed an increase in art education research, often facilitated by the National Art Education Association. The research was usually empirical and based in psychology. This 1954 NAEA publication was edited by Manuel Barkan.

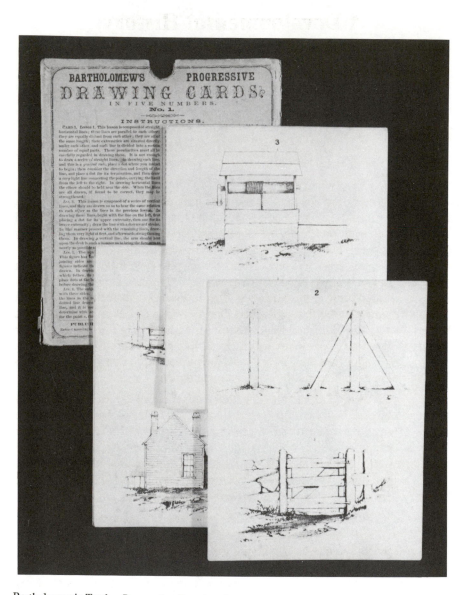

Bartholomew's Twelve Progressive Drawing Cards (1860), assured students undertaking these problems in graphic representation of posts, gates, and houses: "Care is all that is required." (Korzenik Collection).

A Developmental History of Art Education

13

Diana Korzenik

Beliefs

Over the centuries, new beliefs about art have arisen and been circulated in many ways. In the United States from the 1840s to now, people have relied heavily on books on art education. Books that survive from different eras show their authors' ideals and explain the virtues of drawing according to their particular advice. Text describes the procedures. Illustrations show them. Writers on art education had substantial influence over whatever families drew at the kitchen table or children drew at their desks in classrooms all over the country. John Gadsby Chapman, who first published *The American Drawing-Book* in 1847, Walter Smith who published his textbook series largely in the 1870s, Arthur Wesley Dow whose *Composition* had its greatest impact in the first decade of this century, and Viktor Lowenfeld whose several volumes appeared years later, each had their time to command the American imagination.

For much of my life, the art education I experienced—even before I knew it—was influenced by ideas attributed to Viktor Lowenfeld. Coloring books were taboo. I was encouraged to make my own mark. Storybooks surviving from our family's home offer evidence that I avidly crayoned over my open spaces within black and white line drawings. In the absence of these or any other pictures to "color," I used wax crayons to create forms of my own. Paths of crayon became people, merry-go-rounds, and animals that fascinated adults.

My relatives and teachers said I was "good at art." They said I was "free" because no teacher had yet "spoiled" me. Adults were sure that I made those wonderful things *because* no one taught me. Even as a child, I remember wondering about that. It seemed odd and felt very peculiar for adults to value my independence from *their* influence, especially since every other aspect of my childhood life demanded that I master skills that adults wanted me to have.

Now, as an adult, I see the approval and cultivation of "child art" as a specific form of regulation of children. "Child art" was very much a part of the adult world. It was valued in the then contemporary context of adults' social, aesthetic, and political priorities. Parents' magazines and newspaper advertising provided the rationale; one did not have to read Lowenfeld.

One idea that was current was that "free" children didn't care what their images looked like. They got absorbed in the process. From that notion, a slogan arose: "Process is more important than product." In 1952 Viktor Lowenfeld himself noted the contradiction: "It . . . seems to me of little use to emphasize... that the working process is of greater importance than the final outcome, without analyzing the reasons behind this opinion. Strangely enough, we see these same educators who stress this important viewpoint, thereby laying stress on the effect of the final product" (1952, vi).

Lowenfeld's worry was that teachers were trying to get children to make what adults saw as "child art." He quoted teachers, who feared they were failing because they had problems trying to make children conform to the style of child art. They asked Lowenfeld what they should do: "What should we do if the child does not draw large, with big motions in his uninhibited straightforwardness, as we have read the child is supposed to do?" "My children even if I give them a large sheet of paper, draw only small" (Lowenfeld 1952, vi).

Lowenfeld shows us the self-deception of the teacher who disclaims any interest in the "look" of a painting, while he or she cultivates "child art" as a style with its own predictable appearance, that is, big strokes, with fat bristle brushes and bold colors. In 1947, in his preface to the first edition of his classic, *Creative and Mental Growth,* Viktor Lowenfeld wrote: "The idealistic concept of the child as an innate artist who has simply to get material and nothing else in order to create has done as much harm to art education as the neglect of the child's aesthetic impulse. . . . The aversion shown by some educators for suggesting any teaching method . . . has brought progressive art education to a point where it relies almost completely upon the mere intuitive approach, which the teacher has or has not" (1952, 5).

Idealization of child art has not always been with us. It has many sources. In this century, even people who did not read Freud talked about his ideas. Mental life and hidden content became accepted problems in the lives of adults, the solution for the next generation was to allow them to be freer of adult control.

For a better part of this century, in that climate, psychologists have been studying the development of the child, the transformations of mind and body at each stage. Teachers and psychologists, with parents following their lead, prized age-appropriateness and expressivity. Unlike the past century, which saw the child as an empty container that needed to be filled with information and values, this century saw the child as bursting to externalize feelings and thoughts. For this expression, pencils, paints, and clay were ideal media. Art was interesting to adults, not as it had been a century before, as a way of cultivating a generation of artists and designers, but rather as evidence of the healthy, changing child: a supreme manifestation of physical, cognitive, emotional growth. *Creative and Mental Growth,* Lowenfeld's book title, said it all.

The discovery of the stages of childhood can be attributed to the restructuring of education when, by mid-nineteenth century, traditional mixed-age schools became the new, age-segregated or age-graded classrooms. At first age-segregation did not change the essential technique of instruction; rote learning remained the rule. But toward the end of the century even that changed. Graded classrooms had level-specific exercises, whether in reciting, reading, or drawing. Characteristics of particular ages went virtually unnoticed in mixed-age classes in which children came one-by-one to the teacher to perform the lesson. But by the time teaching methods caught up with age-graded classes, teachers learned to notice age differences (Rodgers 1985).

Almost as soon as age groups were segregated, childhood behavior became subject to ever changing interpretation. The definition and treatment of childhood became professionalized. As work removed adults from work in the home, farm, and immediate neighbourhood, parents, grandparents and neighbours gradually relinquished bits of their influence over children. Teachers and school committees set priorities, regimented children's time, and assumed responsibility for redefining childhood.

By the turn of the century some educators, reeling from society's changes, sought to preserve the child, unsullied by the world that was radically transforming their lives. Psychology promised to offer the methods for ascertaining the needs of a hypothetically pure child.

Like that perhaps apocryphal anecdote about Wordsworth in which he is said to have been peering into baby carriages to learn "the truth," researchers of the child study movement at the start of this century addressed questions to young children to find out how they, without supplying adult answers, understood such matters as space and time. Their findings promised to illuminate children's thinking about subjects such as geography, history and science. Though these studies also had implications for art teaching, others concerned themselves explicitly with art. In 1895 Louise Madeline Maitland of Stanford University published "What Children Draw To Please Themselves." In her analysis of some 1,570 drawings collected from children ages five to seventeen, she wrote: "One is forced to recognize the fact that notwithstanding, or perhaps partly in consequence of, the emphasis laid on the teaching of the beautiful in most of our drawing systems, ...children regard other things as more important and interesting for expression" (1895, 80). She found that children use drawing as a means of description, a language, for showing their material environment and the persons and events which interest them.

Charmed by such findings, teachers of subsequent decades sought less and less intrusive ways to encourage the child to use the characteristics of paint and clay. Though some observers were troubled that the spontaneity so apparent in the free drawing of earlier years seemed to disappear at about the third or fourth

year at school (Sargent and Miller 1916) and designed teaching to compensate for this, by mid-century the popular ideal was that art grew from simply allowing children to build upon their interests and abilities, from largely leaving them minimally contaminated by any adult skills or standards.

With the growth of available research funds and the increasing academic orientation of university-based art education departments in the middle of this century, art educators formalized their hands-off position by concerning themselves with investigation and description of the learner. At a safe distance from children, art educators could "develop a vocabulary by working with psychologists, sociologists, and researchers so that we may know what we are talking about and be able to translate our precise language into terms understandable by the ordinary person" (Dix 1954, 10). Research served two agendas. One was for art educators to gain stature in the hierarchies of the professions. The second agenda was to stimulate public school's demand for art. In the decades of this century, the study of the child becomes the basis of art teacher's professional preparation. Rousseau, Pestalozzi, Froebel, and Americans of the Child Study Movement appeared on reading lists along with Viktor Lowenfeld, Rudolf Arnheim, Erik Erikson, and Jean Piaget. Teachers-to-be learned that children's products, whether in painting, drawing, blockbuilding, or language, grow from the young person's life and concerns. These writers have taught teachers to be appreciators of the achievements of children.

Adult influence, called "interventions" in the late 1960s, was taboo, especially by the colleges, the very places where people learned to be teachers. Many such institutions, chartered as normal schools to provide a much-needed population of teachers for the nation's growing school systems, between the 1930s through the 1960s were becoming liberal arts colleges. Their exclusive mission in teacher training dating back to the mid to later nineteenth century was coming to an end. As liberal arts course work took precedence over teacher training in these institutions, methods courses survived only as vestiges of a rejected past.

To shore themselves up, educators in universities and colleges built their new work upon that of a liberal arts field, psychology. Though a tendency in this direction was visible earlier in this century, by mid-century empirical research preempted other values in writing. The 1954 publication *Research in Art Education* (Barkan) was one tangible bit of evidence of the change.

Research allowed educators to embellish their understanding of children, without ever having to do something with children. Among other things, the pursuit of research prolonged the era in which educators could maintain the position of neutrality. Research extended the myth of the pure child, whose development is best supported by being left undisturbed. Experts could just ask questions and watch what children did. The activity of teaching ceased—for a time—to be the center of the field of education. While enhancing our knowledge of children,

researchers turned the art education spotlight away from the arena of action: the classroom.

Not only did the study of psychological theory divert attention from methods of teaching per se, but it led to some careless confusion between methods of research and methods of teaching. Arnheim, Erikson, and Piaget, whose works the psychologically-oriented art educators read, never intended their studies to be *methods* of teaching. Decisions about what to do in the classroom could not be postponed indefinitely.

Meanwhile, in the liberal arts curriculum structure, some art students still elected to become teachers. Their "Studio Art" courses were to be taught by "artists" who acquired this label by obtaining a heretofore non-existent degree, the Master of Fine Arts (M.F.A.). Because they lacked that degree, many renowned artists were ineligible to become professors. The M.F.A. standards were formalized in a College Art Association resolution of 1970: "No academic degree other than the M.F.A. or equivalent professional achievement should be regarded as qualification. . . . Education degrees should not be regarded as constituting appropriate preparation for teaching studio courses" (College Art Association 1977). A careful reading of the standards revealed that the M.F.A. degree, plus *not* having an art education degree, were the explicitly stated qualifications for becoming a studio art faculty member (Landry 1985). "Studio Art" intentionally pushed art education into the periphery, where it survived as a vestige of the now retired normal school agenda.

This relatively new rivalry between studio and education faculties *in art* put artists and art educators in impossible positions. Ambivalence was institutionalized. Artists in the college studios, where they taught for much of the year, had to downplay their interest in teaching. Artists who chose to be educators had to study psychology, and also resist being too involved with teaching!

In this environment art students received little training in methods. Predictably, teachers who were prepared in this climate and those children who were their students, were confused and felt gypped. Simply being an artist and entering a room full of children whose stage of life is somewhat familiar probably did not seem preparation enough. A reaction was due and today we are in the midst of it.

Now, things are changing. The childish look in art is less vogue. When the fiscal cuts across the states registered the public's distrust of schools, a "back to basics" mentality overtook teaching. Teachers wanted to prove they were teaching. Art skills began to be interesting again. At the same time, taste in home decor, historic preservation, and painting reflected a new, conservative, antiquarian state of mind. It is hardly surprising that art educators are attracted to our field's nineteenth century methods in their search for "basics." The new curiosity about the old methods springs, I believe, from educators noticing that children do learn a skill *when* taught it in a developmentally appropriate way. When, for

example, children discuss what they see in paintings in a museum and bring new ideas into their own work, adults start wondering why it is that they could not or did not want to notice what children could learn this way!

When the Old Is New

People interested in education now are becoming fascinated by methods. They want to think about how they can direct and teach students, how they can plan. They notice that if you have a strong bias toward certain skills, and you teach a child to master them, sure enough they will learn and they will master them. Suddenly, they want to teach everything they know about art, *regardless of age*. For some techniques of copying, drawing from life, and rendering light and shade are now part of the elementary art program. Others even want to start teaching aesthetics, art history, art criticism, and the making of art in the kindergarten. Such is the agenda for The Institute for Educators on the Visual Arts of the J. Paul Getty Trust's Center for Education in the Arts.

In reaction to the various forces reviewed above, art educators are currently entranced with art education's history. Today's teachers are amazed and delighted to find what appear to be usable strategies in art textbooks and *School Arts* magazines from the early twentieth century, and even earlier. These sources show how teachers taught before the era when, it seems, everyone was told to stop directing children. In them, one can see what adults used to believe should be passed along to the next generation.

Teaching methods of the past still have appeal. They seem novel and exotic. In the 1870s Walter Smith, for example, taught people to form curves with even, smooth, uninterrupted pencil lines that no one would know how to make today. I, for one, have become fascinated by how he did that. I am intrigued, too, by what can be learned by drawing from dictation, from practising visual measurement by aiming to replicate a graphic example. Others find appeal in the turn of the century landscape studies promoted in the color plates of the Louis Prang textbooks. Still others see useful application of line and notan (the balance of contrasting black and white) from Arthur Wesley Dow's *Composition*. Each of these methods embodies a slower, more meticulous time when accuracy and effect mattered, when people were unabashed about admitting that their product mattered!

These books have a power for us because they were disregarded for a century. Today we want direction and we want to be able to direct. If the 1979 book *Drawing from the Right Side of the Brain* reflects growing curiosity about methods, the fascination with old teaching methods suits our contemporary agenda even more. Not only do the old lessons provide direction and authority that match the conservatism of our time, but they also engage us in the contemporary

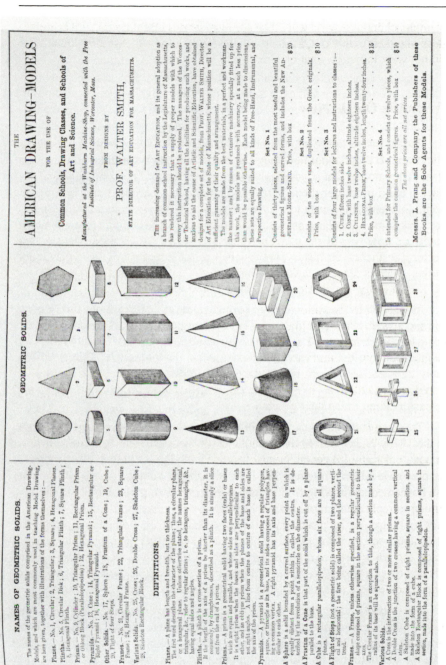

Along with drawing cards and textbooks, Walter Smith in tandem with L. Prang & Co., marketed these student-made wooden geometrical solids, to advance Americans' much wished for artistic improvement. (Korzenik Collection).

attraction of nostalgia. Our interest in these lessons reminds us of how much artists and art educators are enmeshed in the social, political, and economic issues of their time.

Given the conservative preoccupation with directive instruction, many educators have become wary and even suspicious of the developmental viewpoint. There need not be an either-or situation. I would like to see the field of art education retain the developmental view with all its advantages but free itself from false idealization of the pure child. We can use the rich findings of developmental research, after paring away from it the non-interventionist myth.

In our new curriculum work, recognizing qualitatively different approaches to learning that suit a child's particular stage of development can provide a framework into which we can selectively fit old methods. With care we can mesh our relatively recent appreciation of developmental theory with our even newer interest in those well-crafted old methods that historical researchers are uncovering. In many cases, those of us who do historical research are the very same people who used to do developmental research. I think historical researchers today have the responsibility not only of unearthing these intriguing past practices, but of examining how different past instructional credos and procedures would have been understood and felt by past generations at their respective stages of development. A developmental history of art education would emphasize how, in different eras, children and adolescents used the various schemes that teachers presented to them.

But we have a methodological problem. Those old art instruction books are only limited data. They tell us what writers and publishers wanted us to know. They do not inform us about what children actually experienced. They cannot answer the question of the relationship of printed exhortation to actual practise. Did teachers really follow the printed instructions? What did they feel they were doing? Why did drawing matter to them? To their students? When left to their own devices, what drawing did children of different ages prefer to do? Books are mute about these questions.

It is virtually impossible to know how a past school practise actually fit into the students' lives. To imagine the liveliness of a school, we need to invent, or juxtapose, the psychology of the child with available bits of historical evidence. We need to look for evidence of every sort to understand attitudes toward play, responsibility, work, and the transition into adulthood.

Scholars of the history of childhood have struggled with this as a methodological problem. Some, specifically Demos (1970) and Hareven (1982), who respectively have described childhood in the seventeenth and the nineteenth centuries in the United States, accept that children of different eras went through successive physical and psychological changes. Absurdly simple as that statement may sound, much history has been written as if that were not the case.

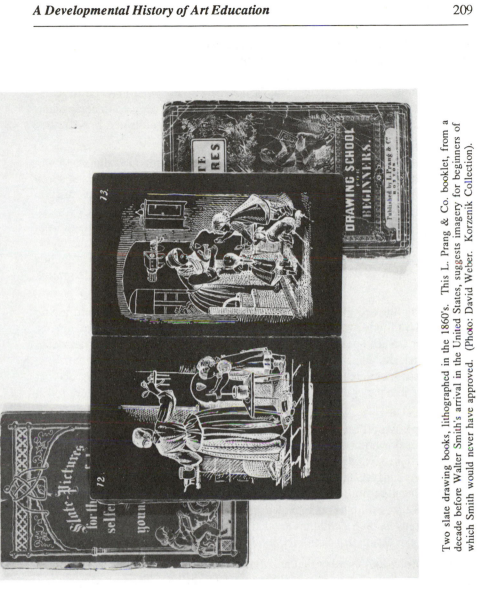

Two slate drawing books, lithographed in the 1860's. This L. Prang & Co. booklet, from a decade before Walter Smith's arrival in the United States, suggests imagery for beginners of which Smith would never have approved. (Photo: David Weber. Korzenik Collection).

It seems appropriate to assume that three or four year old children's thinking, for centuries, was preoccupied with thoughts and feelings quite different from older children, and indeed from adults. It seems likely, too, that with some tool or other, every young child made his or her mark. Eras would have differed in the balance of how much time children had to themselves, devoted to companionship with their peers, and spent under the supervision of adults and in what they did in all those different kinds of time.

Though early in the nineteenth century we know young girls did stitch meticulous samplers, we also have evidence that by 1875, for boys and girls of seven or eight, Walter Smith's disciplined drawing exercises might have been just too frustrating. For the seven and eight year olds we know, drawing is a highly social process. Children enjoy the sharing of skills and the passing along of them from one to the next. Like playground games and chants documented by the Opies (1959), seemingly spontaneously generated exchanges of drawing ideas grow in a childhood culture in which seven and eight year olds play with drawing (Korzenik 1979).

I have glimpsed this stage occasionally at flea markets where, in drawing books, I have found awkwardly pencilled representations of people and animals. On pristine framed spaces that printers intended as places for serious students to practise their drawing, even on pages in Walter Smith's *American Textbooks of Art Education,* children drew to please themselves. Sometimes they pasted cut out figures like paper dolls along with equally carefully cut out furniture to fill those empty spaces.

Though Walter Smith never intended fantasy and spontaneity to enter the pages of his drawing books, here they were, all but obliterating the Smith drawing instructions. That the children used a drawing book at all for their less mature explorations suggests that the mere existence of a student's drawing book probably gave them permission to draw, to play, to make something on their own. Though Walter Smith never intended it, his books ironically served as springboards for invention for children in other, younger stages of growth, who sought a form of expression that Smith totally disregarded.

It is useful to remember that children are full of ideas that occurred to them quite independently from adults' deliberate didactic efforts. The surviving sketchbooks with the "wrong" drawings spread all across their pages show us that children of the 1870s were less malleable and subject to adult control than teachers may have wished. Without these spontaneous drawings, we might have accepted that children then never played nor ever expressed their own ideas at an immature level of skill. Unconsciously, we might have accepted that children of a century ago had none of the needs of the children we know.

Accepting these gaps in our knowledge, it can be productive for art educators to speculate about how it might have felt for children actually to have spent time

on the various past methods of instruction. The findings of American history, American Studies, and our own field's historians, inch us toward possible integration of developmental psychology and the surviving past art educational method books.

Embedding historical evidence in a developmental context requires two kinds of work: *historical reconstruction,* reading what is available on the tasks of childhood in the historical era when a certain method was advised, and *psychological thinking,* understanding how today's psychologists would describe a child of a certain stage. Knowledge from both these domains then permits us to ask when, if at all, these past practices might be stimulating and suitable to specific stages of children's growth and learning. In this manner, the developmental research on children's thinking can enrich our thinking about the history of art education.

Conclusion

By asking "What are the cognitive and emotional challenges built into a particular art instructional method?", one can begin to read history with a focus. If we read the history of art education with the child's mind and body in our mind, and with awareness of the changes it will undergo, we develop an empathic appreciation of what it would have been like to be a learner of each of the many historical approaches. This attitude will produce better historical thinking. The empathy demanded of the reader would force him or her to wonder about the space within classrooms, the furniture, how people were dressed, the homes to which the children returned, and the attitudes of friends, siblings, and parents. History becomes more alive and useful to classroom practice.

In our time, we now are no longer in the grips of that double-speak in which teachers claimed to be only cultivating, and not instructing, the child. We no longer need confound the methods and purposes of teaching and research. Now we can openly express our interest in instruction. Because of this, we are at an ideal moment to match the legacy of past methods with that more recent inheritance, developmental psychology.

As we read the various art education methods of the past, though there are only rare references in the 1850s to drawing as play, we know we should consider how drawing might have provided a form of play for children of the nineteenth century. We know that the psychology of the child would have demanded that opportunity for play, that no instruction could suppress it. What we learn from human development and what we learn from the history of art instruction can be useful in tandem for creating new ideas for teaching.

References

Barkan, Manuel, ed. 1954. *Research in Art Education*. Kutztown, Pa.: National Art Education Association.

Chapman, John Gadsby. 1847. *The American Drawing-Book*. New York: J.S. Redfield.

College Art Association. 1977 May. "Standards for Studio Faculty: A Resolution." *College Art Association Newsletter*.

Demos, John. 1970. *A Little Commonwealth, Family Life in Plymouth Colony*. New York: Oxford University Press.

Dix, Lester. 1954. "Introduction." In *Research in Art Education,* edited by Manuel Barkan, 7-10. Kurtztown, Pa.: National Art Education Association.

Dow, Arthur Wesley. 1899. *Composition*. New York: Baker and Taylor.

Hareven, Tamara K. 1982. *Family Time and Industrial Time*. Cambridge, England: Cambridge University Press.

Korzenik, Diana. 1979. "Socialization and Drawing." *Art Education* 32 (no. 1): 26-29.

Landry, Adrienne. 1985. "What Gave Rise to the Master of Fine Arts Degree in Studio Art?" Boston: Massachusetts College of Art, unpublished.

Lowenfeld, Viktor. [1947] 1952. *Creative and Mental Growth*. Rev. ed. New York: The Macmillan Company.

Maitland, Louise Madeline. 1895 Sept. "What Children Draw to Please Themselves." *The Inland Educator:* 77-81.

Opie, Iona, and Peter Opie. 1959. *The Lore and Language of Schoolchildren*. London: Oxford University Press.

Rodgers, Daniel T. 1985. "Socializing Middle Class Children: Institutions, Fables, and Work Values in Nineteenth Century America." In *Growing Up In America,* edited by Ray H. Hiner and Joseph M. Hawes. Urbana, Ill.: University of Illinois Press.

Sargent, Walter, and Elizabeth E. Miller. 1916. *How Children Learn to Draw*. Boston: Ginn and Company.

Index

This index is organized with both the general reader and researchers in mind. In addition to giving you quick access to topics, details, facts, and chapters relevant to your interest, the index's sub-categories and cross-references direct you to subjects treated in different ways by the book's various authors. For readers seeking additional information on a subject, careful use of the index, references, and the first chapter will lead you to further sources. To facilitate this, the index lists not only items that are examined in depth in this book, but also those that are discussed more briefly. Information in the endnotes is also indexed. The index lists a few historians (e.g. authors in this book, Ashwin, Bell, Carline, Cremin, Freedman, Logan, Macdonald, Sutton). When an indexed subject is cross-referenced with these historians, it is because they have discussed that subject in a book or article listed in chapter one's references. Please note, however, that such cross-references are far from exhaustive. For example, this type of cross-reference may not be found in the index if connections between a historian and a subject are already made clear in the book's text.

List of Contributors

Patricia M. Amburgy, Assistant Professor, The Pennsylvania State University

Paul E. Bolin, Lecturer, University of Oregon

F. Graeme Chalmers, Professor, The University of British Columbia

Arthur Efland, Professor, The Ohio State University

Diana Korzenik, Professor, Massachusetts College of Art

Suzanne Lemerise, Professor, Université du Québec à Montréal

Anthony W. Rogers, Lecturer, South Australia College of Advanced Education, Adelaide, Australia

Robert J. Saunders, Art Consultant, State of Connecticut, Department of Education

Leah Sherman, Professor, Concordia University

Donald Soucy, Associate Professor, University of New Brunswick

Mary Ann Stankiewicz, Associate Professor, California State University, Long Beach

John Swift, Director of Studies: School of Art and Design Education, City of Birmingham Polytechnic

David J. Thistlewood, Professor, University of Liverpool

B. Anne Wood, Associate Professor, Dalhousie University

Foster Wygant, Professor Emeritus, University of Cincinnati